Edward Lear in Albania:

Journals of a Landscape Painter in the Balkans

Edward Lear in Albania:
Journals of a Landscape Painter in the Balkans

Edited by Bejtullah Destani and Robert Elsie,
with a preface by Vivien Noakes

in association with
THE CENTRE FOR ALBANIAN STUDIES

Published in 2008 by I.B.Tauris & Co. Ltd.
6 Salem Road, London W2 4BU
175 Fifth Avenue, New York NY 10010
www.ibtauris.com

In association with
The Centre for Albanian Studies

In the United States of America and in Canada distributed by Palgrave
Macmillan, a division of St Martins Press, 175 Fifth Avenue, New York,
NY 10010

ISBN: 978 1 84511 602 6

A full CIP record for this book is available from the British Library
A full CIP record for this book is available from the Library of Congress
Library of Congress catalog card: available

Printed and bound in Great Britain by Biddles Ltd.

Table of Contents

List of Illustrations

The Centre for Albanian Studies gratefully acknowledges the assistance of
Harry Bajraktari, Vehbi Bajrami, Zef Balaj, John Bitici, Sergio Bitici,
Gjon Bucaj, Mike Bytyçi, Shaqir Gashi, Martino Hasanxhekaj,
Rudolf Hisenaj, Sejdi Hisenaj, Binak Hysenaj, Agim Karagjozi,
Agim Rexhaj, former Ambassador to the UK Kastriot Robo,
Bruno Selimaj, Pjeter Vulaj and Rexhë Xhakli.

The Centre would also like to thank:
Arsim Canolli for help with preparation of the text and photographs;
Ilir Hamiti for the Index; Simon Edsor for use of the front cover image.

Noel Malcolm and Alexander Duma for their
continuing advice and support.

Preface

EDWARD LEAR WAS born in 1812, the twentieth of twenty-one children. His life was one of contrasts. Always short of money, he nevertheless moved amongst the rich and powerful. He had a wide circle of devoted friends, yet was often deeply lonely. As a young man, he established a reputation as one of the finest ornithological illustrators of all time, yet for a hundred years his fame rested on his success as a nonsense writer, the creator of limericks and of the perennial children's favourite, 'The Owl and the Pussy-cat'. Largely self-taught as an artist, from his mid-twenties he turned from ornithological work to landscape, and is now one of the most highly regarded painters of his age.

In 1837, at the age of twenty-five, he went to live in Rome, then a gathering place for artists of many nationalities. Murray's 'Handbook of Travellers in Central Italy', published in 1843, suggests that an agreeable diversion for visitors to the Holy City is to spend time in the studios of the leading painters. Lear, an 'artist of great promise', is one of those singled out. By 1848, however, he knew that, in order to establish a wider, more lasting, reputation, he must return to England. Before doing so, he decided to spend fifteen months exploring countries around the Mediterranean.

He went first to Greece, but his visit there was cut short when he fell sick with malaria. From Athens he sailed to Constantinople, and it is here, in early September, that his 'Journals of a Landscape Painter in The Balkans' begins. At this time Albania, still part of the Ottoman Empire, was a country little explored by the English. Lear particularly enjoyed venturing into remote and picturesque countryside, discovering places and people unknown to less intrepid travellers. The demands of journeying through such rugged and often perilous countryside

would have been exhausting for anyone. For Lear, who suffered from epilepsy, asthma and short-sight, the achievement was truly remarkable.

Before setting out he read the works of earlier explorers. He particularly admired Colonel W. Martin Leake's 'Travels in Northern Greece', published in 1835, with its mass of description and useful information. He took great care about practical preparations, and the advice he gives on this in the introduction to his 'Journal' was reproduced in Murray's 'Handbook for Travellers in Greece', a book that also draws extensively on his description of the journey he made through the Acroceraunian Mountains, a part of Albania that had never before been described by an Englishman. Since he did not speak the language and the country was so little charted, he engaged a local guide who not only knew the suitable resting places for the night, but also negotiated on Lear's behalf with the authorities through whose districts they travelled. Before leaving, he had procured letters of introduction to local Turkish governors, or beys. This was partly to ensure safe passage while in their territory, for the Ottoman Empire was breaking up and suspicion of unknown visitors was high; on one occasion the local people even believed him to be a Russian who planned to sell the local inhabitants to the Tsar. The introductions also meant that he would be invited to stay in the beys' residences in considerably more comfort than he found in the rough and primitive wayside resting places or khans that were his usual stopping place. But their generous hospitality, where thirty courses might be served in a single meal, lost him the valuable daylight time that was so important to an explorer and artist. Travelling in Albania, he wrote, presents two alternatives, 'luxury and inconvenience on the one hand, liberty, hard living, and filth on the other'. Despite the disagreeable experience of sleeping surrounded by chickens and horses, accompanied by fleas, spiders and bugs, he preferred hardship for the freedom it gave.

Travelling in a Muslim country where drawing was seen as an act of profanity, he was often attacked as an infidel with shouts of 'Shaitán' or 'Devil'. Sometimes, though, he was a source of amusement rather than anger. When he gathered watercress from a stream to eat with his bread and cheese, the local people laughed hugely at his eccentricity and brought him thistles, sticks, grass

and even a grasshopper suggesting that he might like to sample these as well. If there was humour to be found in any situation, Lear was able to discover it.

He had planned to travel with a companion, Charles M. Church, the nephew of Sir Richard Church who had commanded the Greek forces in the War of Independence. He and Church had earlier been together in Greece, but a cholera 'cordon sanitaire' prevented them meeting up and so, apart from his guide, he travelled alone. His routine was to be up before sunrise and out on horseback before dawn. In the mid-morning he would stop for a meal and possibly a short rest, and then journey on in order to reach his destination before nightfall. On occasion this took longer than expected and it was dark before they arrived, offering the moonlit beauty of riding through a silent forest etched in silver light.

When he came to a scene that seemed suitable as the subject for a painting, he would stop and make a pencil drawing. He did not use oil paints when he travelled, but worked entirely in pencil on paper. He drew swiftly and would make often extensive pencil notes that gave details of colour and form; these would help him to recall the particulars of a scene when he was back in his studio. There, on winter evenings, he would go over the pencil lines with sepia ink, a process he called 'penning out', and lay in watercolour washes based on the colour notes he had made. These travel drawings he showed to potential buyers who might commission a finished studio watercolour or oil painting of the scene.

He responded with delight to the countryside through which he travelled, enjoying the contrast between the gentle scenery of northern Greece and 'the grandest phases of savage, yet classic picturesqueness' in the wilder parts of Albania. There were patches of desolate and melancholy scenery, but then he would cross suddenly into a wide valley with open plains and distant hills, and the roughness of travel would be forgotten 'in the enjoyment of scenery so calm and lovely'. He knew that his drawings could never do justice to this scenery, that his work would only ever be an imperfect representation of the beauty and magnificence he had seen.

It was not only the countryside that fascinated him, but also the birds and animals. He watched with amusement as a pair of storks constructed a nest on the roof of the Vice-Consul's house in Yannina, and enjoyed the cavortings of a baby

goat, 'who resembled nothing so much as a large white muff upon stilts'. He delighted in the gatherings of local people in their costumes which reminded him, in their polychromatic brilliance, of tulips swaying in the wind or exotic parrots, and he vividly describes their music and their dance.

Lear found pleasure, too, in historic associations, and was particularly interested to see places he had long known about from their uprisings against the Turkish occupiers. He particularly admired the Suli people and the courage they had shown during their struggles against Ali Pasha thirty years before. Suliot guards had ridden with Byron in the days before he died, and the poet's work was often in his mind as he travelled, with lines from 'Childe Harold' running through his head.

As a landscape painter, he rejoiced in making drawings and paintings of beautiful and dramatic scenery, but he wished to record his response in words as well as pictures, seeking to represent not only the physical features of the countryside but also the essential character of the places he had seen. The daily diary that he kept throughout his travels formed the basis of his travel books. The 'Journal' of his time in Albania and northern Greece is perhaps the most fascinating of them all, for it is the personal, often delightfully idiosyncratic, response of an extraordinary man to a remarkable country and its people.

Vivien Noakes

Introduction

THE FOLLOWING NOTES were written during two journeys through part of Turkey in Europe; the first, from Saloniki in a north-western direction through ancient Macedonia, to Illyrian Albania, and by the western coast through Epirus to the northern boundary of modern Greece at the Gulf of Arta - the second, in Epirus and Thessaly.

Since the days of Gibbon, who wrote of Albania: "a country within sight of Italy less known than the interior of America," much has been done for the topography of these regions; and those who wish for a clear insight into their ancient and modern definitions, are referred to the authors who, in the present century, have so admirably investigated and so admirably illustrated the subject. For neither the ability of the writer of these journals, nor their scope, permit of any attempt on his part to follow in the track of those learned travellers: enough if he may avail himself of their labours by quotation where such aid is necessary throughout his memoranda of an artist's mere tour of search among the riches of far-away landscape. To the unlearned tourist, indeed, Albania is a puzzle of the highest order. Whatever he may already know of ancient nomenclature - Epirus, Molossia, Thesprotia, &c. - is thwarted and confused by Turkish divisions and Pashaliks. Beyond these, wheel within wheel, a third set of names distract him in the shape of native tribes and districts - Tchamouriá, Dibra, &c. And no sooner does he begin to understand the motley crowd which inhabits these provinces - Greeks, Sclavonians, Albanians, Bulgarians, or Vlachi - than he is anew bewildered by a fresh list of distinctive subsplittings: Liape, Mereditti, Khimáriotes, and Tóskidhes.[1] Races, religions, and national denominations seem so ill-defined or so entangled, that he would give up the perplexing study in

despair, were it not for the assistance of many excellent books already published on the subject, a list of the principal of which is subjoined.[2] Of these, the works of Colonel Leake stand highest, as conveying by far the greatest mass of minutely accurate information regarding these magnificent and interesting countries. Invaluable and remarkable as is the amount of erudition set forth in these volumes, the untiring research by means of which it has been obtained is not less extraordinary, and can only be fully appreciated by those who are aware of the impediments with which travelling in all seasons in those countries must, at that period, have fettered the writer.

Geographer, antiquarian, classic, and politician, having done all in their power for a region demanding great efforts of health and energy to examine it, there is but little opportunity left for the gleanings of the landscape-painter. Yet of parts of Acroceraunia, of Króia (the city of Scanderbeg), and of scenes in the neighbourhood of Akhridha - the Lake Lychnitis, the author believes himself to be the only Englishman who has published any account; and scanty and slight as his may be. It is something in these days to be able to add the smallest mite of novelty to the travellers' world of information and interest.

The general and most striking character of Albanian landscape is its display of objects, in themselves beautiful and interesting, rarely to be met with in combination. You have the simple and exquisite mountain-forms of Greece, so perfect in outline and proportion - the lake, the river, and the wide plain; and withal you have the charm of architecture, the picturesque mosque, the minaret, the fort, and the serai, - which you have not in modern Greece, for war and change have deprived her of them. You have that which is found neither in Greece nor in Italy, a profusion everywhere of the most magnificent foliage recalling the greenness of our own island - clustering plane and chestnut, growth abundant of forest oak and beech, and dark tracts of pine. You have majestic cliff-girt shores; castle-crowned heights, and gloomy fortresses, palaces glittering with gilding and paint, mountain-passes such as you encounter in the snowy regions of Switzerland, deep bays, and blue seas with bright, cairn isles resting on the horizon, meadows and grassy knolls, convents and villages, olive-clothed slopes, and snow-capped mountain peaks - and with all this a crowded variety of costume and pictorial incident such as bewilders and delights an artist at each step he takes.

Let us add besides that Olympus, Pindus, Pharsalus, Actium, &c., are no common names, and that every scene has its own link with some historic or poetic association, and we cannot but perceive that these parts of Turkey in Europe are singularly rich in a combination of qualities, hardly to be found in any other land. These remarks apply more strictly to the southern parts of Albania than to the extreme north (or Ghegheria); for nearer the confines of Bosnia the mountains are on too gigantic a scale, and the features of the landscape too extensive and diffuse to be easily represented by the pencil. There is, however, abundance of grandeur and sublimity through the whole country, though the farther you wander north of Epirus, the less you find of that grace and detail which is so attractive in southern Greece, and more especially in Attica and the Peloponnesus.

Regarding the best mode of travelling, it is almost superfluous to write, as the *Handbook for Travellers in the Ionian Islands, Greece, Turkey, &c.*[3] supplies excellent information on that head; yet the leading points of a traveller's personal experience are frequently worth knowing.

A good dragoman, or interpreter, is absolutely necessary, however many languages you may be acquainted with. French, German and Italian are useless, and modern Greek nearly as much if you travel higher than Macedonia. Bulgarian, Albanian, Turkish and Sclavonic are your requisites in this Babel. Those who dislike account-books and the minutiae thereof, may find it a good plan to pay their dragoman a certain sum per diem - as C. M. C. and I did last year in Greece, where for one pound five, including their own pay, the guides are accustomed to provide for all your daily wants - food, lodging, and conveyance, that is, if you travel singly - or for one pound from each person, if your party be two or more. In the present case, I gave the man who accompanied me one dollar daily, and settled for all the expenses of food, horses, &c., at fixed times; the result of which plan, at the end of the journey, was about the same, namely, that one pound five a day covered the whole of my expenditure.

Previously to starting, a certain supply of cooking utensils, tin plates, knives and forks, a basin, &c., must absolutely be purchased, the stronger and plainer the better; for you go into lands where pots and pans are unknown, and all culinary processes are to be performed in strange localities, innocent of artificial

means. A light mattress, some sheets and blankets, and a good supply of capotes and plaids should not be neglected; two or three books; some rice, curry-powder, and cayenne; a world of drawing materials if you be a hard sketcher; as little dress as possible, though you must have two sets of outer clothing: one for visiting consuls, pashas, and dignitaries, the other for rough, everyday work; some quinine made into pills (rather leave all behind than this); a Boyourldi, or general order of introduction to governors or pasha's; and your *teskere,* or provincial passport for yourself and guide. All these are absolutely indispensable, and beyond these, the less you augment your impedimenta by luxuries, the better, though a long strap with a pair of ordinary stirrups to throw over the Turkish saddles may be recommended to save you the cramp caused by the awkward shovel-stirrups of the country. Arms, and ammunition, fine raiment, presents for natives, are all nonsense. Simplicity should be your aim. When all these things, so generically termed *roba* by Italians, are in order, stow them into two Brobdignagian saddlebags, united by a cord (if you can get leather bags so much the better, if not, goats'-hair sacks); and by these hanging on each side of the baggage-horse's saddle, no trouble will ever be given from seceding bits of luggage escaping at unexpected intervals. Until you adopt this plan (the simplest of any), you will lose much time daily by the constant necessity of putting the baggage in order.

Journeys in Albania vary in length according to your will, for there are usually roadside khans at from two to four hours' distance. Ten hours' riding is as much as you can manage, if any sketching is to be secured; but I generally found eight sufficient.

A khan is a species of public-house rented by the keeper or Khanji from the Government, and is open to all comers. You find food in it sometimes - sometimes not, when you fall back on your own rice and curry-powder. In large towns, the khan is a three-sided building enclosed in a courtyard, and consisting of two floors, the lower a stable, the upper divided into chambers, opening into a wooden gallery which runs all round the building, and to which you ascend outside by stairs. In unfrequented districts, the khan is a single room, or barn, with a raised floor at one end for humanity, and all the rest devoted to cattle - sometimes quadrupeds and bipeds are all mixed up together. First come, first served, is the rule in these establishments; and as any person who can pay the

trifle required by the Khanji for lodging may sleep in them, your company is oftentimes not select; but of this, as of the kind of khan you stop at, you must take your chance.

The best way of taking money is by procuring letters on consular agents, or merchants from town to town, so as to carry as little coin as possible with you; and your bag of piastres you pack in your carpet-bag by day, and use as a pillow by night. In the orthography of names of places, &c. throughout the tour, I have implicitly followed Colonel Leake.

Chapter I

1848, SEPTEMBER 9th

After severe illness in Greece, and repeated subsequent attacks of that persevering enemy, fever, six weeks of repose in the house of the British Embassy on the banks of the Bosphorus, under the care of the kindest of families, have at length restored energy, if not perfect health; and as the summer flies and the time for travelling is shortened, a long-anticipated plan of visiting parts of Greece, Albania, &c., must be put in effect now or not at all. To see the classic vale of Tempe, the sacred mountain of Athos, and the romantic Ioánnina have always been among my wishes; and I had long ago determined on making, previously to returning to England, a large collection of sketches illustrative of the landscape of Greece. So, now that change of air and place is desirable as a matter of health, my motives for making this journey are more powerful than ever, and overcome even the fear of renewed illness on the way. C. M. C. is already gone before me to the Troad, and from thence will meet me in the peninsula of Athos, whence we shall pursue our travels together as heretofore.

3 P.M.

Came on board the 'Ferdinando' an Austrian steamer running between
Constantinople and Saloniki; and a pretty place does it seem to pass two or three
days in! Every point of the lower deck - all of it - is crammed with Turks, Jews,
Greeks, Bulgarians, wedged together with a density, compared to which a
Gravesend steamer is emptiness; a section of a fig-drum, or of a herring-barrel is
the only apt simile for this extraordinary crowd of recumbent human beings, who
are all going to Saloniki, as a starting-point for Thessaly, Bosnia, Wallachia, or any
part of Northern Turkey. This motley cargo is not of ordinary occurrence; but the
second Saloniki steamer, which should have started today, has fallen indisposed
in its wheels or boiler; so we have a double load for our share.

Walking carefully over my fellow-passengers, I reached the first-class part of
the deck- a small, raised triangle, railed off from the throng below, half of which
is allotted to Christians (the Austrian Consul at Saloniki and his family being the
only Christians besides myself), and the other half tabooed for the use of a
hareem of Turkish females, who entirely cover the floor with a diversity of robes,
pink, blue, chocolate, and amber; pea, sea, olive, bottle, pale, and dark green;
above which parterre of colours are numerous heads, all wrapped in white
muslin, excepting as many pair of eyes undistinguishably similar. There is a good
cabin below; but owing to a row of obstructive Mussulmen who choose to cover
up the grated opening with shutters, that they may sit quietly upon them to
smoke, it is quite dark, so I remain on deck. We are a silent community: the
smoking Turks are silent, and so is the strange hareem. The Consul and his wife,
and their two pretty daughters, are silent, because they fear cholera at Saloniki -
which the young ladies declare is "*un pessimo esilio*"[1] - and because they are
regretting northern friends. I am silent, from much thought, and some weakness
consequent on long illness: and the extra cargo in the lower deck are silent also -
perhaps because they have not room to talk. At four, the anchor is weighed, and
we begin to paddle away from the many domed mosques and bright minarets of
Constantinople, and the gay sides of the Golden Horn, with its caiques and its
cypresses towering against the deepening blue sky, when lo! we do not turn
towards the sea, but proceed ignominiously to tow a great coal-ship all the way to
Buyúkdere, so there is a moving panorama of all the Bosphorus bestowed on us

2

gratis, - Kandili, Baltalimán, Bebék, Yenikoi, Therapia, with its well-known walks and pines and planes, and lastly Buyukdere, where we leave our dingy charge and return, evening darkening over the Giant's Hill, Unkiar Skelessi, and Anatóli Hissár, till we sail forth into the broad Sea of Marmora, leaving Scútari and the towers of wonderful Stamboul first pale and distinct in the light of the rising moon, and then glittering and lessening on the calm horizon, till they, and the memory that I have been among them for seven weeks, seem alike part of the world of dreams.

SEPTEMBER 10th

Half the morning we lie off Gallipoli, taking in merchandise and indulging in eccentric casualties, demolishing the bowsprit of one vessel and injuring divers others, for which we are condemned to three hours of clamour and arrangement of compensation. In the afternoon we wait off the Dardanelles, not an inviting town as beheld from the sea. C. M. C. (says the Consul's son) sets off for Athos in two days to meet me. Again we move, and day wears away amid perplexing twinges foreshadowing fever (for your Greek fever when once he has fairly secured you is your Old Man of the Sea for a weary while; you tremble - and fly to quinine as your only chance of escape). Towards four or five, the mountains of the Troad fade away in the distance; later we pass near the isles of Imbros and Samothrakos; and later yet, when the unclouded sun has sunk down, a mountain pile of awful form looms sublimely in the west - rising from the glassy calm waters against the clear amber western sky: it is Mount Athos.

SEPTEMBER 11th

At sunrise the highest peaks of Athos were still visible above the long, low line of Cape Drépano, and at noon we were making way up the Gulf of Saloniki, Ossa and Olympus on our left - lines of noble mountain grandeur, but becoming rapidly indistinct as a thick sirocco-like vapour gradually shrouded over all the features of the western shore of the gulf. *N'importe* - the Vale of Tempe, so long a dim expectation, is now a near reality; and Olympus is indubitably at hand,

though invisible for the present. There were wearily long flat points of land to pass (all, however, full of interest as parts of the once flourishing Chalcidice), ere Saloniki was visible, a triangle enclosed in a border of white walls on the hill at the head of the gulf; and it was nearly six P.M. before we reached the harbour and anchored.

Instantly the wildest confusion seized all the passive human freight. The polychromatic hareem arose, and moved like a bed of tulips in a breeze; the packed Wallachians, and Bosniacs, and Jews started crampfully from the deck, and disentangled themselves into numerous boats; the consular *esiliati* departed; and lastly, I and my dragoman prepared to go, and were soon at shore, though it was not so easy to be upon in Saloniki is inhabited by a very great proportion of Jews; nearly all the porters in the city are of that nation, and now that the cholera had rendered employment scarce, there were literally crowds of black-turbaned Hebrews at the water's edge, speculating on the possible share of each in the conveyance of luggage from the steamer. The enthusiastic Israelites rushed into the water, and seizing my arms and legs, tore me out of the boat, and up a narrow board with the most unsatisfactory zeal; immediately after which they fell upon my enraged dragoman in the same mode, and finally throwing themselves on my luggage, each portion of it was claimed by ten or twelve frenzied agitators, who pulled this way and that way, till I who stood apart, resigned to whatever might happen, confidently awaited the total destruction of my *roba*. From yells and pullings to and fro, the scene changed in a few minutes to a real fight, and the whole community fell to the most furious hair pulling, turban-clenching, and robe-tearing, till the luggage was forgotten, and all the party was involved in one terrific combat. How this exhibition would have ended I cannot tell, for in the heat of the conflict my man came running with a half-score of Government Kawási, or police, and the way in which they fell to belabouring the enraged Hebrews was a thing never to be forgotten. These took a deal of severe beating from sticks and whips before they gave way, and eventually some six or eight were selected to carry the packages of the Ingliz, which I followed into the city, not unvexed at being the indirect cause of so much strife.[2]

In Saloniki there is a *locanda* - a kind of hotel - the last dim shadow of European "accommodation" between Stamboul and Cáttaro. It is kept by the

4

politest of Tuscans, and the hostess is the most corpulent and blackest of negresses. Thither we went, but I observed with pain, that the state of the city was far more melancholy than I had had reason to suppose. All the bazaars (long lines of shops) were closed and tenantless. The gloom and deserted air of the streets was most sad, and I needed not to be told that the cholera, or whatever were the complaint so generally raging, had broken out with fresh virulence since the last accounts received at Constantinople, and nearly three-fourths of the living population had fled from their houses into the adjacent country. And no sooner was I settled in a room at the inn, than, sending Giorgio to the British Consulate, I awaited his return and report with some anxiety. Presently in came Giorgio with the dreariest of faces, and the bearer of what to me were, in truth, seriously vexatious news.

The cholera, contrary to the intelligence received in Stamboul, which represented the disease as on the decline, had indeed broken out afresh, and was spreading, or - what is the same thing as to results, if a panic be once rife - was supposed to be spreading on all sides. The surrounding villages had taken alarm, and had drawn a strict "*cordon sanitaire*" between themselves and the enemy; and, worse than all, the monks of Mount Athos had utterly prohibited all communication between their peninsula and the infected city; so that any attempt on my part to join C. M. C. would be useless, no person being allowed to proceed beyond a few miles outside the eastern gate of Saloniki. No one could tell how long this state of things would last; for, although the epidemic was perhaps actually decreasing in violence, yet the fear of contagion was by no means so. Multitudes of the inhabitants of the suburbs and adjacent villages had fled to the plains, and to pass them would be an impossibility. On the southwestern road to Greece or Epirus, the difficulty was the same: even at Katerina, or Platamóna, the peasants would allow no one to land.[3]

Here was a dilemma! A pleasant fix! Yet it was one that required the remedy of resolve rather than of patience. To remain in a city full of epidemic disease (and those only who have seen an Oriental provincial town under such circumstances can estimate their horror), myself but convalescent, was literally to court the risk of renewed illness, or at best compulsory detention by quarantine. Therefore, after weighing the matter well, I decided that my first step must be to leave

Saloniki at the very earliest opportunity. But whither to go? Mount Athos was shut; the west coast of the gulf was tabooed. There were but two plans open: the first was to return by the next steamer to Constantinople; but this involved a fortnight's waiting, at least, in the place of pestilence, with the chance of being disabled before the time of departure came; and even could I adopt such means of escape, the expense and mortification of going back was, if possible, to be shunned.

The second "modus operandi" was to set off directly, by the northwest road, through Macedonia to Illyrian Albania, by the ancient Via Egnatia, and so rejoin C. M. C. at Ioánnina. This plan, though not without weighty objection -of which the being compelled to go alone and the great distance of the journey were prominent - appeared to me the only safe and feasible one; and after much reflection, I finally determined to adopt it. After all, looking at things on their brightest side, when once they were discovered to be inevitable - though I was unable to meet my friend, I had a good servant accustomed to travel with Englishmen; health would certainly improve in the air of the mountain country, and professional objects, long in view, would not be sacrificed. As for the risk run by thus rushing into strange places, and among unknown people, when a man has walked all over the wildest parts of Italy, he does not prognosticate danger. Possibly one may get only as far as Monastir, the capital of Macedonia, and then make southward, having seen Yenidjé and Edéssa - places all full of beauty and interest; or, beyond Monastir, lies Akhridha and its lake, and farther yet Elbassán, or even Skódra - highest in the wilds of Ghéghe Albania. Make, thought I to myself, no definite arrangement beyond that of escape from Saloniki; put yourself, as a predestinarian might say, calmly into the dice-box of small events, and be shaken out whenever circumstances may ordain. Only go, and as soon as you can. So, Giorgio, have horses and all minor matters in complete readiness at sunrise the day after tomorrow.

SEPTEMBER 12th

This intervening day before my start "somewhere or other", I set apart for lionizing Saloniki with a *cicerone*.[4] Whatever the past of Saloniki, its present seems

gloomy enough. The woe, the dolefulness of this city, its narrow, ill-paved streets (evil awaits the man who tries to walk with nailed boots on the rounded, slippery stones of a Turkish pavement!), the very few people I met in them, carefully avoiding contact, the closed houses, the ominous silence, the sultry, oppressive heat of the day; all contributed to impress the mind with a feeling of heavy melancholy. A few Jews in dark dresses and turbans; Jewesses, their hair tied up in long, caterpillar-like green-silk bags, three feet in length; Greek porters, aged blacks, of whom - freed slaves from Stamboul - there are many in Saloniki; these were the only human beings I encountered in threading a labyrinth of lanes in the lower town, ascending towards the upper part of this formerly extensive city. Once, a bier with a corpse on it, borne by some six or eight of the most wretched creatures, crossed my path; and when I arrived at the beautiful ruin called the Incantada, two women, I was told, had just expired within the courtyard, and, said the ghastly-looking Greek on the threshold, "You may come in and examine what you please, and welcome; but once in you are in quarantine, and may not go out," an invitation I declined as politely as I could, and passed onward. From the convent at the summit of the town, just within its white walls, the view should be most glorious, as one ought to see the whole of the gulf, and all the range of Olympus; but, alas! beyond the silvery minarets relieving the monotonous surface of roofs below, and the delicately indented shore and blue gulf, all else was blotted out, as it were, by a curtain of hot purple haze, telling tales to my fancy of miasma and cholera, fever and death.

Willing to exercise the mind as much as possible in a place so full of melancholy influences, I examined, in order, every ruin and record of old Thessalonica - the mosques in the lower town, and in the courtyard of one of these the pulpit said to be St. Paul's, the Roman arch, with its *bassi rilievi*, and the Hippodrome; and, although there was no one of these I particularly regretted that I could not draw, yet I saw an infinity of picturesque bits, cypresses, and minarets, and latticed houses; and doubtless, under more cheering circumstances, a week in Saloniki might be well spent. But the fear of fever deterred me from great exertion, and sent me home long ere noon. Sad, gloomy and confused memories of Saloniki are all I shall carry away with me. In the afternoon, Mr. C. Blunt, our Consul, came to me and strongly recommended my own decision as the best, his

account of Athos and the west coast being confirmatory of that I had previously heard. The evening was passed with his agreeable family, long resident here.

SEPTEMBER 13th

By 7 A.M. the four post-horses and the Soorudji are ready. In these parts of Turkey, blessed with a post-road, you have no choice as to your mode of travelling, nor can you stop where you will, so easily as you may with horses hired from private owners. Yenidjé being the next post from Saloniki (reckoned ten hours), thither must I go. The Soorudji or post-boy always rides first, leading the baggage-horse, and is almost always fair food for the pencil, for he wears a drab jacket with strange sky-blue embroideries, a short kilt, and other arrangements highly artistical. The morning was sultry and uninviting. We left the ill-paved, gloomy Saloniki by the Vardhári gate, which, at that early hour, was crowded with groups of the utmost picturesqueness, bringing goods to market in carts drawn by white-eyed buffaloes: immense heaps of melons appeared to be the principal article of trade; but their sale being prohibited within the walls of the city, on account of the cholera, the remaining inhabitants came outside to buy them, taking them in "*nascostamente.*"[5]

The broad, sandy road, enlivened for a time by these peasants, soon grew tiresome, as it stretched over a plain, whose extent and beauty were altogether hidden by the thick haze which clung close to the horizon. Hardly were the bright white walls of Saloniki long distinguishable; and as for the mountains and Olympus, they were all as if they were not, a colourless desert "*pianura*" - such seemed my day's task to overcome. Nevertheless, though the picture was a failure as a whole, its details kept me awake and pleased, varieties of zoology attracting observation on all sides. Countless kestrils hovering in the air, or rocking on tall thistles; hoopoes, rollers, myriads of jackdaws, great broad-winged falcons soaring above, and beautiful grey-headed ones sitting composedly close to the roadside as we passed - so striking in these regions is the effect of the general system of kindness towards animals prevalent throughout Turkey - the small black-and-white vulture was there too, and now and then a graceful milk-white egret, slowly stalking in searchful meditation.

The usual pace of the *menzil*[6] is a very quick trot, and the great distance accomplished by Tatars[7] in their journeys is well authenticated; but not being up to hard work, I rode slowly. Besides, the short shovel stirrups and peaked saddles are troubles you by no means get used to in a first lesson. At half-past eleven we reached the Vardhári, a broad river, (the apple of discord between Greek and Turk, as a boundary question), and here crossed by a long structure of wood, bristling with props and prongs. Near its left bank stands a khan - destined to be our midday resting-place.[8] A sort of raised wooden dais, or platform, extends before the roadside Turkish khan. Here mats are spread, and day-wayfarers repose, the roof, prolonged on poles, serving as shelter from sun or rain. Three Albanian guards - each a picture - were smoking on one side, and while Giorgio was preparing my dinner of cold fowl and an omelette on the other, I sketched the bridge and watched the infinite novelty of the moving part of the scene, which make this wild, simple picture alive with interest, for the bridge and a few willows are foreground and middle distance: remote view there is none. Herds of slow, bare-hided buffaloes, each with a white spot on the forehead, and with eyes of bright white, surrounded by juvenile buffalini, only less awkward than themselves; flocks of milk-white sheep, drinking in the river; here and there a passing Mohammedan on horseback, one of whom, I observed, carried a hooded falcon, with bells on his turban; how I wished all these things could be portrayed satisfactorily, and how I looked forward to increasing beauty of costume and scenery when among the wilder parts of the country.

1 P.M.

Again in travelling trim and crossing the rickety bridge, we trotted, or galloped for three hours across a continuous, wide, undulating bare plain, only enlivened by zoological appearances as before, all the distant landscape being hidden still. Near the road many great tumuli were observable on either side during the day, and a large portion of the plain near the Vardhári was white with salt, a kind of saline mist appearing to fall for more than an hour. At the eighth hour we had approached so near the mountains that their forms came out clearly through the hazy atmosphere, and one needle-like white column, the minaret of the chief

mosque of Yenidjé was visible, the town itself being nearly reached at the ninth hour, an event which, with a stumbling horse and fatigued limbs, I gladly hailed. It would not do to let a day pass without making a large drawing, so I waited outside the town or village, to work until sunset. Yenidjé[9] is near the site of ancient Pella, the birthplace of Alexander the Great; in our days it is a beautiful specimen of Macedonian town-scenery, situated in groves of rich foliage, over-topped by shining white minarets, with here and there, one or two mosque domes, and a few tall, dark cypresses; these are the most prominent features; all the little dirty houses, which a nearer acquaintance makes you too familiar with, are hidden by the trees, so that the difference between that which seems, and that which is, is vastly wide. Yet as (my drawing done) I entered the place, nothing can be more striking and characteristic than the interior of the village, though the poetry and grandeur vanish. Lanes, rich in vegetation, and broken ground, animated by every variety of costume, surround the entrance and conduct you to streets, narrow and flanked with wooden, two-storied houses, galleried and raftered, with broad-tiled eaves overshadowing groups of Turks or Greeks, recumbent and smoking in the upper floor, while loiterers stand at the shop-doors below. In the kennel are geese in crowds, and the remainder of the street is as fully occupied by goats and buffaloes, as by Turks or Christians.

Beyond all this are mountains of grandest form, appearing over the high, dark trees, so that altogether no artist need complain of this as a subject. Curious to know how one would be off for lodgings in Macedonia, I found Giorgio at the postmaster's house, where, in one of the above-noticed wooden galleries (six or eight silent Turks sat puffing around), I was glad of a basin of tea. But it is most difficult to adopt the Oriental mode of sitting; cross-leggism, from first to last, was insupportable to me, and, as chairs exist not, everything must needs be done at full length.

Yet it is a great charm of Turkish character that they never stare or wonder at anything; you are not bored by any questions, and I am satisfied that if you chose to take your tea while suspended by your feet from the ceiling, not a word would be said, or a sign of amazement betrayed. In consequence you soon lose the sense of the absurd so nearly akin to shame, on which you are forced to dwell if constantly reminded of your awkwardness by observation or interrogation.

Whatever may be said of the wretchedly "bare" state of a Turkish house, or khan, that, in my estimation, is its chief virtue. The closet (literally a closet, being about six feet six inches by four, and perfectly guiltless of furniture) in which my mattress was placed, was floored with new deal, and whitewashed all over, so that a few minutes' sweeping made it a clean, respectable habitation, such as you would find but seldom in Italian *locanda* of greater pretension. One may not, however, always be so lucky; but if all the route has accommodations like this, there will be no great hardship to encounter.

Chapter II

Turkish politeness - Departure from Yenidjé - Giorgio, the dragoman - The village of Arnaoutlik and its picturesque environs - Approach to Vodhená - Its extreme beauty of situation - The town and its accommodations - View of Olympus - Dervishes' tombs - Sketching in the streets - "Scroo, scroo!" - A wet morning's ride to Ostrovo - Its lake and scenery - The slender comforts of its khan - Another start for Monastir - Uninteresting day's journey - Tilbeli and halt for the night - Jackdaws and geese - Dreary hills - The gipsy guide - Approach to Monastir or Bitólia, the capital of modern Macedonia - Lively appearance of the city - Its traffic and streets - Its military aspect - Description of its characteristic scenes - Tolerable accommodation.

SEPTEMBER 14th

To make sure of as long a day as possible, the elaborate northern meal of breakfast may be well omitted; a good basin of coffee and some toast is always enough, and is soon over, and until starting-time there are always stray minutes for sketching. The inhabitants of Yenidjé seem to know little of the "*malattia*"[1] (though but nine hours distant) at Saloniki, and ask few questions about it; but Turks are such imperturbable people that it is not easy to discover their thoughts. The outskirts of this quiet town are most peaceful and rural, and the picturesque odds and ends within might occupy the man of the pencil pleasantly and profitably.

While taking a parting cup of coffee with the postmaster, I unluckily set my foot on a handsome pipe-bowl (pipe-bowls are always snares to near-sighted people moving over Turkish floors, as they are scattered in places quite remote

from the smokers, who live at the farther end of prodigiously long pipe-sticks), - crash; but nobody moved; only on apologizing through Giorgio, the polite Mohammedan said: "The breaking such a pipe-bowl would indeed, under ordinary circumstances, be disagreeable; but in a friend every action has its charm!" - a speech which recalled the injunction of the Italian to his son on leaving home, "Whenever anybody treads upon your foot in company, and says, 'Scusatemi,' only reply: '*Anzi - mi ha fatto un piacere!*'[2]

The morning seemed lowering, and a drizzling rain soon fell. This perpetual haze must end in some one or two days' hard rain before the weather clears, and I speculate where the durance is to be borne the while. Avoiding the grass-grown raised pavement, which is the post-road in Turkey, wherever mud or water prevent your using the broad track parallel to which it leads, we advanced by well-worn paths over a plain somewhat similar to that of yesterday, but which became more marshy, and in parts more cultivated, as we approached the hills of Vodhená, backed by the dark cloudy mountains beyond. From time to time we pass herds of buffaloes; falcons are numerous on all sides, and, added to yesterday's ornithology, there are hooded crows, rooks, coots, quails, and plovers. At eleven, we arrive at Arnaoutlik, a village of Greek and Bulgarian Christian peasants.

Of Giorgio, dragoman, cook, valet, interpreter and guide, I have had as yet nothing to complain; he is at home in all kinds of tongues, speaking ten fluently, an accomplishment common to many of the travelling Oriental Greeks, for he is a Suliote by birth. In countenance my attendant is somewhat like one of those strange faces, lion or griffin, which we see on door-knockers or urn-handles, and a grim twist of his underjaw gives an idea that it would not be safe to try his temper too much. In the morning he is diffuse, and dilates on past journeys; after noon his remarks become short and sententious - not to say surly. Any appearance of indecision evidently moves him to anger speedily. It is necessary to watch the disposition of a servant on whom so much of one's personal comfort depends, and it is equally necessary to give as little trouble as possible, for a good dragoman has always enough to do without extra whims or worrying from his employer.

At Arnaoutlik the horses rest, and the fire of the khan is in request, for rain has fallen all the morning, though capotes and plaids kept it off pretty well. The village, composed of scattered wooden houses, is full of prettiness; but fierce dogs,

when the rain ceases, prevent my going near any of the buildings, as much as a multitude of wasps do my eating a peaceful dinner on the khan platform. Yet, spite of dogs, wasps and wet, distances veiled over by cloud, and all other hindrances, there is opportunity to remark in the scene before me a subject somewhat ready-made to the pencil of a painter, which is marvellous: it is not easy to say why it is so, but a picture it is. Copy what you see before you, and you have a picture full of good qualities, in its way - a small way, we grant - a mere village landscape in a classic land. Blocks of old stone - squared and cut long ago in other ages - overgrown with very long grass, clustering lentisk, and glossy leaves of arum, form your nearest foreground; among them sit and lie three Soorudjis, white-kilted, red, brown and orange-jacketed, red-capped, piped, moustached, blue-gaitered, bare-footed. Your next distance is a flat bit of sandy ground, with a winding road, and on it one white-capoted shepherd: beyond, yet still near the eye, is a tract of grey earth, something between common and quarry, broken into miniature ravines, and tufted with short herbage: here, lie some fifty white and black sheep, and a pair of slumbering dogs, while near them two shepherd-boys are playing on a simple reed-like flute, such as Praxiteles might have put in a statue's hand. A little farther on you see two pale stone and wooden houses, with tiled roofs, mud walls, and long galleries hung with many a coloured bit of carpet. Close by, in gardens, dark-cloaked women are gathering gourds, and placing them on the roofs to dry. Grey, tall willows, and spreading planes overshade these houses, and between the trees you catch a line of pale lilac plain, with faint blue hills of exquisite shapes - the last link in the landscape betwixt earth and heaven.

At half-past one P.M. a re-start.

Sky clearing, and high mountains peeping forth. Cultivation increases, and fields of gran-turco or Indian corn are frequent as we approach the valley of the Karasmák,[3] which we cross by a bridge, and the country becomes more and more thickly studded with groups of planes and various trees. At half-past three we are in sight of Vodhená,[4] and a more beautifully situated place can hardly be imagined, even shorn as it is just now by cloud and mist of its mountain background. It stands on a long-ridge of wooded cliff, with mosques sparkling above, and waterfalls glittering down the hill-side, not unlike the Cascatelli of

Tivoli, the whole screen of rock seeming to close up the valley as a natural wall. The air began to freshen as the road ascended from the plain through prodigiously large walnut and plane trees shading the winding paths, and as the valley narrowed, the rushing of many streams below the waving branches was most delicious; between the fine groups of dense foliage, the dark mass of the woody rock of Vodhená is irresistibly beautiful, and before we reached the dreary scattered walls and suburb lanes, by climbing for half an hour up a winding pass between high rocks, I was more than once tempted to linger and draw. From the proud height on which this ancient city stood, the combination of green wood, yellow plain, and distant mountain was most lovely, and I can conceive that when the atmosphere is clear, and all the majesty of Olympus, with the gulf of Saloniki (and perhaps Athos) also are visible, few scenes in Greece can surpass the splendour of this.

After six, we arrived at the postmaster's house in the centre of the town - one of those strange, wide-eaved, double-bodied, painted and galleried Turkish abodes which strike the stranger with wonder; but the whole place was full of the retinue of some travelling Pashá - guards above, and horses below - a small outhouse abounding with cats and cobwebs being also full of a large party of Bulgarian merchants. So Giorgio set out to seek a lodging in some Greek tradesman's house, and I wound up the evening by a prowl through the streets of the town, in which, to all the varieties of Yenidjé, is added a profusion of fountains of running water, and numerous streams half the width of its sloping streets. Tea and lodging (so called) I found prepared over a large stable - a great falling off from last night's accommodation - the floor of the barn being of that vague nature that one contemplated the horses below through various large cavities, by means of some of which one might, by any too hasty movement, descend unwittingly among them ere morning.

SEPTEMBER 15th

By five I was out on the road to Yenidjé, at a dervish's tomb, not far from the town, a spot which I had remarked yesterday, as promising, if weather permitted, a good view eastward. All the plain below was bright yellow as the sun rose

gloriously, and Olympus was for once in perfect splendour with all its snowy peaks; but the daily perplexity of mist and cloud rapidly soared upward, and hardly left time for a sketch ere all was once more shrouded away.

The dervish's, or saint's tomb, is such as you remark frequently on the outskirts of Mohammedan towns in the midst of wide cemeteries of humble sepulchres - a quadrangular structure three or four feet high, with pillars at the corners, supporting a dome of varying height; beneath its centre is usually the carved emblem of the saint's rank, his turban, or high-crowned hat. As these tombs are often shaded by trees, their effect is very pleasing, the more so that the cemeteries are mostly frequented by the contemplative faithful. Often, in their vicinity, especially if the position of the tombs commands a fine view, or is near a running stream, you may notice one of those raised platforms, with a cage-like palisade, and supporting a roof, in the shade of which the Mohammedan delights to squat and smoke. There is one close by me now, in which a solitary elder sits, in the enjoyment of tobacco and serenity, and looking in his blue and yellow robes very like an encaged macaw.

A quick run down the rocky pass of last evening brought me to the great plane trees and the bright stream whence Vodhená on its hill is so lovely - a scene difficult to match in beauty. I met many peasants and long strings of laden mules, but no one took the faintest notice of me - a negative civility highly gratifying, after all one hears of the ferocity of the aborigines of these regions. That the road as far as Vodhená is considered carriageable was proved to me by the strange spectacle which passed me on my way up to the town - eight horses pulling up the steep ascent with a carriage full of masked ladies, the beloved of some Mohammedan dignitary. Eight armed outriders preceded this apparition, and a troop of guards followed the precious charge.

Before an early *"déjeûner"* at ten, there was yet time to draw a street-scene, though the curiosity of half the people of Vodhená obliged me to stand on a stone in the midst of the kennel to draw. Their shouts of laughter, as I represented the houses, were electrifying: "*Scroo! scroo! scroo!*" (He writes it down! he writes! he writes!) they shouted. But it was all good nature: no wilful annoyance of any kind.

Before eleven I had quitted this beautiful place, and was once more on the road to Monastir, not that one hoped to get there ere nightfall, but only to some

midway khan, or village. Rain began to fall as I turned away from woody Vodhená and its streams, and heavier showers fell in the narrow cultivated valley through which our route lay, on the left bank of the Karasmák. Having crossed it, we ascended towards the higher mountains, their heads hidden in mist, and, as the road rose rapidly among their steep sides, many a lofty summit, towering above screens fringed with hanging wood, was more and more magnificent, while, looking back over Vodhená, the plain of Yenidjé and the hills of Saloniki were visible afar off. But as we scaled the highest part of the pass, and I saw the last glimpse of the eastern sea, the rain fell in tremendous torrents, and we urged the horses to the full speed of Tatar trot and gallop. A vale and marshy lake lying at the foot of chestnut-clothed hills, and a world of purple rock and waterfall reminding me of Borrowdale - high peaks frowning through the driving clouds, stony lanes, paths through overhanging oakwoods, rivulets, clay ravines, slippery rocks - all flitted by in rapid succession, as we galloped on, without a halt, till the drenching tempest ceased about half-past one, and I found myself looking down on the Lake of Ostrovo, whose dark grey bosom stretched dimly into worlds of clouded heights on either side of its extent. The whole of the pass from Vodhená to Ostrovo, I doubt not, is full of great beauty, and I lost it with regret.

At Ostrovo I decided to remain[5], too fearful of returning fever to hazard the seven hours' journey between it and the next village - Tilbelí; and on descending a steep path to the lake, the little town and mosque shone out brightly against the lead-coloured waters and cloud-swept mountains, a scene of grandeur reminding me, in its hues, of Wastwater and Keswick, while the snow peaks, dark cypresses, and gay white minarets stamped the whole as truly Moslem-Macedonian.

But, notwithstanding all these ecstasies, what a place is Ostrovo for a night's abode! This most wretched little village contains but one small khan, with two tiny rooms on the ground-floor, in one of which, half suffocated by the smoke of a wood fire, I was too glad to change dripping garments and don dry ones; - let the traveller in these countries be never forgetful of so wrapping up his *roba*, that he may have dry changes of raiment when needful. Happily the weather cleared after the storm, and I drew till dusk, none the worse for the morning's wetting, and feeling hourly the benefit of the elastic mountain air.

Broiled and boiled salmon trout, rice soup and onions awaited me in the Mivart's of Ostrovo - and, let me say, that is by no means a bad supper to find in a Macedonian khan. The evening passed in the intellectual diversion of drying one's wet clothes by little bits of firewood, and in packing one's self so as to sleep tolerably, spite of there being no bolt to the door. But, in truth, in so forlorn a spot as this, no precautions could ensure safety against force, were robbery intended. Never, in the wildest of countries, have I met with any robber adventure, and not being troubled by suspicions of danger, I have come to believe that carelessness as to attack is the best safeguard against any. Mats hung to the roof and window keep out some of the air (for an unglazed hole in the wall, and a series of apertures in the roof, add to the charms of this hotel), but the wood-smoke is the worst enemy, and I am glad to seek refuge from it in slumber.

SEPTEMBER 16th

Bitter cold saluted me at rising - if that may be called rising which, in this chair-less land, consists in a perpetual scramble on the floor, reminding the performer of such creatures as swallows and bats, of whom naturalists relate that their difficulty of leaving the ground, when once there, is extreme. Brightly silvered with snow were all the great mountains round the lake, and till half-past seven I drew, charmed with the grandeur and beauty of this noble scene. However miserable the village of Ostrovo (it bears marks of greater size and prosperity), its position is magnificent; the people also seem thoroughly quiet and civil.

The route to Monastir lies round the head of the lake, where, on the marshy tract, stalk numbers of ivory-white herons, and after leaving the shores, we mount high above their level, by zigzag paths, whence there is many a wide and brilliant view over all the waters of Ostrovo.

For two hours we proceed by brushwood-covered hills, possessing small share of beauty or interest, to some bleak downs, where on our left stands a village, half an hour beyond which is a magnificent view of another lake (which I somewhat believe to be that of Kastoriá, the ancient Celetrum), the shores of which were beautifully indented and varied with promontories and bays, and the lines of hills on all sides graceful and striking. But beyond this oasis, two hours and a half of

weariness followed, treeless, bare hillsides, unbroken by the least variety of interest, and I began to repent heartily of ever having come to Macedonia, the more that rain again began to fall as I approached Tilbelí, still three hours and a half from Monastir. But it was necessary to rest the horses here, the roads of the morning having been unusually stony and fatiguing, and after such halt, it would be too late to start afresh, as another tempest was evidently gathering. So at Tilbelí I remain for the night, much against my will, for this straggling village in a wide green valley presents little for the pencil. By way of compensation, the khan is very decent, and my lodging is in a little chamber like a pigeon-house, over the gate of the courtyard, the ascent to which is by a ladder, which being removed, the dweller above remains suspended in air. This comfortless weather is very dispiriting, for it is bitterly cold, and the pigeon loft trembles spasmodically in every gust of wind. Yet writing letters on the floor, and drinking tea out of a plate (for the basin is broken) wear away the evening quickly after all.

SEPTEMBER 17th

The ornithological attractions of the village of Tilbelí seem divided between jackdaws and geese; it is difficult to imagine the numbers of these feathered musicians in every lane and on every roof; their noise is perfectly stunning. Off by six, and a dreary commencement is prolonged for three hours in a bitter cold wind, over hideous hill-plains, stony and shrubless, and recalling the melancholy Murgie of Altamura in South Italy. Descending about half-past nine to the great plain of Bitólia, or Monastir (the military centre and capital of modern Macedonia and Northern Albania), white minarets, extensive buildings and gardens were a pleasant sight, as the city seemed to expand on our approaching the high mountains at the foot of which it is built.

Had it not been for the caprices of our guide, a wild gipsy Soorudji, we should sooner have arrived at our destination than we did; that worthy having met with a fellow gipsy on horseback, the twain indulged in convivial draughts of rakhee at two roadside khans to so great an extent, that their merriment became boundless, and having loosened the baggage and led horses, they drove them facetiously in and out of fields of maize and corn - for we were now near the city

- till their sport terminated in the lively new-comer subsiding into a quagmire, where his horse, anxious to make a good meal in the next field of gran-turco, left him to his fate. This catastrophe rather pleased me than not, till, on entering Monastir, our own Soorudji suddenly gave way to pangs of conscience, and neither threats nor entreaties could prevent his returning for his lost friend, which meritorious act caused us an hour's delay ere we reached the barrier of the city.

Here we were interrogated by an official, who in the matter of passports, was soon satisfied by the *Αυτός μιλόρδος Ινγλίς* of Giorgio - ("this English Milord," all English travellers being so termed in the East) - and we passed onward. Close to the town, on the eastern side, stretches a wide common, used as a cemetery, and forming the unmolested abode of troops of dogs, who lie in groups of ten or twenty till the town scavengers bring them their morning and evening meal.

Monastir (or Bitólia) contains not less than fourteen or fifteen thousand inhabitants, and is the metropolis of these remote provinces, a preeminence evidently justified by its activity and prosperity. It is also a place of the greatest importance, as commanding the direct entrance from Illyria into Macedonia by the passes of the river Drilon or Drin, and as a military centre from which Epirus and Thessaly are equally accessible.[6]

Anticipating - as in every previous case during this journey - that the glitter and beauty of outward appearance would be exchanged on entering the city for squalor and dreariness, I was agreeably surprised at the great extent of public buildings, barracks, and offices at the entrance of the town, and, within it, at the width and good pavement of the streets, the cleanliness and neatness of the houses. The bazaars are exceedingly handsome, some entirely roofed over, and lighted from above with windows, others only partially sheltered, or semi-roofed with matting on poles. Great numbers of vendors and buyers throng these resorts, the principal part of the former being merchants - Greek or Bulgarian Christians, - and of the latter Christian peasantry from the neighbouring villages and country. The Turks resident in Monastir are for the most part either military or officials: Greeks and Bulgarians form the majority of the inhabitants. Albanians there are few, excepting guards or exiles (Monastir is a frequent place of banishment for rebel Beys): of Jews, a vast number. Being the central situation for

all military operations relating to North and South Albania, Thessaly, Macedonia and Bosnia, the bustle and brilliancy of Monastir is remarkable, and its effect appeared particularly striking, coming to it, as I did, after passing through a wild and thinly-peopled region. You are bewildered by the sudden re-appearance of a civilization which you had apparently left for ever: - reviews, guards, bands of music, pashas, palaces and sentry-boxes, bustling scenes and heaps of merchandise await you at every turn.

The natural beauties of Monastir are abundant. The city is built at the western edge of a noble plain, surrounded by the most exquisitely shaped hills, in a recess or bay formed by two very high mountains, between which magnificent snow-capped barriers is the pass to Akhridha. A river runs through the town, a broad and shifting torrent, crossed by numerous bridges, mostly of wood, on some of which two rows of shops stand, forming a broad, covered bazaar. At present, three of these bridges are in ruins, or under repair after the winter's floods. The stream, deep and narrow throughout the quarter of private houses and palaces, is spanned by two good stone bridges, and confined by strong walls; but in the lower, or Jew's quarter, where the torrent is much wider and shallower, the houses cluster down to the water's edge with surprising picturesqueness. Either looking up or down the river, the intermixture of minarets and mosques with cypress and willow foliage, forms subjects of the most admirable beauty.

We went to the largest and best khan of Monastir - Yeni khan, - an extensive building, surrounding three sides of a courtyard, which was full of Greek merchants in blue tunics, or white-coated Albanians, with laden horses, &c.; and luckily I obtained a corner room overlooking all this moving scene, amongst which I mean to halt two days, as I shall hardly see a more beautiful place. A clean, whitewashed cell, with glazed windows, and new mats, betokens the comparative luxury of this little metropolis.

Late in the day, I devote an hour or two to reconnoitring and choosing sites for tomorrow's work. The bazaars with the groups of figures in them are endless kaleidoscopes of pictures. The houses are mostly of unpainted wood, the larger palaces are whitewashed and ornamented, and some are as gay as red and white paint can make them: the neatness and cleanliness of the place is delightful.

At sunset, I find myself at the edge of the cemetery-common, and pass the last half-hour of day in watching the effects of light and shade on the noble plain, glittering like gold in its frame of purple mountains.

Chapter III

Costume of Greek peasantry - I come to grief from the want of a passport - Difficulty of sketching in the streets of Monastir - View of the city from the great cemetery - Dogs - Objection of the Mohammedans to artist occupations - Vain attempts to make drawings - Visit to the Seraskier Pashá - Return to sketching with a guard and consequent success - Great picturesqueness of the city and environs of Monastir - Albanians and their mode of passing time - Muezzins, or callers to prayers - Departure from Monastir - Mountain roads to Peupli - Its village and lake and uninviting khan - Increasing wildness of character in the scenery and people - Magnificent mountain range above Akhridha - Exquisite views over the lake and plain - Descent to the shores of the lake and arrival at the town of Akhridha - Mohammedan salutations and the want of a fez - Description of costumes of the Ghéghe Albanians - Streets of the town - Khan, &c.

SEPTEMBER 18th

The wind blows keenly off the snowy mountains on the west of the town, but the sun rises brightly as I begin the day by sketching in the suburbs. Greek peasantry from the hills are entering the town with market wares. The costume of the women is a black outer capote with red borderings, worked petticoats, dresses, gaiters, and handkerchiefs; scarlet-striped aprons, and enormously thick, long bunches of black silk tied to their hair, tail-fashion. But my wanderings are soon stopped by an ancient Turk, who yells forth: '*teskere - teskere,*' namely, a passport; and, as I had it not about me, the unbending policeman would not listen to any explanations from Greek passers-by, but hurried me - somewhat as I was once

served on a similar occasion in the Kingdom of Naples - before the bar of a judge, who unluckily lived a long way off, so that half my morning was wasted by this foolish adventure, the end of which was a horrible scolding from the dignitary to the old Mohammedan - who, after all, was not in fault.

When at length I endeavoured to draw in the streets of Monastir I found it impossible to work, so great was the crowd collected to see my operations, and I was fairly mobbed to the khan, resolving that I would use my Boyourldi to procure me a guard forthwith, - for one does not come to Macedonia every day, and time and opportunity are not to be thrown away. But the great man here - the Seraskier Pashá, or commander of the forces - is unwell, so I passed my afternoon in sauntering warily to distant points of the surrounding hills to obtain some general view of the city, dodging about to avoid lurking companies of dogs, and shunning sentinels and passport-hunters.

Marking a dervish's tomb on the northern side of the city, I threaded my way through narrow lanes to the river, at this season a scanty stream, and crossing it where the broken bridges and the long strings of laden mules, four or five hundred together, - their loads covered with white and brown striped cloths, made the most perfectly picturesque scene, I arrived at the cemetery on the hill whence all Monastir is visible. A more magnificently placed city it is hardly possible to imagine, and the great quantity of cypress and plane setting off its delicate white and pink mosques is wonderfully beautiful. But the evening began to draw on, and fearful of being massacred for a ghoule, I left the home of the dead, and made my way to the khans, passing over the common near the Barracks, that "Piazza de' Cani," where from eighty to a hundred wolfish dogs were snarling, and howling over a dead horse. Meanwhile his Highness Emim Seraskier Pashá had sent, requesting me to come to him tomorrow.

SEPTEMBER 19th

Sunrise: and I am drawing the plain and hills from the "Piazza de' Cani;" lines of convicts are passing from the Barracks, carrying offal in tubs to the ghoulish burying-grounds and followed by some hundreds of dogs, who every now and then give way to their feelings and indulge in a general battle among themselves.

It is no easy matter to pursue the fine arts in Monastir, and I cannot but think -
will matters grow worse as I advance into Albania? For all the passers-by having
inspected my sketching, frown or look ugly, and many say, "*Shaitán*," which
means, Devil; at length one quietly wrenches my book away and shutting it up
returns it to me, saying, "*Yok, Yok!*"[1] So as numbers are against me, I bow and
retire. Next, I essay to draw on one of the bridges, but a gloomy sentinel comes
and bullies me off directly, indicating by signs that my profane occupation is by
no manner of means to be tolerated; and farther on, when I thought I had
escaped all observation behind a friendly buttress, out rush legions of odious
hounds (all bare-hided and very like jackals), and raise such a din, that, although
by means of a pocket full of stones I keep them at bay, yet they fairly beat me at
last, and give me chase open-mouthed, augmenting their detestable pack by fresh
recruits at each street-corner. So I gave up this pursuit of knowledge under
difficulties, and returned to the khan.

Giorgio was waiting to take me to the Pashá; so dressing in my "best," thither
I went, to pay my first visit to an Oriental dignitary. All one's gathered and
hoarded memories, from books or personal relations, came so clearly to my mind
as I was shown into the great palace or serai of the Governor, that I seemed
somehow to have seen it all before; the ante-room full of attendants, the second
state-room with secretaries and officers, and, finally, the large square hall, where
- in a corner, and smoking the longest nargilleh, the serpentine foldings of which
formed all the furniture of the chamber save the carpets and sofas - sat the
Seraskier Pashá himself - one of the highest grandees of the Ottoman empire.
Emim Seraskier Pashá was educated at Cambridge, and speaks English fluently.
He conversed for some time agreeably and intelligently, and after having
promised me a Kawás, the interview was over, and I returned to the khan,
impatient to attack the street-scenery of Monastir forthwith under the auspices of
my guard. These availed me much, and I sketched in the dry part of the river-bed
with impunity - ay, and even in the Jews' quarter, though immense crowds
collected to witness the strange Frank and his doings; and the word, "*Scroo,
Scroo*,"[2] resounded from hundreds of voices above and around. But a clear space
was kept around me by the formidable baton of the Kawás, and I contrived thus
to carry off some of the best views of the town ere it grew dark. How picturesque

were those parts of the crowded city in the Jews' quarter, where the elaborately detailed wooden houses overhung the torrent, shaded by grand plane, cypress, and poplar! How the sunset lit up the fire-tinged clouds floating over the snow-capped eastern hills! How striking were the stately groups of armed guards clearing the road through the thronged streets of the bazaars for some glittering Bey, or mounted Pashá! Interest and beauty in profusion, oh ye artists, are to be found in the city of Monastir!

The Seraskier's letter to the principal Bey of Akhridha awaits my return to the khan, together with a large basket of pears for which a deal of baksheesh[3] is required. Tea, and packing for a start tomorrow, fill up the evening. Giorgio seems by no means to like the idea of committing himself to Albanians, Gheghes, and Mereditti, and avoids all speech about Albanians in general or particularly. Three of these men occupy part of the gallery near me, and seem to pass life in strutting up and down, in grinding and drinking coffee, or in making a diminutive sort of humming to the twanging of an immensely long guitar. Sitting on their crossed legs they bend backwards and forwards and from side to side, shaking their long hay-coloured hair, or screwing their enormous moustaches; now and then they rise, whirl their vast capotes about them, flounce out their full skirts, and then bounce up and down the gallery like so many Richard the Thirds in search of Richmonds. But Giorgio by no art can be induced to say more of them than, "*Sono tutti disperati;*"[4] and by all, this race seems disliked and mistrusted most markedly.

SEPTEMBER 20

At Monastir the Muezzins, or callers to public prayer from the minarets, are delightfully musical: none of the nasal Stamboul monotony is heard, but real bits of melody, echoing at night or early morn from the still city to the cloud-veiled hills.

Good horses are ready before sunrise, though it is past six ere we escape from the full bazaars and narrow suburban streets; carts, oxen, laden mules, buffaloes in herds "choked up each roaring gate;" and when we had a little cleared these obstacles, all the luggage suddenly lopsided, and after fruitless attempts to balance

it with stones, all had to be finally re-adjusted. I had not yet adopted the bi-sack principle. The morning's journey was not interesting, the less so that its monotonous features were gloomy with dark and lowering clouds, making the snow above look unnecessarily cold, and shading the vale below, where large herds of goats browsingly wandered among the stunted herbage under the guarding care of ferocious dogs. About five hours were consumed in winding through two valleys or passes shut in between lofty hills, in all which expenditure of time and patience no object of beauty or interest presented itself. But in these regions such a cause for complaint is of no long duration, and about noon, the road - a wide, dishevelled, stony track - emerged from the pass into a valley, which opened into a plain, disclosing at its southern extremity a bright lake, walled in by high, snowy mountains.[5]

Westward, a charming village, embosomed in plane and chestnut, and spangled with two or three glittering minarets, enlivened the scene with all the characteristic loveliness of Albanian landscape, and surrounded, except on the southern side, by most richly-wooded heights. But, as usual, all the charm is outside. The village of Peupli possesses only the filthiest of khans, and it was difficult to find a spot to cook the midday meal. Wandering meanwhile, I succeeded, between heavy showers, in making a drawing from a rising ground, whence village, lake and hills formed a most beautiful scene; dark purple mountains delicately and sharply delineated against sweeping rain-clouds; a foreground of massy chestnut trunks; foliage in gloomy, forcible masses against the silver lake and light parts of the sky; and in the plain below, the village, with its tufts of shade. Spite of threatening, no more rain fell, so I resolved that it was wisdom to go on to Akhridha, where lodgings could hardly be worse than at Peupli, and scenery probably more valuable.

At half-past two, left Peupli. Its inhabitants are a different order of beings to those I have yet seen, a wilder and more savage race than the inhabitants of Macedonian plains; there are fewer Greeks and Bulgarians apparently, and more Turks and Albanians; the Bulgarian language is also on the decrease.

If the morning's ride were all valley, this of the afternoon is all mountain. Straightway out of the valley of Peupli went we up the steepest of heights, climbing it by a constantly winding staircase-road, though a better one than might

be expected in these parts. Beautiful was the afternoon, and rejoicing in all sorts of cloud effect. As we ascended towards magnificent hanging beech-woods, the plain and mountains behind, with the blue lake of Peupli, its southern side fringed with pale hills fading into the distance, were a scene of the most gorgeous description. At the summit of the pass is a guard-house (a hut containing two armed Albanians, and an irritable dog, who watch over the interests of passers-by), and here, ere the western descent begins, the view is one of the loveliest eye can see. From this great height, one looked over all the lake of Peupli, to plains beyond plains, and hills, and blue Olympus beyond all; the whole seen through a frame, as it were, of the gnarled branches of silver-trunked beeches crowning the ridges of the hill, whose sides feathered down to the lake in folds of innumerable wood screens: it was difficult to leave the scene, and I resolved, at any hazard, to revisit it.

Less than half an hour was occupied in crossing the height we had been scaling - a narrow rocky plain, interspersed with stunted beeches - and here, properly speaking, begins my tour in Albania, for all I have passed through is Macedonia, nor is the Albanian tongue in much use eastward of Akhridha.

Soon a new world charmed the eye, and on arriving at the edge of the western face of this high ridge, the beautiful plain and lake of Akhridha burst, as it were, into existence; gilded in the setting sun, and slumbering below hills, forest, and snow, piled up and mingled with cloud midway in heaven. It is scarcely possible to dream of finer scenes than these, their beauty perhaps enhanced by grand storm effects, which gave them more than ordinary magic of colour and variety of interest. Bright, broad, and long lay the great sheet of water - the first of Grecian lakes - and on its edge the fortress and town of Akhridha (in form singularly resembling the castle rock of Nice, in the Sardinian States), commanding the cultivated plain which stretches from the mountains to the shores of the lake. Such sublime scenery obliterated from the memory all annoyances of travel, and astonished and delighted at every step, I already repented of my repentance that I had undertaken this journey.

The descent to the plain of Akhridha is exceedingly steep, and one watches the lake, as one slowly reaches its level, diminishing most beautifully in perspective. Nor was time wanting to observe it, for the downward passage was

uncomfortably obstructed by numerous mules laden with long planks of wood, which, as their bearers jolted down the sharp turns of the mountain-path, were apt to smite incautious foot-passengers who approached them. Pictures without end might be made among the majestic groups of tall beech which clothe these heights, combining with the aerial effects of sky, earth and water. On the southern side of the lake the hills are not of so fine a form, but the general effect is good, and strongly reminded me of Celáno or Fucino, in the Abruzzi. Towards the last turns of this steep path, a strange edifice - a convent - stands in a nook of the rocks, adhering, as it were, to the brown face of the mountain, and consisting of some twenty detached cells, each like the box of Punch and Judy. Beyond this, we came to a village on the level plain, and through its vistas of walnut trees, the Castle of Akhridha appears now and then charmingly. Hence, over a fertile tract of garden, and pasture studded with flocks - a perfect picture of peaceful quiet - we arrived at the town of Akhridha about half-past six.

A territory more naturally defined than that of Akhridha,[6] it is not easy to conceive. The whole lake is surrounded by hills, allowing small space between their base and the water, excepting on the northern side, where they recede some three miles, and leave a plain, which the position of the Castle of Akhridha, on its isolated rock, entirely commands. The city lies on three sides of the castle hill; and extends east and west of the fortress along the water's edge, the rock itself being a perpendicular precipice towards the south. The unvarying characteristics of these scenes were not wanting, in the white minarets and thickly-grouped planes studded over the environs of the town; and, as I advanced into the streets, some pretty mosques attracted my attention, and here and there a broad bazaar, or marketplace, shaded by plane trees of immense magnitude.

In this, the first town I had seen in Northern Albania, the novelty of the costumes is striking; for, rich as is the clothing of all these people, the tribes of Ghegheria (a district comprising all the territory north of the river Apsus, generally termed Illyrian Albania, and of which Skódra may be said to be the capital, and Akhridha the most western limit) surpass all their neighbours in gorgeousness of raiment, by adding to their ordinary vestments a long surtout of purple, crimson, or scarlet, trimmed with fur, or bordered with gold thread, or braiding. Their jackets and waistcoats are usually black, and their whole outer

man contrasts strongly with that of their white neighbours of Berát, or many-hued brethren of Epirus. Other proofs were not wanting of my being in a new land; for, as we advanced slowly through the geese frequented kennels (a running stream with "*trottoirs*" on each side, and crossed by stepping-stones, is a characteristic of this place), my head was continually saluted by small stones and bits of dirt, the infidel air of my white hat courting the notice and condemnation of the orthodox Akhridhani; "And," quoth Giorgio, "unless you take to a Fez,[7] Vossignoria will have no peace, and possibly lose an eye in a day or two."

Moving on through picturesque streets, we at last reached the most considerable khan the town possessed, a building of the same description as almost all public resting-places in this part of the world. It stood around three sides of a courtyard, with the lower part appropriated to stables, the upper to some twenty chambers, communicating with a broad gallery. Glass windows are unknown here, and paper as a substitute is rare; the rooms are little, dark dens - their emptiness and facility of being swept out forming their highest claim to praise. With a mat spread in a corner, and bed thereon, one soon feels at home, and after a cup of tea, sleep needs little waiting for.

Of many days passed in many lands, in wandering amid noble scenery, I can recall none more variously delightful and impressive than this has been.

Chapter IV

Exploring Akhridha - Its fortress - Serái - Visit to the Governor - His reception-chamber, &c., described - Sketching pursued under the care of a guard - Night companions - Revisit the mountain above the Lake of Peupli - Another day in Akhridha - The shores of the lake - Their ornithological tenants - Objections to drawing unaccompanied by a guard - Exquisite beauty of the evening hours at Akhridha - Zoology in the streets - Albanians and their fashions - Attentive ducks - Departure from Akhridha - Gipsies - The lake - War between hawks and coots - Village of Istruga - Solitary and unsatisfactory khan - Valley of the Skumbi - Magnificent scenery - The khan of Kukues - Wilds of Albania and new night-scenes - Mule-tracks on the banks of the Skumbi - Extraordinary mountain scenery - Dangerous paths - Approach to and arrival at Elbassán - Its disagreeable streets and filthy khans - The dark cell.

SEPTEMBER 21st

An early walk in the town, which is full of exquisite street-scenes (the castle-hill, or the mountains always forming a background), would have been more agreeable had I not been pelted most unsparingly by women and children from unexpected corners. Escaping to the outskirts, I sketched the town and castle from a rising ground, when a shepherd ventured to approach and look at my doings; but no sooner did he discover the form of the castle on the paper, than shrieking out

"*Shaitán!*" he fled rapidly from me, as from a profane magician. A mizzling rain began to fall, and when - avoiding herds of buffaloes, and flocks of sheep, with large dogs on the look-out - I made for the lake through some by-lanes, several of these wild and shy people espied me afar off, and rushed screaming into their houses, drawing bolts, and banging doors with the most emphatic resolve against the wandering apparition. Returning to the khan, I prepared to visit Sheréeff Bey, the Governor and principal grandee of Akhridha, to whom the Seraskier Pashá's letter was addressed.

The fortress, towering over all the town of Akhridha, and commanding an equally good view of lake, plain, and mountain, contains the serai, or palace of the Governor; its overhanging, ornamented roof, lattices, and bow-windows, and the groups of wild, strange creatures peering and lounging about the narrow stairs and wooden galleries, were all objects of curiosity to one who had seen but little of barbaric pomp and circumstance, for in Monastir the dignitaries are like great officials in any other great town; and were a traveller to go to that city after visiting the wilder parts of Albania, its effect would be unprofitably flat and civilized, though, to those coming from Stamboul, it is striking enough.

The room in which Sheréeff Bey was sitting - a square chamber (so well described in Urquhart's "Spirit of the East") of no very great size - was full enough of characters and costumes to set up a dozen painters for life. The Bey[1] himself, in a snuff-coloured robe, trimmed with fur, the white-turbaned Cogia,[2] the scarlet-vested Gheghes; the purple and gold-brocaded Greek secretary, the troops of long-haired, full-skirted, glittering Albanian domestics, armed and belted - one and all looking at me with an imperturbable fixed glare (for your nonchalant Turkish good-breeding is not known here) - all this formed a picture I greatly wished I could have had on paper. The Bey, after the ceremonies of pipes and coffee, offered a letter to Tyrana, a town on the road to Skódra, and expressed his willingness to send guards with me to the end of the world, if I pleased, declaring at the same time that the roads, however unfrequented, were perfectly safe.

Mindful also of missiles, I begged for a Kawás to protect me while drawing in the town of Akhridha, and then returned to the khan to dine, and afterwards passed the afternoon in sketching about the town with my Mohammedan guard, unannoyed by any sticks or stones from the hands of true believers. At sunset the

view from the portal of the fortress becomes a scene of placid splendour one can never tire of contemplating, and both in mass and in detail, Akhridha has already far surpassed my expectation. They talk of the Monastery of St. Naum at the far, or southern end of the lake, as the great lion of the district; but I rather postpone the wish to see it until I am in the neighbourhood of Berát, as a visit thither at present must involve a return here, and occupy two days. The certainty of night-rest is not among the good things of Akhridha; in the small cell I inhabit, a constant clawing and squalling of cats on one side of my pillow, and quacking of ducks on the other, is not favourable to sleep.

SEPTEMBER 22nd

A cloudless morning, fresh and brilliant, induces me to put in execution my plan of retracing the route to the mountain pass by which I came hither, for the purpose of sketching the Lake of Peupli; wherefore my armed Kawás and horses were ready at seven A.M. At the foot of the hills, the little monastery was exquisitely pretty in the clear shadows of early morning, and an outline of it occupied me some time; after which I began the deep ascent to the beech forests, and in the course of the upward progress, many were my pauses to contemplate the wide silver lake, and its castled rock. A Government *"avant-courier,"* blazing in scarlet and white, his robe trimmed with fur, and his kilt and gilt belt looking afar off like the plumage of some tropical bird among the dark-green foliage, met us when halfway up the mountain, and shortly afterwards the Bey-Governor of Tyrana, with a long string of laden mules and glittering retainers added interest to the novel and beautiful scene. By half-past ten, we had passed the little plain at the mountain's summit, and had reached the solitary guardhouse.

I was glad to have devoted a day to revisiting this most noble scene. Soothing and beautiful is that vision of the Lake of Peupli, so dreamy and delicately azure, as it lies below ranges of finely-formed mountains, all distinct, though lessening and becoming more faint, till the outline of Olympus closes the remote view. Then the nearer hills, with their russet smoothness and pard-like spots of clustering forest groups; - and closer, the dark masses of feathery beech, glowing with every autumnal hue! It is long since I have tasted hours of such quiet, and

all the roughnesses of travel are forgotten in the enjoyment of scenery so calm and lovely. Many a day - month - summer passed among the beautiful forests of Monte Casale, amid the steep ravines and oak-tufted rocks of Civitella di Subiaco, in the sheltered convent and the gleaming village of the woody Apennines; - many a recollection of the far plains of Latium and the Volscians - of the brightness of Italian mornings - the still freshness of its mountain noon - the serenity of its eventide, when laden villagers wind up the stony paths to aerial homes, chanting their vesper chorus, - all this, and a great deal more, flashed strongly on my memory as I sat hour after hour on this glorious hill-summit, when the present, by one of those involuntary actions of thought which all must have experienced, was thus linking itself with places and persons of the once familiar past, with all the decision and vivacity of reality.

At half-past two, after a rural dinner of excellent cold fish (the trout of the Lake of Akhridha are surpassingly fine), I retraced my way westward, and was once more at the khan before dusk.

SEPTEMBER 23rd

One more day in Akhridha, and then westward and northward. There is a street scene below the castle, where a majestic plane shades bazaars rich with, every sort of gay-coloured raiment. Through its drooping foliage gleams the bright top of a minaret, and below it are grouped every variety of picturesque human beings. To carry away a sketch of this was the work of half the morning; the rest was occupied in a walk on the eastern shore of the lake, an excursion I was obliged to make alone, as the protecting Kawás was sent to procure horses for tomorrow's journey. Beautiful was the castle on its rock reflected in the clear bright water; but what most amused me was the infinite number of birds which, all unsuspectingly sociable, enlivened the scene; thousands of coots fraternising with the domestic ducks and geese - white egrets performing stately tours of observation among the reeds - magpies (a bird remarkably abundant in the vicinity of Akhridha), hooded crows and daws, - a world of ornithology. Far away at the end of the lake[3] glitters a solitary white speck, which they tell me is the Monastery of St. Naum, but that is out of my track for the present; so I sauntered back to the khan, lingering now

and then to look at the Greek women who, with embroidered handkerchiefs on their heads and dressed in scarlet and black capotes, were washing linen in the lake, when, having watched their opportunity, and seeing me unescorted, a crowd of the faithful took aim from behind walls and rocks, discharging unceasing showers of stones, sticks, and mud. May my spectacles survive the attack! thought I, as forced into an ignominious retreat I arrived at the khan considerably damaged about the nose and ears, and not a little out of humour.

In the afternoon, with my guide, I was able to laugh at my enemies, while I drew a fine old Greek church, now turned into a mosque, and obtained lastly an extensive view from the clock-tower on the castle hill, whence the town tranquilly lying among tufted planes and tall cypresses recalls the lines of Childe Harold:

> "And the pale crescent sparkles in the glen
> Through many a cypress grove within each city's ken."

Certainly Akhridha is a beautiful place. All the hill-side below the fortress is thickly studded with Mohammedan tombs - little wedges of rough stone growing out of the soil, as it were, like natural geological excrescences - by thousands. From the streets below, parties of women clad in dark-blue, and masked in white wrappers, wander forth to take the air, and near me several crimson and purple coated Ghéghes smoke abstractedly on scattered bits of rock; when the sun throws his last red rays from, the high western mountains up the side of the castle hill, long trains of black buffaloes poke hither and thither, grunting and creaking forth their strange semi-bark, which sounds like the cracking of old furniture. On the whole, the zoological living world of Akhridha is very oppressive; what with dogs, geese, buffaloes, asses, mules, and horses, jackdaws, goats, and sheep, the streets are a great deal too full of animated nature to be comfortable, however confiding and amiable the several species may be. As for the white-eyed buffaloes, they are lazy and serene brutes, very opposite in character to their relatives in the marshes of Terracina and Pesto. You may bully them, either by pushing their noses or tugging at their horns as much as you please when they are in your way, and they never resent the indignity.

The khan was swarming with magnificence when I returned to it, the Bey of Tyrana and all his train having arrived. Simplicity is the rule of life with Albanian grandees; they sit silently on a mat and smoke, but their retinue bounce and tear about with a perfectly fearful energy, and after supper indulge in music according to their fashion until a late hour, then throwing themselves down to sleep in their capotes, and at early morning going through the slightest possible form of facial ablution - for cleanliness is not the most shining national virtue. These at Akhridha seem a wild and savage set, and are not easy to catch by drawing. Yet tomorrow I enter the wildest parts of Ghegheria, and must expect to see "a rugged set of men" indeed. In preparation, the Frangistan "wide-awakes" are packed up, as having a peculiar attraction for missiles, on account of their typically-infidel appearance. Henceforth I adopt the fez, for with that Mohammedan sign on the head it matters not how you adorn the rest of your person.

SEPTEMBER 24th

The wind, which whistles through the planks and holes of my "bedroom" here, is conducive to cold in the head, and seems to prevent my neighbours, the ducks, from sleeping any more quietly than myself. Why these domestic animals inhabit the "first floor" I cannot divine. Some fifteen of them thrust their heads through the lower crevices of the wall, and resting them on my mattress and pillow, look at me with one eye in the most comical manner, and seem to wish I was made of barley or duckweed.

Although we were ready at five A.M., yet our guard was not, and it was six ere he joined us, flaunting in crimson drapery, and we made for the land of the "*poveretti, paurosi, desperati, spaventati, fuor di loro, fuor di tutti,*"[4] as Giorgio distinguishes the Albanesi. On leaving the suburbs large parties of Zingari or gipsies, employed by Sheréeff Bey in various agricultural works, were setting out to their labour. These people are very numerous in Albania, and their peculiar physiognomy and dark complexion at once distinguishes them from the natives, who are mostly light-faced and yellow-haired. Our route lay westward by the shore of the silver lake, now enchantingly quiet and bright in the cloudless morning sun. High in air was a large falcon - possibly an eagle - hovering over a great colony

of jet black coots, who were swarming together in dismay, every one drawn up in a long straight line, and all performing simultaneous dives whenever the spoiler made a downward swoop. I saw three sets of these battles, waged by one against many, but could not observe that the persevering watchers gained aught by their warfare. By eight we reached Istruga, a picturesque village not far from the egress of the river Drino, and as all the women here (with that caprice or love of variety which characterises the costume of every Greek province), wore white and pink capotes instead of black and crimson, there was a pleasant air of gaiety in the bazaar. From hence, the native place of Bekir our Albanian guard (whom I had taken with me, not knowing certainly if the road were or were not unsafe), we proceeded after a short delay through pleasant groves of chestnut, until quitting the beautiful Lake of Akhridha, we toiled for three hours up a dull pass, walled in by low hills covered with stunted oaks. The sun was hot; and a fez, if you are not used to wear it, is an unsatisfactory substitute for a "wide-awake" felt hat, so that, after a descent as uninteresting as the ascent, and beyond that two hours of a narrow, dull valley, I was most heartily tired, and rejoiced to see a khan, never more welcome than when seven hours of sleepy riding in an abominable Turkish saddle have made a man anything but happy. Luckily we had brought food, for at this forlorn place there was literally nothing to be procured, not even a drop of water, nor did the situation of the khan possess interest, though I contrived to pass an hour by sketching it from the shelter of an oleander bush, surrounded by scores of tame kids.

At half-past two P.M. we were again in the saddle. A most desolate and wild country does this part of Albania seem, with scarcely a single habitation visible in so great a space; stern-wrinkled hills wall in the horizon, covered midway with oak forests; but after passing another range of low hills we came to the valley of the Skumbi,[5] and thenceforth the landscape began to assume a character of grand melancholy not to be easily forgotten. About five, the infinitely varied lines of the western heights were most glorious, their giant-rock forms receding into golden clouds as the sun sank down, while below stretched the deep widening valley of the Skumbi, a silvery stream winding through utterly wild scenes of crag, forest, and slope as far as eye could see. By six we crossed over the river on a high single arch, and shortly began to ascend the heights on the left bank, where, among

dark clusters of trees a straggling village was perceptible far above a solitary khan, at which we were to rest, for there is here but little choice of a night's lodging.

Until it was too dark to discern either pencil or paper, I worked away at a sketch of this lonely place, half hidden among huge rocks and walnut trees, and then turned into the single room or floor of the little windowless khan, which is the first and only inn of Kukues - so is the spot named. The accomplished dragoman had swept it perfectly clean. In the middle was a bright wood fire, the smoke escaping by a hole in the roof. On one side was my bed on a mat, while six or seven of the sons of the soil were preparing their kabóbs[6] at the blazing logs, squatting quietly enough, and busying themselves about their own cookery, without overmuch remarking the tea and toast Giorgio prepared for me. Scenes of this kind are most striking and picturesque, and the traveller lies down, as it were, with one eye open - the savage oddity of all around fixing itself with his last waking thoughts in the imagination. Long after all the inmates of the khan were fast asleep, I lay watching the party by the dying embers. The Albanians were slumbering in their capotes, each with his bare feet turned, and closely, to the hot charcoal; and if years of shoeless walking have not hardened the said feet, they must inevitably become altogether broiled before morning.

SEPTEMBER 25th

In spite of the apparent discomforts of the place, I slept well enough. The lively race of "F sharps" do not abound in these solitary khans half as much as in an Italian *locanda*. The Albanians never stirred; and as the fire burned more or less all night, their feet must have been handsomely grilled. Once, only, I was awakened suddenly, by something falling on me - flomp - miaw - fizz! - an accidental cat had tumbled from some unexplored height, and testified great surprise at having alighted on a moveable body. Would that her disturbance of my slumbers had been her only fault, and that she had not carried off a whole fowl and some slices of cold mutton - the little all I had to rely on for dinner through tomorrow's journey! Our Albanian co-tenants of the khan would assuredly have been blamed for this "*mancanza*,"[7] had not a fierce quarrel over the fowl, between the invading robber and an original cat belonging to the

establishment, betrayed the cause of evil - the bigger cat conquering and escaping from the roof with the booty.

At half-past five A.M. we were off; the red morning sky, and the calm shade of that broad valley were very striking; and the line of country we were to pursue promised a hard day's work. Continuing to ascend, on the left bank of the Skumbi, towards those gigantic rocks I had drawn yesterday evening, and once or twice pausing to make hasty memoranda sketches, we advanced by perilous paths along the mountain-sides towards a village at a great height above the river. It is very difficult, on such days of travel as this, to secure anything like a finished drawing. Even let the landscape be ever so tempting, the uncertainty of meeting with any place of repose or shelter obliges the most enthusiastic artist to pass hastily through scenes equal or superior to any it may be again his lot to see. Our progress here, too, is of the very slowest: either along sharp narrow paths cut in the rock, at the very edge of formidable precipices, or by still narrower tracks running on the bare side of a perpendicular clay ravine, - or winding among huge trunks of forest trees, between which the baggage-mule at one time is wedged - at another loses her load, or her own equilibrium, by some untimely concussion; such was the order of the day for travelling ease and accommodation; so that Dragoman Giorgio, greatly desirous of reaching Elbassán ere nightfall, strongly besought me not to linger. Nevertheless, after diving by a tortuous path into the depths of an abyss - (the home of a lateral stream which descended from the mountains to the Skumbi) - and after mounting a zigzag staircase out of it to the village above-mentioned, I could not resist sitting down to draw when I gazed on the extraordinary scene I had passed; it combined Greek outline - Italian colour - English luxuriance of foliage - while the village with its ivory minarets peeping from huge walnut and chestnut groves, was hanging, as it were, down the stupendous precipices to the stream below; - all these formed one of the wildest and grandest of pictures.

Beyond this (to appease Giorgio I made but a slight outline of that which I should gladly have employed a day to portray), the road was perhaps more dangerous, and our progress still slower; at the narrowest point we encountered some fifty laden mules, and a long time was consumed in arranging the coming and going trains, lest either should jostle and pitch into the abyss beneath. At

another sharp turning lay a dead ox skinned, filling up half the track (the edge of that track a sheer precipice of sixty or eighty feet in depth), and by no measures could we cause our horses to pass the alarming object; nor till our united strength had dragged the defunct to a niche in the rock, could we progress one foot's length. At a third *cattivo passo*[8] a projecting rock interfered with the sumpter horse's idea of a straight line; and lo! down went all the baggage, happily to no great distance, but far enough to occasion a half hour's delay in readjusting it. Every stony descent, and every toilsome climb up this mountain ridge side, brought us, if possible, to more vast and wondrously beautiful scenes; far below in the valley the river wound among dark dense oaks, sparkling like a silver thread, while above towered a mountain screen, whose snow-crowned, furrowed summits, frowned over slopes richly clothed with hanging woods. Perhaps the extreme beauty and variety of the colour in these scenes was as attractive as their sublimity, and in some degree offered a compensation for a certain clumsiness and want of refinement in many of the larger mountain outlines; while tracts of green wood, of bright pink or lilac earth, of deep grey hollows, or silver sides of snowy barriers, fascinated the eye from hour to hour.

On approaching the midway khan (really four hours and a half from Kukues, but which it took me till eleven to reach), I drew till dinner was ready, many peasants opportunely passing on their way to a fair or bazaar at Tyrana. The female costume is a blue dress and white petticoat, with white or yellow aprons, embroidered with crimson. The khan was situated as most of these halting places are, in a dell, whence there is no discernible object of interest; and as soon as dinner was despatched, two old cats and an army of ducks and fowls assisting at the repast, I was again en route by noon.

After three hours of winding along frightful paths at the edge of clay precipices and chasms, and through scenery of the same character, but gloomier under a clouded sun, we began to descend towards the seaward plains, and were soon effecting a steep and difficult passage between trunks of oak trees to the purple vale of the Skumbi, which wound through the plain below till it was lost in a *gola* or chasm through which is the pass to Elbassán. We crossed the Skumbi, here a very formidable stream, by one of those lofty one-arched bridges so common in Turkey, and as the baggage horse descended the last step, down came

the luggage once more, so that my sketches would have been lost, "*senza rimedio,*"[9] had the accident occurred two seconds sooner.

Two hours were occupied in passing the opening between the rocks, which admitted only a narrow pathway besides the stream, and after another hour's ride through widening, uncultivated valleys, and Elbassán is in sight, lying among rich groves of olives on a beautiful plain, through which the Skumbi, an unobstructed broad torrent, flows to the Adriatic. The same deceptive beauty throws its halo over Elbassán as over other Albanian towns; and, like its fellow *paesi,*[10] this was as wretched and forlorn within, as without it was picturesque and graceful. It was six P.M. ere we reached its scattered and dirty suburbs, and threaded its dark narrow streets, all roofed over with mats and dry leaves, and so low that one had to sit doubled over the horse to avoid coming into sharp contact with the hanging sticks, dried boughs, loose mats and rafters. The gloomy shade cast by these awnings did not enliven the aspect of the town, nor was its dirty and comfortless appearance lightened by a morose and wild look - a settled, sullen, despairing expression which the faces of the inhabitants wore. At length, thought I, these are fairly the wilds of Albania!

Three khans did we explore in vain, their darkness and vermin being too appalling to overcome; luckily there was still a fourth, which was a palace in comparison, though its accommodations were scanty, consisting of a row of perfectly dark cells, cleanly white-washed and empty, but without a glimmer of any light but what entered at the doors, which opened into a corridor exposed to the street; so you had your choice of living in public or in the dark.

Chapter V

SEPTEMBER 26th

A grey, calm, pleasant morning. The air seeming doubly warm from the contrast
between the low plains and the high mountains of the last two days' journey. I set
off early, to make the most of a whole day at Elbassán - a town singularly
picturesque, both in itself, and as to its site. A high and massive wall, with a deep
outer moat, surrounds a large quadrangle of dilapidated houses, and at the four
corners are towers, as well as two at each of the four gates: all of these

fortifications appear of Venetian structure. Few places can offer a greater picture of desolation than Elbassán; albeit the views from the broad ramparts extending round the town are perfectly exquisite: weeds, brambles, and luxuriant wild fig overrun and cluster about the grey heaps of ruin, and whichever way you turn, you have a middle distance of mosques and foliage, with a background of purple hills, or southward, the remarkable mountain of Tomóhr, the giant Soracte of the plains of Berát.

No sooner had I settled to draw - forgetful of Bekir the guard - than forth came the populace of Elbassán, one by one, and two by two, to a mighty host they grew, and there were soon from eighty to a hundred spectators collected, with earnest curiosity in every look; and when I had sketched such of the principal buildings as they could recognise, a universal shout of "*Shaitán!*" burst from the crowd; and strange to relate, the greater part of the mob put their fingers into their mouths and whistled furiously, after the manner of butcher-boys in England.

Whether this was a sort of spell against my magic I do not know; but the absurdity of sitting still on a rampart to make a drawing, while a great crowd of people whistled at me with all their might, struck me so forcibly, that come what might of it, I could not resist going off into convulsions of laughter, an impulse the Ghéghes seemed to sympathise with, as one and all shrieked with delight, and the ramparts resounded with hilarious merriment. Alas! this was of no long duration, for one of those tiresome Dervishes - in whom, with their green turbans, Elbassán is rich - soon came up, and yelled, "*Shaitán scroo! - Shaitán!*"[1] in my ears with all his force; seizing my book also, with an awful frown, shutting it, and pointing to the sky, as intimating that heaven would not allow such impiety. It was in vain after this to attempt more; the "*Shaitán*" cry was raised in one wild chorus - and I took the consequences of having laid by my fez for comfort's sake - in the shape of a horrible shower of stones, which pursued me to the covered streets, where, finding Bekir with his whip, I went to work again more successfully about the walls of the old city. Knots of the Elbassaniotes nevertheless gathered about Bekir, and pointed with angry gestures to me and my '*scroo*.' "We will not be written down," said they. "The Frank is a Russian, and he is sent by the Sultan to write us all down before he sells us to the Russian Emperor." This they told

also to Giorgio, and murmured bitterly at their fate, though the inexorable Bekir told them they should not only be scroo'd, but bastinadoed, if they were not silent and obedient. Alas! it is not a wonder that Elbassán is no cheerful spot, nor that the inhabitants are gloomy. Within the last two years one of the most serious rebellions has broken out in Albania, and has been sternly put down by the Porte. Under an adventurer named Zuliki, this restless people rose in great numbers throughout the north-western districts; but they were defeated in an engagement with the late Seraskier Pashá. Their Beys, innocent or accomplices, were exiled to Koniah or Monastir, the population was either drafted off into the Sultan's armies, slain, or condemned to the galleys at Constantinople, while the remaining miserables were and are more heavily taxed than before. Such, at least, is the general account of the present state of these provinces; and certainly their appearance speaks of ill-fortune, whether merited or unmerited. Beautiful as is the melancholy Elbassán - with its exquisite bits of mosques close to the walls - the air is most oppressive, after the pure mountain atmosphere. How strange are the dark covered streets, with their old mat roofing hanging down in tattered shreds, dry leaves, long boughs, straw or thatch reeds; one phosphorus match would ignite the whole town! Each street is allotted to a separate bazaar, or particular trade, and that portion which is the dwelling of the tanners and butchers is rather revolting, - dogs, blood, and carcasses filling up the whole street, and sickening one's very heart.

At three P.M. I rode out with the scarlet and gold-clad Bekir to find a general view of the town. But the long walled suburbs, and endless olive-gardens, are most tiresome, and nothing of Elbassán is seen till one reaches the Skumbi, spanned by an immensely long bridge, full of ups and downs and irregular arches. On a little brow beyond the river I drew till nearly sunset; for the exquisitely graceful lines of hill to the north present really a delightful scene, - the broad, many-channelled stream washing interminable slopes of rich olives, from the midst of which peep the silver minarets of Elbassán.

The dark khan cell at tea-time was enlivened by the singing of some Gheghes in the street. These northern, or Sclavonic Albanians are greatly superior in musical taste to their Berát or Epirote neighbours, all of whom either make a feeble buzzing or humming over their tinkling guitars, like dejected flies in a

window-pane, or yell forth endless stanzas of a whining, monotonous song, somewhat resembling a bad imitation of Swiss yodelling. But here there is a better idea of music. The guardian Bekir indulged me throughout yesterday with divers airs, little varied, but possessing considerable charm of plaintive wild melody. The Soorudji, also, made the passes of the Skumbi resound with more than one pretty song.

SEPTEMBER 27th

Great was my alarm, when two hours before sunrise the whole khan was knocked up by a government Tatar, raging for horses to proceed towards Skódra. All that were to be found in Elbassán I had engaged for my own journey, and the fear was, that should the Khanji yield our steeds to the new-comer, my detention in so charming a place as this might be indefinitely prolonged; but for some reason of his own the Khanji chose to lie in the most fertile manner, saying that some of his horses were ill, some away; and so the baffled Tatar retreated; and as the fibs were not uttered by my orders I became composed, and went to sleep again with a good conscience.

At half-past six A.M. we left Elbassán, Giorgio growling at all the inhabitants, and wishing they might be sold to the Czar, according to their fears. In any case, attachment to Abdul Medjid is not the reigning characteristic of this forlorn place. It was long before we left walls and lanes (there is more cultivation, especially of the olive, in these environs than in any part of Albania I have yet seen), or ceased to jostle in narrow places against mules laden with black wool, and driven by white-garbed, black-cloaked men; but when the route began to ascend from the valley, the view southward over to Skumbi, in which the giant Tomóhr, forms the one point of the scene, was remarkably grand. In the early morning's ride there was but little interest; the greater part of it being through the narrow valley of a stream tributary to the Skumbi; the winding bed of which torrent we crossed more than thirty times ere we left it; and much after-time was occupied in painfully coasting bare clay hills till we began to climb the sides of the high mountain which separates the territory of Elbassán from that of Tyrana.

How glorious, in spite of the dimming sirocco haze, was the view from the summit, as my eyes wandered over the perspective of winding valley and stream to the farthest edge of the horizon - a scene realizing the fondest fancies of artist imagination! The wide branching oak, firmly rivetted in crevices, all tangled over with fern and creepers, hung half-way down the precipices of the giant crag, while silver-white goats (which chime so picturesquely in with such landscapes as this) stood motionless as statues on the highest pinnacle, sharply defined against the clear blue sky. Here and there the broken foreground of rocks piled on rocks, was enlivened by some Albanians who toiled upwards, now shadowed by spreading beeches, now glittering in the bright sun on slopes of the greenest lawn, studded over with tufted trees, which recalled Stothard's graceful forms, so knit with my earliest ideas of landscape. These and countless well-loved passages of auld lang syne, crowded back on my memory as I rested, while the steeds and attendants reposed under the cool plane tree shade, and drank from the sparkling stream which bubbled from a stone fountain. It was difficult to turn away from this magnificent mountain view - from these chosen nooks and corners of a beautiful world - from sights of which no painter-soul can ever weary: even now, that fold beyond fold of wood, swelling far as the eye can reach - that vale ever parted by its serpentine river - that calm blue plain, with Tomóhr in the midst, like an azure island in a boundless sea, haunt my mind's eye, and vary the present with visions of the past. With regret I turned northwards to descend to the new district of Tyrana; the town (and it is now past eleven) being still some hours distant.

By half-past twelve we had descended into a broad undulating valley-plain, with limits melting into undistinguishable hill and sky (for the day was a sirocco with its dust-like mist, and the atmosphere like an oven), and were, soon at a roadside khan, where a raised platform, with matting shelter, was by no means unacceptable. The magnificent Akhridhan, Bekir, who was charged to accompany me as far as Tyrana, is of very little service in any way; his first care is to secure a good place on the platform - to take off his shoes, and smoke; while Giorgio's alacrity in cooking a good dinner is a strong contrast to the Albanian's idleness. There were whispering olives hanging over the khan-yard; and while a simple melody was chanted by three Ghéghes in the shade, the warm, slumbrous midday halt brought back to memory many such scenes and siestas in Italy.

Starting at two, the scenery along the banks of a river, a noble stream enclosed between fine rocks (the name of which I know not) was fine and varied; but the fear of arriving late at Tyrana urged me onward, to the omission of all drawing - though, had time allowed, it would not have been easy to have selected only one from so many continually-changing pictures as the afternoon's ride afforded. Other things also, good and bad, were included in the day's carte, such as capital grapes at the khan, and from frequent gardens as we approached Tyrana; - many objects of costume among the peasantry, - great flocks of turkeys, - and insecure wooden bridges over little streams, which obliged us, for fear of the horses falling through the planks, to make detours through charming bosky oases of cultivation. At four we forded the river, and hastened on, gradually descending by low brushwood undulations to the plain of Tyrana, while to the east, the long rugged range of the Króia mountains became magnificently interesting from picturesqueness and historical associations.

A snake crossing the road gave Giorgio an occasion, as is his afternoon's wont, to illustrate the fact with a story. "*In Egitto,*" said he, "are lots of serpents; and once there were many Hebrews there. These Hebrews wished to become Christians, but the King Pharaoh - of whom you may have heard - would not allow any such thing. On which Moses (who was the prince of the Jews) wrote to the Patriarch of Constantinople and to the Archbishop of Jerusalem, and also to San Carlo Borromeo, all three of whom went straight to King Pharaoh, and entreated him to do them this favour; to which he only replied '*No, signori.*' But one fine morning these three saints proved too strong for the King, and changed him and all his people into snakes; which," said the learned dragoman, "is the real reason why there are so many serpents in Egypt to this day."

Wavy lines of olive - dark clumps of plane, and spirally cypresses marked the place of Tyrana when the valley had fully expanded into a *pianura*, and the usual supply of white minarets lit up the beautiful tract of foliage with the wonted deceptive fascination of these towns. As I advanced to the suburbs, I observed two or three mosques most highly ornamented, and from a brilliancy of colour and elegance of form, by far the most attractive of any public building I had yet beheld in these wild places; but though it was getting dark when I entered the town (whose streets, broader than those of Elbassán, were only raftered and matted half

way across), it was at once easy to perceive that Tyrana was as wretched and disgusting as its fellow city, save only that it excelled in religious architecture and spacious market places.

Two khans, each abominable, did we try. No person would undertake to guide us to the palace of the Bey (at some distance from the town), nor at that hour would it have been to much purpose to have gone there. The sky was lowering; the crowds of gazers increasing - Albanian the only tongue; so, all these things considered, I finally fixed on a third-rate khan, reported to be the 'Clarendon' of Tyrana, and certainly better than the other two, though its horrors are not easy to describe nor imagine. Horrors I had made up my mind to bear in Albania, and here, truly, they were in earnest.

Is it necessary, says the reader, so to suffer? and when you had a Sultan's Boyourldi could you not have commanded Beys' houses? True; but had I done so, numberless arrangements become part of that mode of life, which, desirous as I was of sketching as much as possible, would have rendered the whole motives of my journey of no avail. If you lodge with Beys or Pashás, you must eat with them at hours incompatible with artistic pursuits, and you must lose much time in ceremony. Were you so magnificent as to claim a home in the name of the Sultan, they must needs prevent your stirring without a suitable retinue, nor could you in propriety prevent such attention; thus, travelling in Albania has, to a landscape painter, two alternatives; luxury and inconvenience on the one hand, liberty, hard living, and filth on the other; and of these two I chose the latter, as the most professionally useful, though not the most agreeable.

O the khan of Tyrana! with its immense stables full of uproarious horses; its broken ladders, by which one climbed distrustfully up to the most uneven and dirtiest of corridors, in which a loft some twenty feet square by six in height was the best I could pick out as a home for the night. Its walls, falling in masses of mud from its osier-woven sides (leaving great holes exposed to your neighbour's view, or, worse still, to the cold night air); - its thinly raftered roof, anything but proof to the cadent amenities resulting from the location of an Albanian family above it; its floor of shaking boards, so disunited that it seemed unsafe to move incautiously across it, and through the great chasms of which the horses below

were open to contemplation, while the suffocating atmosphere produced thence are not to be described!

O khan of Tyrana! when the Gheghe Khanji strode across the most rotten of garrets, how certainly did each step seem to foretell the downfall of the entire building; and when he whirled great bits of lighted pitch-torch hither and thither, how did the whole horrid tenement seem about to flare up suddenly and irretrievably!

O khan of Tyrana! rats, mice, cockroaches, and all lesser vermin were there. Huge flimsy cobwebs, hanging in festoons above my head; big frizzly moths, bustling into my eyes and face, for the holes representing windows I could close but imperfectly with sacks and baggage: yet here I prepared to sleep, thankful that a clean mat was a partial preventive to some of this list of woes, and finding some consolation in the low crooning singing of the Gheghes above me, who, with that capacity for melody which those Northern Albanians seem to possess so essentially, were murmuring their wild airs in choral harmony.

SEPTEMBER 28th

Though the night's home was so rude, fatigue produced sound sleep. The first thing to do was to visit Machmoud Bey, vice-governor of Tyrana, to procure a Kawás as guardian during a day's drawing, and a letter to his nephew, Alí Bey, of Króia, for to that city of Scanderbeg I am bent on going. Of the Bey's palace, nothing can be said beyond what has already been noted of the serais of similar grandees.

Returning to the khan, I gave five dollars to Bekir of Akhridha, for his five days' service, an expense I resolved in future to forego, as the chance of robbery in these mountains seems a great deal too small to authorize it - the more, that the only assistance I really want (that of a guard while sketching in the towns) I have no difficulty in procuring. But even with a guard, it was a work of trouble to sketch in Tyrana; for it was market, or bazaar day, and when I was tempted to open my book in the large space before the two principal mosques - (one wild scene of confusion, in which oxen, buffaloes, sheep, goats, geese, asses, dogs, and children, were all running about in disorder) - a great part of the natives, impelled

by curiosity, pressed closely to watch my operations, in spite of the Kawás, who kept as clear a space as he could for me; the women alone, in dark *feringhis*, and ghostly white muslin masks, sitting unmoved by their wares. Fain would I have drawn the exquisitely pretty arabesque-covered mosques, but the crowds at last stifled my enthusiasm. Not the least annoyance was that given me by the persevering attentions of a mad or fanatic dervish, of most singular appearance as well as conduct. His note of "*Shaitán*" was frequently sounded; and as he twirled about, and performed many curious antics, he frequently advanced to me, shaking a long hooked stick, covered with jingling ornaments, in my very face, pointing to the Kawás with menacing looks, as though he would say, "Were it not for this protector you should be annihilated, you infidel!" The crowd looked on with awe at the holy man's proceedings, for Tyrana is evidently a place of great attention to religion.

In no part of Albania are there such beautiful mosques, and nowhere are collected so many green-vested dervishes. But however a wandering artist may fret at the impossibility of comfortably exercising his vocation, he ought not to complain of the effects of a curiosity which is but natural, or even of some irritation at the open display of arts which, to their untutored apprehension, must seem at the very least diabolical.

The immediate neighbourhood of Tyrana is delightful. Once outside the town and you enjoy the most charming scenes of quiet, among splendid planes, and the clearest of streams. The afternoon was fully occupied in drawing on the road from Elbassan, whence the view of the town is beautiful. The long line of peasants returning to their homes from the bazaar, enabled me to sketch many of their dresses in passing; most of the women wore snuff-coloured or dark vests trimmed with pink or red, their petticoats white, with an embroidered apron of chocolate or scarlet; others affected white capotes; but all bore their husband's or male relative's heavy black or purple capote, bordered with broad pink or orange, across their shoulders. Of those whose faces were visible - for a great part wore muslin wrappers - (no sign hereabouts of the wearer being Mohammedan, for both Moslem and Christian females are thus bewrapped) - some few were very pretty, but the greater number had toil and careworn faces. There were many

dervishes, also, wearing high, white felt, steeple-crowned hats, with black shawls round them.

No sooner, after retiring to my pig-stye dormitory, had I put out my candle and was preparing to sleep, than the sound of a key turning in the lock of the next door to that of my garret disturbed me, and lo! broad rays of light illumined my detestable lodging from a large hole a foot in diameter, besides from two or three others just above my bed; at the same time a whirring, humming sound, followed by strange whizzings and mumblings began to pervade the apartment. Desirous to know what was going on, I crawled to the smallest chink, without encountering the rays from the great hiatus, and what did I see? My friend of the morning - the maniac dervish - performing the most wonderful evolutions and gyrations; spinning round and round for his own private diversion, first on his legs, and then pivot-wise, "*sur son seant,*" and indulging in numerous other pious gymnastic feats. Not quite easy at my vicinity to this very eccentric neighbour, and half anticipating a twitch from his brass-hooked stick, I sat watching the event, whatever it might be. It was simple. The old creature pulled forth some grapes and ate them, after which he gradually relaxed in his twirlings, and finally fell asleep.

SEPTEMBER 29th

It was as late as half-past nine A.M. when I left Tyrana, and one consolation there was in quitting its horrible khan, that travel all the world over, a worse could not be met with. Various delays prevented an early start; the postmaster was in the bath, and until he came out no horses could be procured (meanwhile I contrived to finish my arabesque mosques); then a dispute with the Khanji, who, like many of these provincial people, insisted on counting the Spanish dollar as twenty-three, instead of twenty-four Turkish piastres. Next followed a row with Bekir of Akhridha, who vowed he would be paid and indemnified for the loss of an imaginary amber pipe, which he declared he had lost in a fabulous ditch, while holding my horse at Elbassan; and lastly, and not the least of the list, the crowd around the khan gave way at the sound of terrific shrieks and howlings, and forth rushed my spinning neighbour, the mad dervish, in the most foaming state of

indignation. First he seized the bridles of the horses; then, by a frantic and sudden impulse, he began to prance and circulate in the most amazing manner, leaping, and bounding, and shouting "Allah!" with all his might, to the sound of a number of little bells, which this morning adorned his brass-hooked weapon. After this he made an harangue for ten minutes, of the most energetic character, myself evidently the subject; at the end of it he advanced towards me with furious gestures, and bringing his hook to within two or three inches of my face, remained stationary, in a Taglioni attitude. Knowing the danger of interfering with these privileged fanatics, I thought my only and best plan was to remain unmoved, which I did, fixing my eye steadily on the ancient buffoon, but neither stirring nor uttering a word; whereon, after he had screamed and foamed at me for some minutes, the demon of anger seemed to leave him at a moment's warning; for yelling forth discordant cries, and brandishing his stick and bells, away he ran, as if he were really possessed. Wild and savage were the looks of many of my friend's excited audience, their long matted, black hair, and brown visage, giving them an air of ferocity, which existed perhaps more in the outward, than the inner man; moreover, these Gheghes are all armed, whereas out of Ghegheria no Albanian is allowed to carry so much as a knife.

I was glad enough to leave Tyrana, and rejoiced; in the broad green paths, or roads, that lead northwards, through a wide valley below the eastern range of magnificent mountains, on one of which, at a great height from the plain, stands the once formidable Kroia, so long held out against the conquering Turk, by Iskander Bey. Certain of its historical interest, I was now doubly anxious to visit it, from its situation, which promised abundance of beauty.

After four hours' ride, over ground much intersected with marks of inundation, we arrived at a khan where, under a sort of "*pergola*"[2] of dry matting, I remained to dine, and to draw the sublime view before me over the plain, and wide beds of torrents towards the bare, craggy, dark mountain of Króia, with the town and rocks glittering like silver aloft, below a heavy curtain of black cloud. At two we left the Skódra, or post-road - the Soorudji growling frightfully at my so doing - and struck directly across the vale to Króia - a winding ascent through green wooded hill-buttresses or shoulders, changed ere long for a sharp climb up to the foot of the great rock round which the town clusters and hangs - at which

point I arrived at half-past four P.M., and where I gladly paused to sketch, rest, and enjoy the view above, below, and around. Few prospects are more stately than those of this renowned spot; and perhaps that of the crag, with its ruined castle projecting from the great rocks above, and lording over the spacious plain country north and south from Skodra towards Durázzo, reminded me more of Olévano, that most lovely landscape in a land of loveliness, than any place I ever saw. At the base of this isolated rock lies the town - a covered semicircular line of bazaars; and overlooking all is the Bey's palace, and a tall white minaret against the blue sky. The peasants who passed me while drawing, lingered, whispering quietly while observing the sketch, all thoroughly well-behaved, and a great contrast to my spectators of Elbassán. But evening advanced, and I was compelled to shut up my book, feeling for the hundredth time how difficult it is to portray scenery in a country where the mere daily occupation of journeying from one town to another is attended by so much labour and hurry. Ascending through the dark-roofed bazaars - the huge crags towering over which reminded me of Cánalo in Calabria - we arrived at Alí Bey's palace - a singularly picturesque pile of building, composed of two-storied, painted galleries, with irregular windows, projecting roofs, and innumerable novelties of architecture - all in a dreary courtyard, the high walls of which shut out effectually the glorious landscape below.

In the arabesqued and carved corridor, to which a broad staircase conducted me, were hosts of Albanian domestics; and on my letter of introduction being sent into the Bey, I was almost instantly asked into his room of reception - a three-windowed, square chamber (excellent, according to the standard of Turkish ornament, taste, and proportion) - where, in a corner of the raised divan, sat Ali, Bey of Króia - a lad of eighteen or nineteen, dressed in the usual blue frock-coat now adopted by Turkish nobles or officers. A file of kilted and armed retainers were soon ordered to marshal me into a room where I was to sleep, and the little Bey seemed greatly pleased with the fun of doing hospitality to so novel a creature as a Frank. My dormitory was a real Turkish chamber; and the raised cushions on three sides of it - the high, square, carved wooden ceiling - the partition screen of lofty woodwork, with long striped Brusa napkins thrown over it - the guns, horse-gear, &c., which covered the walls - the fire-place - closets - innumerable pigeon-holes - green, orange, and blue stained-glass windows - all appeared so much the

more in the light of luxuries and splendours when found in so remote a place as Króia. It was not easy to shake off the attentions of ten full-dressed Albanian servants, who stood in much expectation, till, finding I was about to take off my shoes, they made a rush at me as the Jews did at Saloniki, and showed such marks of disappointment at not being allowed to make themselves useful, that I was obliged to tell Giorgio to explain that we Franks were not used to assistance every moment of our lives, and that I should think it obliging of them if they would leave me in peace. After changing my dress, the Bey sent to say that supper should be served in an hour, he having eaten at sunset, and in the meantime he would be glad of my society; so I took my place on the sofa by the little gentleman's side, and Giorgio, sitting on the ground, acted as interpreter.

At first Alí Bey said little, but soon became immensely loquacious, asking numerous questions about Stamboul, and a few about Franks in general - with the different species of whom he was not very well informed. At length, when the conversation was flagging, he was moved to discourse about ships that went without sails, and coaches that were impelled without horses; and to please him I drew a steamboat and a railway carriage; on which he asked if they made any noise; and I replied by imitating both the inventions in question in the best manner I could think of - "Tik-tok, tik-tok, tik-tok, tokka, tokka, tokka, tokka, tokka - tok" (crescendo), and "Squish-squash, squish-squash, squish-squash, thump-bump" - for the land and sea engines respectively - a noisy novelty, which so intensely delighted Alí Bey, that he fairly threw himself back on the divan, and laughed as I never saw Turk laugh before.

For my sins, this imitation became fearfully popular, and I had to repeat "squish-squash," "tik-tok," till I was heartily tired, the only recompense this wonderful little Bey offered me, being the sight of a small German writing-box (when new it might have cost three or four shillings), containing a lithograph of Fanny Ellsler, and two small looking-glasses in the lid. This was brought in by a secretary, attended by two Palikari,[3] at the Bey's orders, and was evidently considered as something uncommonly interesting. So, when this very intellectual intercourse was over, I withdrew to my wooden room, and was glad of a light supper before sleeping.

Chapter VI

Splendour of the environs of Króia - Majestic rook-scenery - Alí Bey's dinner - An untimely fit of the cramp - "Tik-tok" - The silent hareem - Muezzins and their musical call - Parting interview with Alí Bey - His ambition for starched shirt-collars - Departure from Króia - Descent towards the sea - Obstinate Soorudji - The midday khan, and its inhabitants - Beautiful journey over the plains - Tangled glades of underwood - Arrival at Aléssio, on the banks of the Drino - Miserable village - Tomb of Scanderbeg - Lodging at a Greek Christian's house - Roman Catholic population - The convent and the Capuchin friar - His happy state of mind - Repose at Aléssio - Rainy weather - Journey along the banks of the Drino - The ferry - Costume of Ghegheria - The position of Skódra - The river Boyána - Lake and castle of Skódra - Its bazaars and gardens - Search for the English Consul - Provoking Soorudji - Signor Bonatti - The apothecary's house - Limits of my Albanian tour.

SEPTEMBER 30th

But one day can be allotted to Króia, so how to make the best of that day? Little liberty do I look for, the more that while I take my cafe, an Albanian stands at the door, who shies off his slippers if I only move a finger - rushing forward to know if I want anything. However, I have caused it to be known through Giorgio, that I only require a single attendant, and that that one should be well paid. Spite of forebodings, I actually escaped from the palace, and having re-passed the bazaars, was at work on a drawing of a castle rock, one of the most imposing of subjects, ere yet the sun had risen over the eastern hills. Above the town the view was still

more majestic, and although many of the inhabitants came and sat near me, yet no one annoyed me in the least, and I drew comparisons between these well-bred people and the rude men of Elbassán and Tyrana. At eleven I returned to dine with Alí Bey, an amiable little fellow, who was evidently anxious to make my stay agreeable, though he could not long control his childish curiosity from bidding Giorgio (who could ill keep his gravity), to ask me to imitate the noises of the steam-boats and coaches. So I again went through, "Tik-tok, tokka, tokkey," and "Squish-squash, squash, squash," to the great delight of the Bey and his retinue. The routine of dinner was as follows: ten servants, in full Albanian dress, came in at once, for all the world like in an opera ballet. One of them places a little stool on the ground, upside down, as much as to say, that is not to be sat upon; others fix thereon a large flat plate of tin, or some similar metal, with a spoon, or piece of bread, to each diner (there were two guests beside myself); then an ewer with water is handed to each person by one of the domestics, who kneels until you have used it and the Brusa towel. Soup, somewhat like sago and vinegar, was the first dish placed before us; and here my good genius basely forsook me, for endeavouring to sit cross-legged like my entertainers, I somehow got my knees too far below the pewter table-top, and an ill-conditioned violent cramp seizing me at the unlucky moment in which the tureen was placed on the table, I hastily endeavoured to withdraw the limb, but unsuccessfully - gracious! - sidelong went the whole table, and all the soup was wasted on the ground! Constantly as a Frank is called on to observe the unvarying good breeding and polite ease of Turkish manner, this was a most trying proof of the endurance of those qualities. Nobody spoke, or even looked, as if anything had gone amiss; one of the "corps de ballet" wiped up the catastrophe, and others soon brought in a new bowl-full of soup, as if nothing had happened. Nor was my awkwardness alluded to except by Giorgio, who, by my orders, offered a strong apology for the stiffness of Frank's legs in general, and of mine in particular.

But I took care not to commit myself by unexpected cramps any more, and sprawled sideways through the rest of the dinner as I best could. A pilaf of fowls, full of spices and bones, kabobs, a paste of rice, onions, and pie-crust, and some round balls of chopped meat concluded the repast, some grapes excepted. Nobody drank anything, and abstemiousness was the order of the day, a virtue I

was compelled to practise, even more than my companions, seeing that I was unskilled at selecting proper bits from the dishes with my fingers, and not only caught at unsatisfactory bones, but let half of what I did catch fall midway between my mouth and the single bowl into which we dipped in rotation. So ended my first Turkish dinner.

It is not easy to keep conversation going, on terms so unequal as those in which my host and I communicated, so I was not sorry to be once more at work, and the outside of Alí Bey's palace, fretted, and galleried, and painted, occupied me an hour or two, while the castle rock, taken from the east, filled up my time till sunset. After this, I was devoted for two hours to the little Bey, during which my employment was repeating in English the names of the days of the week, and the twelve months, and the letters of the alphabet, varied by "squish-squash, squish-squash, thump, thump, tikka-tok-katok," and by occasional contemplations of the Fanny Ellsler writing-box. Later, Alí Bey showed me the rooms of his hareem (the first and last I am most probably destined to see), which he was repairing with an indistinct view to future matrimony. Very picturesque and Arabian-night-like chambers they were, with a covered gallery, looking down on the (now) still bazaars and the tall minarets, to the rocks and the oak woods sloping down, down by undulating hills to the boundless plains, moonlit sea, and far faint hills of Skódra. Imagination peopled this gallery with houri tenants, waving *feringhis*, and laughing faces, but the halls of Alí Bey were silent for the present.

Supper - a facsimile of the dinner, save that I did not upset the soup - concluded my day in Kroia, and I took leave of good-natured little Alí Bey with the sort of half regret with which any human being, whose salt one has eaten more than once in wilds such as these, is bade a farewell for ever.

OCTOBER 1st

The Muezzins' call to prayers is more delightfully musical at Króia than at any place I have yet been to. It is the wildest of singular melodies. We were off by six A.M. While the horses were being got ready, Alí Bey desired to see me again, and accordingly we had series the last of coffee, pipes, "squish-squash, tikka-tok," and

the alphabet. He had asked Giorgio of his own accord, how the Franks saluted each other, and hearing that it was by shaking hands, he seized both of mine, and shook them as a London footman might a doorknocker. Long after I had left the palace, he was watching me from his corner window, and doubtless will longer remember the Frank who ran about and wrote down houses, and divulged to him the noises of steam-ships and coaches. Ali is representative of his uncles, Suleiman and Machmoud Beys, governors of Tyrana, and as their deputy, judges all disputes in Króia. Young as he is, he has a good deal of energetic character, and keeps the people in strict order. "I took away all their guns," said he, "directly I was chief here." For why? "They shot more men than birds." Among other amusing questions which he asked, one was, after long and accurate observation of my dress: "How does the Frank make the collars of his shirt stand upright?" Giorgio informed him, by means of starch, on which he inquired the nearest place where he could purchase a Frank laundress; and being told Trieste, he expressed his determination to send for one shortly.

The morning was clouded and grey, and a heavy mist over the northern plains and shore foretells rain. We began to descend from Króia through graceful olive woods and pretty scenery, above which, on the right, the tops of the high mountain range peeped out through gathering clouds. Great fragments of dark rock cumber the downward path, and on the left the distant view would have been glorious, if the spreading mist had been less dense. Crossing a stream by a high-arched bridge, the route lay through ever increasingly beautiful oak forests, stretching from hill to hill, and wrapping the bald and gloomy mountains in their grey and brown robes; and had not the day become more threatening each minute, I should have enjoyed the scenery more. In the thickest of the wood, down came the rain in torrents; the paths were slippery, our progress was slow; and Giorgio, who considers Albania and Albanians as the most depressing of horrors, made the morning truly melancholy by incessant croaking about robbers; besides all which evils, a most odious impish little Soorudji, who had brought me from Tyrana, and who was aggrieved at being taken, as he called it, up into the hills, delayed me out of spite in every possible way, by rushing into quagmires, and leaving the path suddenly to search for imaginary pools of water in impenetrable copses, that his horses might drink thereof; these symptoms of unruliness we were

at last obliged to check, by leading his horse forcibly, spite of his yell of "Sui-sui."[1] In about three hours from Króia, we reached the Skódra road once more, and in half an hour arrived at a khan situated in a close jungly wood, a small spot of ground being cleared around the tenement, which, says the Khanji, is five hours from Alessio, the place meant to be the end of my day's journey. Here I resolve to halt, as the rain cannot be more violent than it is at present. Moreover, there is a fine fowl roasting, which I seize on, and purchase for two piastres. These by-road khans are infinitely preferable to the vile places in the towns of Albania; a floor and a fire are comforts, and the stable at the far end of the long building did not incommode me, whose luncheon on the fowl, with rice, was only more or less disturbed by little chickens and kittens, who continually ran over me, snatching at casual bits of fugitive food. No parasitical creatures are more worrying to a traveller in Albania than chickens; they swarm by scores in these khans, and their incessant chirp and flutter are incorrigible, nor until they have shared the picking of their ancestors' bones can they be quieted.

At eleven o'clock - the rain ceasing unexpectedly - we were off again, ever through a thick wooded tract of country, the tangled branches, heavy with the rain, greatly impeding our progress, and the roads being deep in mud and water. Often, to avoid the high raised causeway (the government post-road) - the unequal pavement of which it is misery to ride over - we went aside into quiet glades of green, returning when the too thick foliage prevented the secondary pathway being followed. At an hour's distance another khan stands on the right of the road, and beyond this the wood gives place to more open glades, until we reached the plain of the broad and rapid river Máthis, which, always a disagreeable process, was forded about one P.M. Hence the hills we had passed began to gleam in returning sunshine, and covered with thickest foliage, seemed like vast piles of moss; while northward, and to the west, flat ground, with occasional spots of cultivation, appeared to spread to the sea - the high rocks of the ancient Lissus rising directly in front of our route. Having passed a third khan on the left at half-past one, the road enters a thick copse or jungle, a belt of underwood stretching over the low marshy grounds near the Drino. The staple productions of this region are tangled brambles and low ilexes through whose green growth tall whispering reeds shoot up, while, above all, trees scattered at intervals tower, their

branches bending with the weight of vines and creepers which swing in graceful festoons, in all the luxuriant rankness that surely indicates a condition of atmosphere fatal to man, but favourable to vegetable life.

In these narrow and intricate paths we met many peasants returning from the bazaars of Aléssio, the women clad in fringed and tasselled dresses, the men all armed; for the Gheghe Albanians, from not having formed any union with their brethren of Toskeria and Tchamouriá in the last rising against the Turkish Government, are still allowed the privilege of carrying arms, which is denied to all south of the Skumbi.

About four o'clock I reached Aléssio[2] - a miserable village representing the ancient Lissus, many remains of which exist around and upon the remarkable pointed hill (the ancient Acropolis) rising above the street of bazaars which forms the chief part of the modern town; the rest of Aléssio consists of houses standing in gardens on the banks of the Drino - in which the Christian population chiefly dwell - -or in suburban residences of the Mohammedans on the hill-side. On the summit of the rock is a mosque, and here tradition says that the remains of Scanderbeg repose beneath the ruins of a Christian church.

The khan of Aléssio was too bad to think of as a lodging; so, by means of a letter from the Bey of Tyrana, we proceeded to a quarter in the house of a Greek Christian residing here as agent to the Austrian Consul at Skódra; and leaving Giorgio to make the best of this refuge - a sort of loft in a courtyard, bearing all the tokens of vermin - I went forth with its master, Signor Giuseppe, and by way of finding a general view of Aléssio, crossed the river in a punt-ferry, and proceeded to a Latin convent which stands on a height opposite the town. Nearly all the Christians in this part of Northern Albania (that is, on the north-western coast, where the Venetian Republic was once so powerful) are of the Latin Church, and the residents of the Greek persuasion are the minority. From this spot the views are most exquisite. Looking south, they extend towards the high mountains above Króia and Tyrana; and northward, they range over a beautiful river which winds down from the heights above Skódra, reflecting trees and hills in the clear water.

The sole tenant of the convent, a Capuchin Friar, came forth to meet me, when, having advanced a few yards, he set up a shout, ejaculating, "O, *possibile! Sí,*

è il Signor Odoardo!" while I on my part recognised him as a monk I had fallen in with some years back when staying with some friends in the Maremma near Corneto, and afterwards had frequently seen at Ara-Coeli in Rome; but the singularity of the circumstance - that we should meet again in this remote corner of Illyria - was one of those events that we should reject if in a novel, as too impossible to happen. Fra Pietro exhibited great glee at seeing a "Christian," as he called me; and on the other side, I was glad enough to hear good Roman speech. "But," said I, "the people of Aléssio are Christians, are they not?" "*Cristiani si, lo sono,*"[3] said the monk, "*ma se domani volesse il buon Dio far crescere il fiume per portargli tutti in Paradiso, ci avrei gusto! - Cristiani? Ladri! Cristiani? - porchi! - Cristiani? Lupi, animali, sciocchi, scimie, brutte bestie, Grechi, Turchi, Albanesi - che gli piglia ad uno e tutti un accidente. O che Cristiani! O che rabbia!*" Seeing that a sojourn in the Latin bishopric of Lissus had by no means improved my friend Fra Pietro's disposition to suavity (he was never, in the days when I formerly knew him, of the calmest or happiest temper), I hastened to change the conversation, but during the rest of our discourse, this victim of exile in "*partibus*" continued to growl out bitter anathemas at all his Aléssian flock. At sunset I left the angry friar (after all, a solitary life here must be no slight *penitenza*), and, promising to visit him on my return, I re-crossed the Drino to Signor Giuseppe's house, where I found bed and supper ready in the upper chamber.

An old Skódrino, who talks Italian, squats on the opposite side of the fire, and tells me a great deal about Skódra and other places hereabouts, which I ought to have remembered, but I fell fast asleep. Eight hundred Latin Christians, according to him, live at Skódra; and he says, "there may be some twenty Greek Christian families." The Roman Catholic Bishop of Lissus resides there. In spite of all his intelligence, the old gentleman was a bore, as he was seized with a literary fit in the middle of the night, and smoked, and scribbled, and coughed, to the utter driving away the little chance of sleep which mice, mosquitoes, and fleas had left me.

OCTOBER 2nd

It is half-past four A.M., and torrents of rain are falling; they may fall for two or three days, in which case I am a prisoner here, as all the rivers will be impassable, so I order the horses to proceed to Skódra at all risks, though of course the obstinate little Soorudji would not bring them till seven.

The journey was of the wettest, and kept always along the banks of the Drino, beneath enormous abele trees, with fine forms of mountains looming through the downward mist. To a man who wears spectacles, a fez is not advantageous as a covering for the head on a rainy day; the glasses are soon dimmed, and little does he see of all above, below, and around. In three hours we arrived at the ferry over the Drino, having passed two or three scattered villages, which were proclaimed as Christian by the fact of pigs (lean, hairy pigs they were) roaming around them. Nothing in the world could be more picturesque than the ferry and its capoted rowers; but the incessant rain forbade attempts to draw, nor did I halt again, till at eleven, when we reached a khan distant still three hours from Skódra. A small bit of salt cheese, and some very bad wine, was all the food I could obtain; but the loss of luncheon was compensated for by the increasing interest of the costumes of the peasantry; their scarlet and crimson capotes, short coarse kilts, long black hair, dark faces, and immoderately long pistols, gave them an air of romance and savageness I had not yet seen.

Half-past eleven - on again, through clay and water, and willowy tangles, and high broken causeways. Turkish paved roads, even when in repair, are miserable ways and means of travel; but when you have twenty yards of elevated stonework, and then a four feet interval of mud, the causeway being often two or three feet in height, the alternation of ups and downs is not pleasant. Vast mountain forms are lowering remotely on all sides, till the castle of Skódra[4] appears in sight. In all the objects of this, to me, new district, extreme wildness is the dominant impression. The peasantry were picturesque to an incredible degree.

Flocks of sheep and goats, guarded by the most savage-looking fellows, armed to the teeth, and magnificent in all the colours of Gheghe clothing, were frequently in our path, and more than once fierce dogs sprang out on our half wild Soorudji, from hidden ambushes. Once, the young pickle made as if he would

pursue one of the invaders, with his raised whip, but the herdsman rose from his lair, and coolly pointed his long gun at the offender, till he resumed his course.

Skódra is situated to the south of the lake of the same name, on a point of land between two rivers, one of which,[5] the Boyána, sweeps below the south side of the isolated ridge of hill on which the fortress stands, which ridge, shutting out the plain, and lake is, as it were, split into two, by a deep hollow immediately to the eastward of the fortress, wherein, and on the southern side of the hill, appears to stand the town. But this is all deception; for having crossed the Boyána - at this season a fordable stream - you arrive at the southern suburbs, only to discover that they are deserted; the walls of numerous houses, ruined in some of the late sieges of this unquiet capital of Illyrian Albania, one or two handsome mosques, and a considerable extent of garden constitute the real condition of the place; while ascending through this scene of desolation to the long lines of bazaars, which cluster below the domineering fortress, and fill up the hollow pass in the ridge of hill, you are still surprised to find that you are not yet in Skódra. For these bazaars, by the oddest arrangement possible, are only tenanted by day; a busy scene throughout the forenoon, they are regularly closed an hour before sunset; every male inhabitant coming to his warehouse early in the morning, and returning as regularly to what is now really the town of Skódra (though it is sometimes called "The Gardens"), namely, a wide collection of villages and detached houses, scattered over the plain on the northern side of the castle-hill and bazaars, between them and the lake. The lake, stretching far and wide to the mountains of Montenegro, is not seen except by climbing high up the rock toward the castle.

On arriving in the piazza in the centre of the bazaars, I was told that Signor Bonatti (the English vice-consul to whom I had letters) resided at some distance: it might be a mile, or two, or four, said the by-standers, with happy vagueness, - the mercantile world of Skódra seemed unprepared to give a decided opinion.

However that might be, the odious little Soorudji of Tyrana instantly vowed he would go no further, and in spite of threats and entreaties became unmanageable. Unloading all the baggage in a rage, he threw it into the mud in the piazza, and decamped with the horses, swearing at all Christians with most emphatic zeal. All the Gheghes looking on, maintained a provoking composure.

To have sent to the Pasha in his castle would have been an operation of an hour's length, and after all of uncertain result: the Consul's abode was afar off, and so little seemed known of him that it was to be doubted if his succours would have availed anything: so, in this climax of discomfort - hard rain falling all the while - we had to wait until another horse was procured for the baggage; and with a very lame guide we left the bazaars, and descended to the suburban or "garden" part of Skódra, in the northern plain. A pretty chase ensued for the Consul's dwelling; for in this strange place your house, or your mosque, or your garden stands, independently of any other building, among walls and labyrinths of lanes intricate beyond belief. Much of this flat ground is afflicted by inundation - the communications across it being formed by very narrow raised causeways, crossing intervals of mud or water as the case may be; and a full hour was consumed in walking among these weary pavements without apparently being any nearer the object of our search. At last we arrived at a door at the end of a cul-de-sac lane, when the lame old man stopped and said: "*To σπιτι*[6] Ingliz Consul." But this was wholly an invention of his own, for no Consul lived there; and had not a friendly scarlet-cloaked Christian woman volunteered acting as guide, I cannot tell when the real house might have been found.

Signor Bonatti, a native of Corfu, and British vice-consul in the city of Skódra, is an active and lively little man, full of kind anxiety to do the agreeable to the few passers-by in these regions; but having a large family of nine or ten children, he is unable to exercise so much hospitality as he is known formerly to have done: the more the pity, for a more amiable set of people one could not be indebted to. He recommended me to a lodging in the village-city; and after a short stay with his family, thither I went. By sunset I was settled in the house of Signor Marco, a Venetian apothecary, whose substantial dwelling standing in a good cortile and garden, contains two or three large rooms. Here - possibly the last place in which rest will be accessible before I arrive at Ioánnina - I purpose staying three days before turning southward - Skódra being the furthest point of my Albanian wanderings; - even were not money becoming scarce, autumn advances, and I shall have scarcely time to reach Malta ere Christmas.

Chapter VII

Wanderings in the village-town of Skódra - Visit to the Pashá - The Roman Catholic Bishop - Pipes and coffee - Skódra merchants - Bridge over the Boyána - Wondrous picturesqueness of Skódra - Storm and rain - The Pasha's dinner - Endless repast, and odd varieties of custom - Pavement of Skódra - Costume of Scutarine bride - Hospitable family of Signor Bonatti - The merchant and his portrait - The apothecary's household - Disagreeable character of Skódra as a place of residence - Departure for the south - Bank of the Drino and arrival at the Capuchin Monastery of Aléssio - The angry monk - Rain, and delay in starting for Tyrana - Slow progress through the plains - Views of the Króia mountains - Moonlight and the forest - The khan and its night-scenes - Ill-omens - Forest scenery - Pouring rain and arrival at Tyrana once more - A better khan.

OCTOBER 3

Half the morning passed by in endeavours to find the lake - which, after all, I - who have no organ of locality - did not succeed in doing. So, after walking in a circle among lanes, houses, tombs, mosques, drains, bridges, and walled gardens, I returned to the apothecary's as wise as when I set out. Repairing to the Consul, and walking with him about the suburbs, I came to the conclusion that the most picturesque points of Skódra are to be found on the southern side of the ridge - or at least that whatever views were to be obtained in the north would occupy, from their remoteness, more time than I commanded, merely to select. To an artist who could remain here for a month, much noble material could be gained on the shores of the lake at the foot of the Albanian mountain-boundary to the

east; and greatly did I long to penetrate towards Podgorizza, and the land of the Montenegrin!

At three P.M. I set out with Signor Bonatti on a visit to the Pashá of Skódra, to whom Mr. Blunt of Saloniki has given me a letter; and after a visit to some of the merchants in the bazaars, we climb the steep castle-hill, whence the line of the lake and mountains are surpassingly lovely. The castle occupies the whole of the summit of the hill, and by its area, walls and numerous decaying forts within, betokens greater extent and power in by-gone days. The palace of the Pashá is a building with no pretensions to size or picturesqueness, nor is its interior otherwise than of the commonest kind. From the windows, however, the view is truly magnificent on all sides; northward, it sweeps across the village, the dotted plain, and wide blue lake to the jagged Montenegro or Tchernigore mountains; southward, it extends over the ruined town at the foot of the hill to the plains of the Drino; westward, along the windings of the Boyána to the Adriatic; and eastward, to the third part of this oddly arranged place - the busy bazaars.

Osman Pashá, the dignitary who at present governs the city of Skódra and its surrounding district, is a Bosniac by birth, and is said to be in great favour with the Porte from having, while in his present command, made some successful warfare against the Montenegrin, who are ever at feud with the Mohammedan Government. His Highness is short and fat, with an intelligent and amiable expression of countenance; and spite of his Oriental attitude as he squatted in his corner, a pale frock-coat and European-made trousers gave him little of the air of a Turk. Beside him sat an individual, whose closely-buttoned grey vest, clerical hat, gold chain and cross, proclaimed the Roman Catholic Bishop; this was Monsignore Topicka, the diocesan of Lissus, in which is included the district of Skódra. By means of the vice-consular dragoman, the conversation became animated. The Pashá was remarkably affable, and asked me to dine with him on the 5th. And then came pipes and coffee - pipes, pipes, sweetmeats - pipes, sherbet, and pipes; throughout which ceremony, discourse was extremely plentiful when compared with the usual run of Turkish visits.

They call this place the Siberia or exile of Turkey in Europe; and indeed it must be little less than banishment to those who have lived in Stamboul. The Pashá made several remarks, showing that he was by no means an ill-informed

man. He asked if Lord Cook (*chi girava il mondo*[1]) had left any children, and if so whether they also went *intorno l'universo?* Various anecdotes - some very facetious, at which His Highness laughed immoderately - were told by the Consul and Bishop; and on the whole the visit, though rather long, was a merry one. There was much talk also regarding reports of battles between the Cattarési and Montenegrini on the far side of the lake. After the departure of the Vescovo, I was invited to walk on the ramparts; and, said the Pashá, "You may note down all the state of the fortress, if you please: you may look at everything, for your Sovereign is a friend of ours." It would have been in vain to have said that I had no commission to report upon fortresses, or that I was totally incapable of so doing: any attempt to disabuse the august mind of so natural a conception would have had no other result than that of appearing to confirm it. After this I had hoped the visit was over, and was horrified to find that we returned to the divan, when fresh pipes and rose-water ensued, and pipes - pipes - like Banquo's posterity, till I was utterly weary; by the time we had taken leave and re-passed the galleries full of retainers, the sun had set, and it was dark ere we reached the plain, where we fell in with long lines of Scutarini leaving the bazaars and returning home, each with his empty sack.

OCTOBER 4th

All day the weather looks threatening, but the clouds add a charm of magnificence to the dark blue mountains surrounding the plain of Skódra. The Skódra merchants cross it in troops at early morn on their way to the bazaars; many of these are men of considerable property, and trade largely to the coasts of Italy, especially Venice, the dialect of which place nearly all of them speak as well as Greek, Sclavonic, Albanian and Turkish. They live in a homely style in their own town, and never adopt the fustianelle or kilt, being clad in dark loose capote-vests, with blue or black linen trousers like those of Corfiotes, or the population of the Greek isles; below these are scrupulously white stockings - changed daily, wonderful to say - but the Scutarini are totally different in appearance, habits and manners, to the southern Albanians. The women have their faces covered, so that when out of doors you cannot distinguish Christians from Mohammedans, and

one and all dress in scarlet cloaks with square hoods. But it is in Venice or Cáttaro that the Skódra merchant unfolds himself, as it were, for at home his fear of exciting the cupidity of the Turks prevents any such display. Abroad he exhibits all the blazing richness of full Gheghe costume; while it is at home that the Skódra lady indulges in a magnificence of costume almost beyond belief. In domestic arrangements the Latin Christians of Skódra have much in common with their Mohammedan rulers, under whose power they have so long dwelt as to adopt most of their practices - such, for instance, as the marriages being fixed by the parents, the bride and bridegroom never meeting till she is brought to her betrothed's house on the day of the marriage. As in Turkey, also, the females of each family are almost close prisoners, excepting when masked, and in no case hold communion with the males of any other household.

While sketching about the village, I was plentifully pelted by little Gheghe boys, until the arrival of a Kawás from the Pashá secured me from annoyance. The Skódra Albanians have the reputation of excessive ferocity and turbulence; and to say truth, their countenances do not belie the report. The Latin Christian populace, on the contrary, seem as timid as civil. By the aid of a tractable Kawás I drew throughout the whole day unremittingly from various points below the south side of the castle, whence the view was very imposing, and near a wondrous old bridge across the Boyána, constructed of pointed arches of irregular width, and having somewhat the effect of the columns in a Gothic cathedral, suddenly resolved on spanning the stream, some with little steps, some with long. Everywhere the various groups of buffalo cars and peasants, or of scarlet-coated Gheghes sitting on the ground, were full of interest; but the thin population of a place so extensive as Skódra is very apparent, and it was a great contrast to the lively and thriving Monastir

Perhaps the grandest of all the views of Skódra was from the rock eastward of the bazaars; the castle, the mountains above - the ruined town below - the river winding beneath its bridges into far distance, form one of the finest of pictures. As the sun was sinking low, its rays, clouded through the day, lit up the northern side of the landscape brilliantly, and from the steep castle hill - my last halt - nothing could have been more splendid than the rich foliage and glittering dwellings on the one side and the dark ranges of deep blue and violet hills against

the bright sky. But there was far to go, and it was time to et out homeward over the ankle-twisting paved causeways to Skódra.

OCTOBER 5th

It rained hard all night and at 10 A.M. (when we should have been going up to the Pashá's dinner), torrents descended, with violent thunder and hail. Towards eleven it let up a little, and as the invitations to three-tailed Pashás are not to be neglected, I set off to the vice-consul's, taking Giorgio with a supply of shoes, linen, and cloth clothes as a remedy against the wetting there was small change of escaping. Whereupon, fresh storms commencing, Signor Bonetti, myself, the dragoman Pazzini and a Kawás all rushed desperately through the falling torrents, by odious paved paths to the castle, arriving there in a perfect deluge. Having changed our dress, the time till dinner was served (about noon) passed in continual repetitions of sherbet, sweetmeats, pipes, and coffee, the Pashá being always very lively and merry.

Osmán Pashá affects European manners, and (to my great relief) we all sat on chairs round a table; a Bímbashi (or captain on guard) appearing about as much at ease in his new position as I had done when in that of the natives. As for the legion dinner, it is not to be described. I counted up thirty-seven dishes, served, as it the custom in Turkey, one upon one in succession, and then I grew tired of reckoning (supposing that perhaps the feast was going on all day) though I think there were twelve or fourteen more. But nothing was so surprising as the strange jumble of irrelevant food offered: lamb, honey, fish, fruit; baked, boiled, stewed, fried; vegetable, animal; fresh, salt, pickled; solid; oil, pepper; fluid; sweet, sour; hot, cold - in strange variety, though the ingredients were often very good. Nor was there an order in the course according to European notions - the richest pastry came immediately after dressed fish and was succeeded by beef, honey and cakes; pears and peaches; crabs, ham, boiled mutton, chocolate cakes, garlic, and fowl; cheese, rice, soup, strawberries, salmon-trout, and cauliflower - it was the very chaos of a dinner! Of those who did justice to the repast, I was not one; and fortunately it is not considered necessary, by the rules of Turkish etiquette, to do more than taste each dish; and although the Pasha twice or thrice helped me

himself, it is sufficient to eat the smallest atom, when the attendant servant removes your plate. As for drink, there were marsala, sherry, hock, champagne, Bass's pale ale, bottled porter, rakhi, and brandy, - a large show of liquor in a Mohammedan house; nor did the faithful seem to refrain particularly from any fluid; but there was no unbecoming excess, and as is remarkably the case with Turkish manners, quiet and order were observable throughout the festivity. Only the Bímbashi, a heavy, dull man, seemed marked out for practical jokes, and they made him take an amazing mixture of porter and champagne, assuring him it was a species of Frank soup, which he seemed to like little enough. As the entertainment draws to a close, it is polite to express your sense of the host's hospitality by intimating a sense of repletion, and by pointing to your throat, the utter impossibility of eating any more; and perhaps the last delicate act of complimentary acknowledgment, which it is not easy to describe otherwise than as a series of remarkable choral ventriloquism, was the queerest and most alarming trait of the whole fete. On the whole, there was much to amuse, though I should not like to dine with Pashás often. Osmán Pashá surprised me by his questions concerning Ireland, Scotland, the game laws, &c., and appeared to have read and understood a good deal about European nations. After dinner, I amused him greatly by drawing one or two of his attendants, and should have obtained the portraits of more, had not the Mufti, or Mollah, or Cadi, in an orthodox green and white turban, been suddenly announced, a visit which put a stop to my unholy pastime. At six we came away. How disagreeable the raised pavement of Skódra is, none but those who have slipped off it into deep mud and water every five minutes can tell.

OCTOBER 6th

An April day of sun and showers. Early I went to the Consul's, to make a drawing of a Gheghe chief, Abdulláh Bey, who was magnificently attired in a full suit of scarlet and gold; and afterwards one of Calliope Bonatti, the Consul's second daughter, a very pretty girl, who good-naturedly sat to me in a bridal Scutarine dress, which Madame Bonatti had most obligingly borrowed. No toilet can be more splendid: purple silk and velvet, elaborately embroidered in gold and silver,

form the outer garment, the patterns worked by hand with the greatest taste; two or three undervests covered with embroidery, full purple trousers, innumerable chains of gold and silver coins and medals, with a long white veil, complete the costume, excepting several coloured silk handkerchiefs, which are sewn inside the outer vest, and have a tawdry and ill-arranged look, when compared with the rest of the dress. This gay attire is only worn on great fete days, or on marked occasions, such as marriages and christenings.

The Consul and his wife are in great distress about the ways and manners of Skodra, as to face-hiding, for, since Christian as well as Mohammedan women conceal their faces, no woman can stir out unmasked without receiving some insult, as indeed to appear barefaced marks total loss of character. Consequently, Mesdemoiselles Bonatti do not like to go out under such risk of reproach, while, on the other hand, their mother will not allow them to wear the yashmack; for she says: "Are you not Christians? And why should you be ashamed of showing your face?"

Their being one of the few families here professing the Greek form of Christianity, probably makes this objection stronger; and the result of this difference of opinion is, that the young ladies never leave the house at all, from one year's end to another. Bitter complaints of Skódra as a residence may be heard on all sides. The clashing of various races, religions, and castes, must render it an odious abode; while alarms and feuds, risk of property and life, hatred and petty warfare, prevail among all.

At one P.M. dinner was served at the vice-consular table, the only guest being Antonio Súmma the merchant, a very good specimen of his order. Of the host and hostess it would be difficult to speak too favourably. The eldest daughter alone is wedded to Skódra fashions; and the being obliged to appear in the company of men was evidently a great pain to the unfortunate girl, who with difficulty refrained from crying if looked at or spoken to: so strong is the force of habit.

At four we adjourned to the house of Antonio Súmma - a substantial building in a large courtyard, all the appurtenances about which indicated opulence and comfort. The usual compliments of pipes, coffee, and lemonade were gone through, and I made a drawing of the worthy merchant in his Skódra

costume; but on his younger brother coming in (both were men of about forty years of age), and requesting to be sketched also, I, for want of paper, was obliged to make a small though accurate portrait of him on the same page as that on which I had drawn his eldest brother, on a larger scale. "O, *santo cielo!*" said the younger, in a fury of indignation when he saw the drawing, "why have you done this? It is true I am the youngest, but I am not smaller than my brother, and why should you make me so diminutive? What right have you thus to remind me of my inferior position? Why do you come into our house to act so insultingly?"

I was so amazed by this afflicting view of my innocent mistake, that I could hardly apologise, when the elder brother took up the tale. "I, too," said he, "am vexed and hurt, O, Signore! I thought you meant well; but if you think that you win my esteem by a compliment paid me at the expense of the affection of my brother, you are greatly mistaken." What could I say? Was there ever such a lesson to unthinking artists in foreign lands? I had made two enemies by one sketch, and was obliged to take a formal addio, leaving the injured brothers bowing me out with looks of thunder. A settling regarding horses and luggage, and the procuring a fresh supply of money in bills, on Avlona and Ioánnina, at the hospitable Casa Bonatti, concluded my fourth and last day in Skódra.

OCTOBER 7th

The apothecary's house has been no bad resting-place in the Illyrian metropolis. It hath very few disagreeables. A large dog sits and howls at the window during the night, and a good many mice and rats course about its rooms - but that is all. Don Marco is a mysterious little man; and his household consists of one old and three young women, of whom two are very pretty, but timid to the last degree of Skódra bashfulness - catching up towels, or saucepans, or whatever comes to hand if they are unfortunate enough to meet a man when their face is uncovered. The apothecary tells Giorgio that he came there from Venice to try his fortunes, and found this widow and family, who let him the house: "And," said he, "while I hesitate as to which of the three daughters I shall marry, time passes, and we all grow old!"

All things being in readiness for starting, I went to take leave of the vice-consular family - the members of which I left with regret, almost the only feeling of the kind I had experienced in a month's travel. How different are these to the days of Abruzzo and Calabria! Poor Signora Bonatti with her ten children! There is something very sad in such isolation as Greek Christians are here doomed to live in. And considering the hopeless character of Skódra, "*vendette, nasconderie, sospetti, incendie,*"[2] - the extremes of revolutionary and despotic Turk against Christian, Latin opposed to Greek. No place seems more fully fraught with the evils of life. Addio, Skódra; and here terminates the northern extent of my Albanian journey - though much novelty yet is in store in the south. I looked my last on the Illyrian city as we came round the eastern side of the castle ridge to avoid the bazaars, and were soon on the flat ground beyond the Boyána.

The day was bright; and the horses being good, we soon reached the khan I had halted at on the 2nd - the roads being far better than was to have been expected after the heavy rains. Grand in form and colour are the ranges of hills east of the Drino, and beautiful are the huge white-stemmed abele trees, their branches loaded with wild vine festooning into the water. At half-past two we reached the river, and crossed it in a crowded ferry-boat. Large parties of Tóskidhe Albanians, known by their white caps and grey capotes, were waiting in many a picturesque group to pass the broad stream, for there is some great bazaar at Skódra tomorrow, and a world of travelling merchants are hastening to it.

After an hour of quick trotting, below the silver-armed abeles by the Latin villages with the hairy lean pigs and scrubby yellow goats, and beyond these, after some slow pacing over ground inundated by the rains, we entered the melancholy Alessio at half-past five. Small time, alas! was there for sketching, since I had still to recross the Drino, a feat soon accomplished by the aid of the Soorudji (a good-natured fellow pleasantly contrasted with that wild ouran-outang who guided me from Tyrana), but it was nearly dark ere I arrived at Padre Pietro's convent, and with a desperate energy I outlined the proportions of the hills as they loomed out from the grey sky, hoping that a bright morning would console me for this second failure in my attempt to sketch Alessio. I found the friar more energetic than ever in abuse of his Albanian flock, "*Maledetti tutti dal cielo,*" being his mildest expression concerning them; the fact of a favourite servant having been that

morning found murdered at a short distance from the convent, being no slight excuse for his anger. The tenantless cells, and large gloomy refectory of the monastery, joined to the unceasing vituperation of its sole occupant, did not add liveliness to the evening. My own stores set forth a very tolerable supper, and the monk's acid wine contributed to vary the repast. In the first part of the evening the poor man was diffuse about his own situation. "*Vita d'inferno,*" &c.; and with that of his co-mates in exile, "*Sparsi siamo noi altri frati della religione vera. Sparsi quà e là ne' boschi come majali spaventati.*"[3] This subject exhausted, he fell upon Pope Pio IX, whose inaptitude to govern, he predicted, was about to bring great miseries on Rome and the Church; then he lashed out against the Turchi of the district, attributing vices by wholesale to their community in a comfortless category of bitter accusation; nor did the Christians escape. A black list of crimes, falsehood, unbelief, immorality of all kinds covered them with blots, and he summed up his maledictions by saying: "*In fine, sono tutti porchi pregiati del gran Diavolone nero.*" Poor Signor Bonatti came in for his share, too, though poverty seemed to be the only evil condition to be attributed to him; and a slight seasoning of flattery to, "*Quella nazione tanta forte che amabile, quel gran popol d'Inghilterra,*" filled up his eloquent discourse. After supper, Padre Pietro insisted on giving up his room to me, a favour I firmly resisted as long as it was possible, for I should greatly have preferred the bare corridors to a closed dormitory filled with books and furniture; but the monk was inexorable, so I retired for the night to wrap myself in my plaid, and endeavoured to think lightly of the gnats, which are very numerous from the vicinity of the river. In the chamber hung engravings of the Piazza del Popolo and San Pietro. How clearly and sharply in this remote place did they bring back the memory of years passed in Rome!

OCTOBER 8th

With difficulty I contrived to obtain two views before it began to rain; and by the time horses and luggage were ferried over the river, a blackening thunderstorm was fast rising in hard edged masses of cloud from all the plains below Króia, soon to burst over the hill of Aléssio. To proceed while it lasted was impossible, so I sat in the empty, dark bazaars; it was Sunday, and no Christians were at their shops,

though the few passing peasants were worth observation, the female costume covered with fringes, tassels, and embroidery, and the men wearing a capote sort of short spencer, the hood of which, square and oddly fashioned, protects the head against rain, and looks like a tuft or crest of some strange black bird. Such deluges fell, that the rattling roofs seemed about to give way; but, as the sky gave token of clearing, we thought it better, towards noon, to remain for the midday meal before starting, and accordingly I adjourned to Signor Giuseppe's house once more, where the old Skódrino still lingered on his way to Skódra.

At one we started, as I was resolved to make some progress, if possible, seeing that the roadside khan below Króia cannot be a worse abode than this, and one is further out of the low country, which may be inundated if the bad weather lasts; but, though the soft sirocco air threatens no distant change, all is bright and clear for the present. Soon we entered the briery copse, with its tall, creeper-hung trees; the pathway which led through its tangled mazes - never very obvious - was now, from the heavy rains, which had beaten down the branches, and half obliterated the narrow, winding track, well nigh impassable. At one moment the long drooping boughs, and drapery-like clematis, seemed to defy all progress; at the next, a tract of mud, two feet deep, threatened to become a stable for the night to our luckless steeds. Many were my misgivings as to the chance of ultimately passing through this hideous swamp; but thanks to patience and our very good horses, we crossed it after two hours' hard work, and were glad to rest for a short space by the road-side khan nearest Aléssio, and then to proceed by less disreputable roads to the Máthis, which was much swollen, and barely fordable.

The Króia range of mountains were magnificently indistinct in a watery haze; and as the sun sunk, a thousand tints were thrown over all the wide landscape. After this, the beautiful oak wood was reached, and the green oases, with the scattered flocks, and the slippery causeway or selciata, winding beneath the fresh, tall trees seemed a perfect paradise, after the frightful copse-wilderness on the plain of Aléssio. About five we arrived at the first khan in the forest; but as there was a moon, or three-quarters of a moon, it was judged feasible to press on to the khan at which we lunched on the 1st, making a better division of distance between Aléssio and Tyrana; so on we went. As the moonlight gained strength, nothing could exceed the beauty of those silent groves; where the giant

aerial stems of abeles, with their white branches loaded with wild vine, grouped together with the majestic oak, and spreading beech - it is long since I have enjoyed so exquisite a forest scene by moonlight. Yet some drawbacks were notable by a short-sighted man; the projecting boughs, against which I came often with great force, had more than once well nigh done a mischief to head and eyes. By seven P.M., furious barking proclaimed the neighbourhood of the "roast fowl khan," and there we shortly arrived. The raised part of it was already occupied by five very unclean-looking Albanians, but one side of the fire was at liberty, and soon swept and arranged for me; and Giorgio, ere long, prepared tea on the little squat stool-table, after which sleep quickly followed; not, however, before I had leisure to meditate on the fact, that I was now actually in the very wildest phase of Albanian life.

Those five wild creatures, blowing the fire, are a scene for a tale of the days of past centuries. When they have sipped their coffee they roll themselves up in capotes, and stretching out their feet to the embers, lie motionless till an hour before daybreak. The large khan is now silent (for even the vile little fussy chickens cease to scrabble about in the dead of night), and only the champing of the horses in the farthest part of this great stable-chamber is heard; the flickering light falls on these outstretched sleepers, and makes a series of wonderful pictures never to be forgotten, though I fear, also, never to be well imitated by the pencil. That I do not speak the language, and that I had not previously studied figure-drawing, are my two great regrets in Albania.

OCTOBER 9th

During the night, a shrill and wild cry echoes through the forest several times, and the barking of distant dogs follows it. This proceeds from shepherds, who perceive the vicinity of a wolf by some movement of the flock, and thereupon alarm their watch-dogs. With morning comes the reflection that I must go to Tyrana tonight, and no further - perhaps even to that very foulest of pig-styes, with the circulating dervish seen through the hole in the wall.

The day begins badly, according to Giorgio's way of regarding omens; for, firstly, as he has made an admirable basin of coffee, with toast, a perverse hen,

either owing to the infirmity of a near sight, or a spasmodic presentiment that she should one day become broth in a similar piece of earthenware, suddenly came down from the rafters above with a great shriek and flutter into the well-filled breakfast platter, upsetting coffee and toast together into the fire in her efforts at self-extrication. Giorgio meekly prepared to make it all over again; but, said he, a day so commenced must have other ill-luck in it before sunset. Secondly (and consequently), the horses being all in starting trim, when an obese buffalo foolishly persisted in walking all among them into the centre of the khan, and when the alarmed beasts put themselves, us, and the luggage in jeopardy, amid a fearful confusion of flying fowls and barking dogs, then Giorgio saw the spell of ill-luck at work, and foreboded more evil ere we reached Tyrana. Thirdly, on starting, down came the rain, and for a long time we could only advance at the very slowest rate through the thick forest, athwart pendant vines and dense foliage, beaten down across the narrow pathways.

The day, however, cleared, and we soon entered beautiful undulating wood scenes, where paintings of Hobbima or Swanveldt start to life at every moment; such were the tall and spreading, or light fairy-like oaks, with misty grey distances of hanging foliage on the green hills below Króia, seen through opening boughs, while below were red winding paths, amid a carpeting of dear old English fern: most lovely were these scenes. At half-past eight the khan of Presa was passed on the right, and after two and a half more hours of riding over alternate wooded undulations or flat ground, we arrived at the khan where, on September 29th, I had drawn majestic Króia soaring high over the plain on the opposite mountain side. Poor little Alí Bey! perhaps he is yet sitting in his corner, meditating on tik-a-tok, squish-squash, A, B, C, &c. Here I halted to dine and ruminate on cold veal - wasps - and clouds; the first I eat, the second I killed as fast as may be; the third grew hideously black, and threatened the most violent of storms.

At two, we were again on the road; the curtain-clouds above the hills gradually lost their outline, and draw a gradual grey veil over all nature, and torrents soon fall. Lucky have I been to get drawings of Króia before this wet season's commencement! Few intervals of light, or of cessation of rain, ensued; and long before Tyrana was reached, I was drenched thoroughly; it was some consolation that we had really good horses, and an active, good-natured Soorudji,

so that we gallopped on at a great rate. Luckily, too, a better khan was found on this, than at our last visit to Tyrana; since only a part of its broken roof admitted the rain, and the walls were tolerably sound. Clearly it is my best plan to make for the south without delay, for the great rivers and swampy land of these Gheghe regions will shortly become totally impassable, and who can tell how long one may be detained among them? Had I remained at Aléssio, this afternoon's rain must have rendered the Máthis, and the marshy copse, a bar to all further progress for the present.

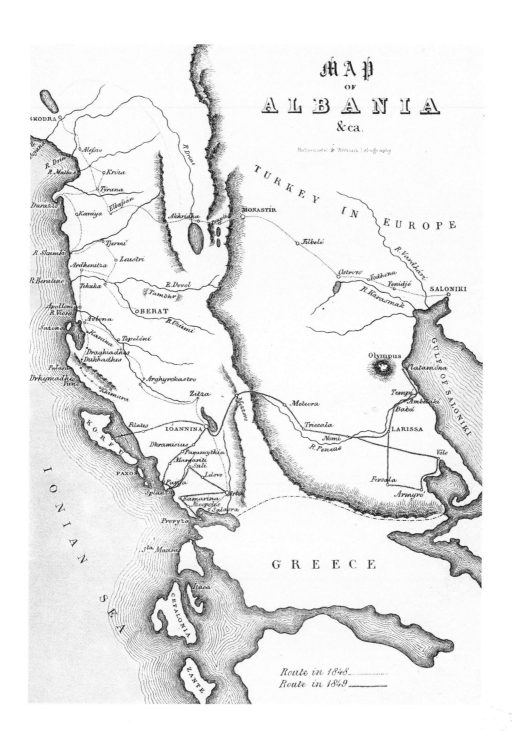

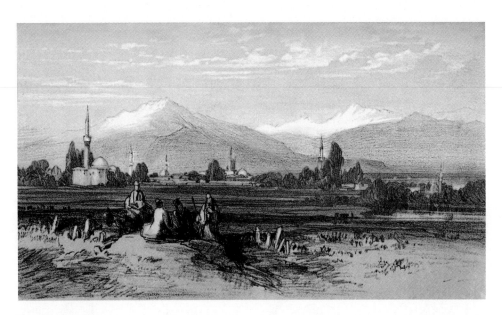

Yenidje

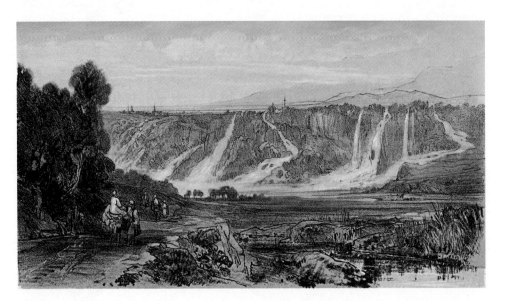

Vodhena

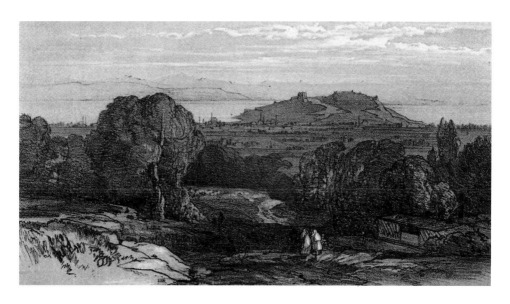

Akhrida

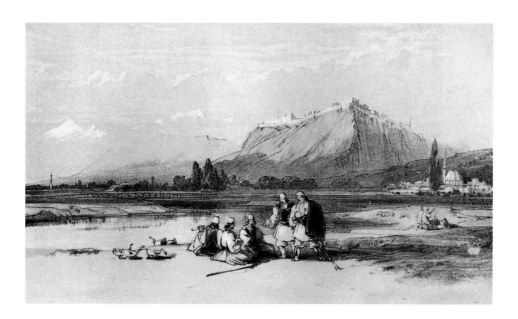

Skodra

Kroja

Tyrana

Durázzo

Berat

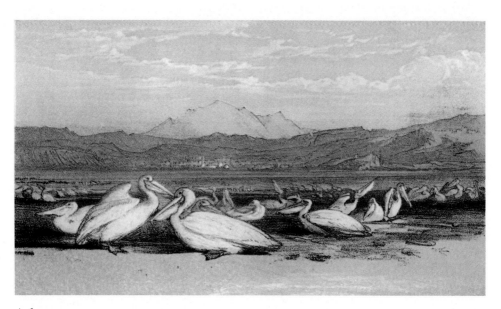

Avlona

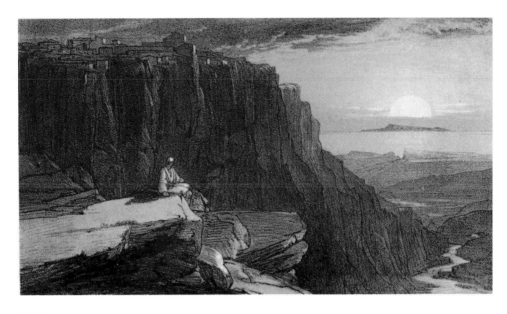

Khimara

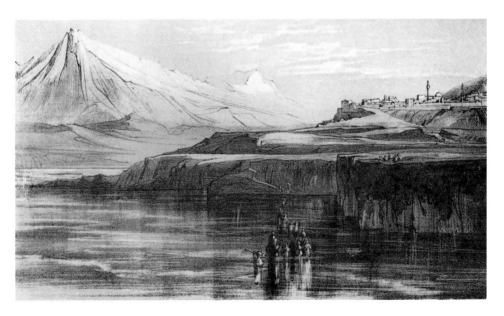

Tepeleni

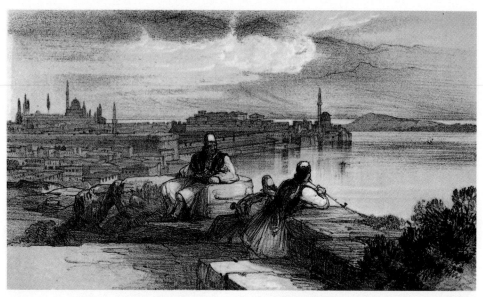

Ioánnina

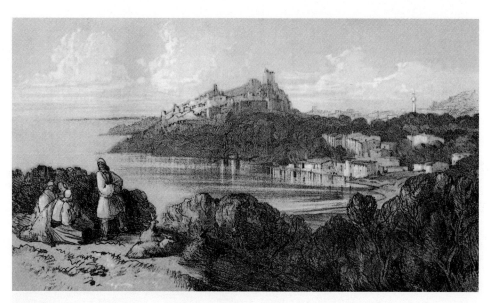

Parga

Suli

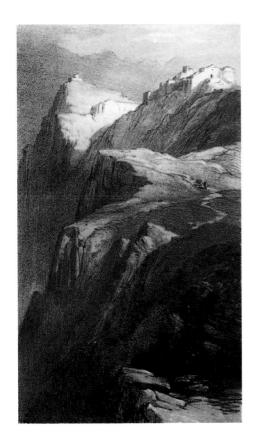

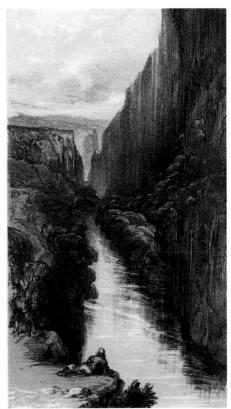

Tempe

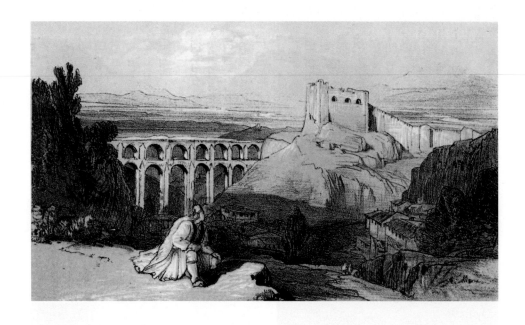

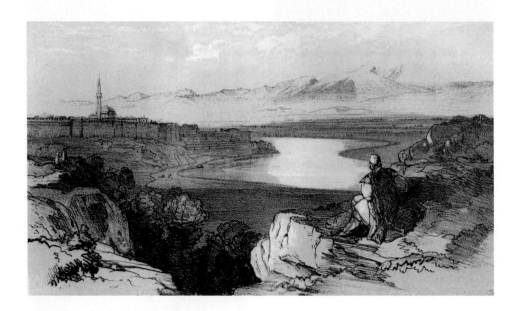

Two views of Arghyro Kastro

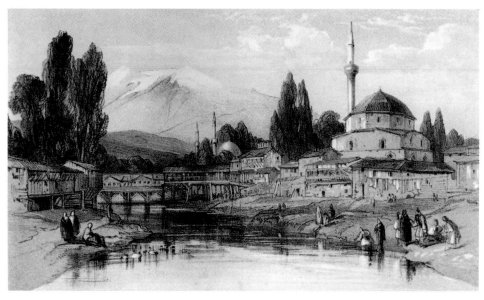

Monastir

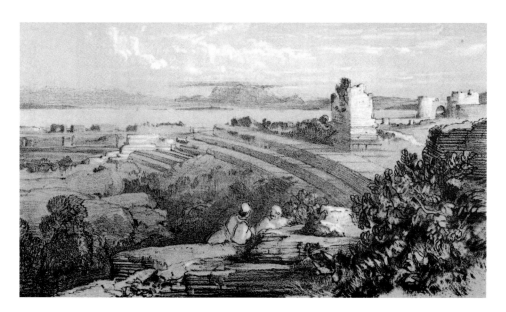

Nicopolis

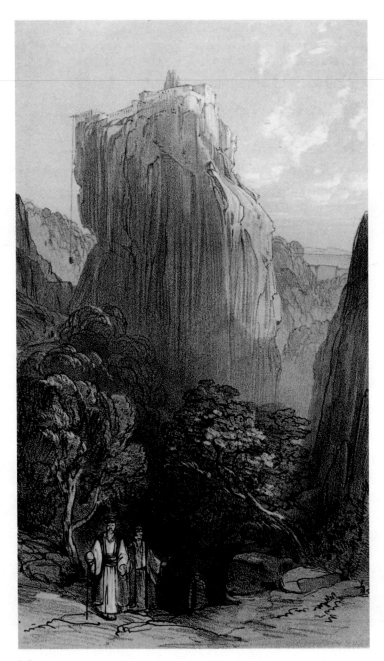

Meteora

Chapter VIII

OCTOBER 10th

It is four A.M., and the Muezzins' chant, so plaintively beautiful in these wild North Albanian places, awakes me. There are other symptoms too of approaching day peculiar to these places; none more so than the incessant tremulous cackle of numberless geese. At seven, spite of the threatening looks of cloud, we prepare for a start; the smallness of this smoky den - for den is the mildest term that can be applied to even this, the best khan here - prevents anything being dried, and one may just as well be making progress in wet clothes as sitting still in them. Yet it is

nine o'clock before horses come, by reason of the postmaster being in the bath as before, - this delay is the more undesirable, inasmuch as that there is every prospect of fresh storms ere we can finish our day's journey. Durázzo is the next place in my route, as I plan to return southward by the coast, striking inward only to Berát, whence to Avlóna, and thence, if it be possible, to Acroceraunia - the great point of novelty in the tour. Shortly after leaving Tyrana, we overtook and joined company with a Mohammedan Albanian of that town. He calls it but eight hours or less to Durázzo, though you pay post for nine. This Osmán, who speaks Italian, is diffuse on his domestic circumstances - he talks of how much substance he had collected during twelve years' service with a Trieste merchant - of what property speculation had since procured him - buffaloes, terre, cavalle, and two wives; and hints that one grows old, and that he should shortly get a third. After two hours' riding we crossed a wide river by a fine stone bridge, built, according to our Albanian companion, by a Trieste merchant of Tyrana, and shortly afterwards we rode into the river itself, the bed of which occupies all the narrow valley down, which we proceeded, the broad but shallow stream winding from side to side, so that before we arrived at Dirócchio, we had passed it eight times - always an unpleasant task. At Dirócchio, a scattered village among olive grounds, the banks advance, and the river runs between high cliffs; in another half-hour the valley widens out towards the sea, into which, as we rose over heights commanding a broad view of the coast, the silver stream can be traced by its white torrent track. There was now a high and barren range of hills to cross, along the sides of which, deeply indented into hollows, runs a pathway so narrow, that had it rained, the slippery clay soil would have prevented the surest footed beast from making progress; for in parts, eight inches of slanting earth were all the foot had to depend on; and I looked down the deep-shelving abyss with a conviction that I might be better acquainted with it before long, the rather, that towards the summit the horses' nerves were miserably troubled by the ferocious attacks of some fourteen or fifteen dogs, who saw us from afar off, and expended a most unnecessary amount of labour and breath in crossing a deep ravine before they reached us. When we arrived at length at the highest point, the view was very beautiful, with a wide expanse of blue sea stretching southward to the plains of Kaváya, and northward to the long slender promontory of Durázzo,[1] on the point

of which stands the ancient castle of that once important city; and doubtless there was much more of extended distance now hidden by heavy cloud and mist. A rapid descent brought us to the shore; and a gallop on the smooth sand was no bad contrast to the tiresome hill-paths.

By four (a seven hours' journey after all) we reached a large khan standing in a suburban street outside the walls. The town itself has now shrunk to the dimensions of a single street running to the end of the promontory, and overlooked by the massive grey towers of the castle, which are built on considerably higher ground. Towards these I speedily set out to procure a good view of Dyracchium. The castle is a building apparently Norman, though much patched and repaired; its fortifications extend down the hill-side to the water's edge, where they join the town-walls; and in various parts of them I observed armorial shields having owls carved on them in basso-rilievo. The combinations of scenery around are very elegant and delightful, and extremely unlike any Albanian view I had yet seen. At this point I thought I was safe from intruders, but all the children of the town soon espied me, and climbed up to my retreat, so that I was surrounded by a host of red-capped, red-robed urchins, all calling out, "*Capitagno! O capitagno! Para! para!*" I adopted one as a guide and safeguard against the rest of his brethren, promising *paras*[2] on returning to the khan; whereon, armed with a little brief authority, he dealt promiscuous blows among his brethren, and kept them at a respectful distance. My sketch finished, I went down to the town, and entering the gates, walked through the single street of modern Durázzo which occupies nearly the whole of the narrow point of land projecting into the sea, and ending in a mole. The houses here are far neater than in the interior of Ghegheria; and although the line of bazaars was as usual partly covered over, it was with rich pergolata of vine-trellis, not with old mats - a substitute which gave an Italian air to the scene. The tradespeople, too, seem to speak Italian - whether from commerce with the opposite coast, or from old links of former Venetian existence, I know not.

As I walked down the bazaars nearly everybody spoke to me - an odd contrast to the savage indifference of Elbassán or Tyrana - and mostly with complete familiarity, as if I had been an old acquaintance. "Ah, *Signor Capitano!* (for the knowledge of foreign parts being confined at Durázzo to the medium of captains

- omne ignotum pro capitano). *Come stai, Capitano? Donde vieni, caro Capitano mio? onde sei? dove vai? Comprate qualche cosa, &c.*" At the end of the bazaar-street is a fortress, through which a quay is reached, where a Turkish garrison were smoking. The Bimbashi or Captain desired to interrogate me, merely looking at my *teskere* as a matter of form, and asking sundry news about the "*malattia*" of Saloniki - whether it was coming that way, &c. - the first I had heard of it since we left Yenidjé. The familiar people of Durázzo nevertheless inveigled me into purchasing some of their wares before I quitted the town, of which an oke (three pounds) of walnuts and apples, though costing one penny only, was not a sample of excellence.

Returning to my cell in the khan at dusk, to supper, I was greatly charmed by the singing of a man in the street (according to Giorgio, he was a Sclavonian of Montenegro), who appeared to enthral the whole neighbourhood by his tuneful voice, and I regretted not being able to take down, otherwise than very imperfectly, the wild and strikingly beautiful airs he sung. His audience seemed to the highest degree enthusiastic, and frequently interrupted him with applause, forcing him to repeat many verses. But there is a musical atmosphere in Durázzo, and I hear many melodious hummings, of which most of Albania seems guiltless.

OCTOBER 11th

Rain again! - but it subsides into drizzle, and meanwhile I prowl about Durázzo. It possesses singularly little of artistic interest, considering its former extent and grandeur, though many fine pictures might still be made in its neighbourhood, the castle being always to be introduced as the principal feature. From eight to ten, between showers, I jotted down scraps of the town and bay, but clouds obscure the line of hills towards Acroceraunia, which ought to be seen from this place, and the damp prevents steady drawing, besides which, the Gheghes came and bullied me (as it was not worth while asking for a Kawás), by shaking my sketch-book in paroxysms of orthodox piety, by secreting pencils, and asking for paper. So I gave up Dyracchium, and retreated to the khan through groups of irascible female buffaloes, which creaked and grunted as I passed, following me with their porcelain-white eyes, as if I intended to embezzle their calves - strange

little beasts, motionless except the twinkle of their ears, and lying crouched together like bits of hairy Indian rubber on the grass.

At twelve, early dinner being over, it is time to start for Kaváya, but from this place there is no more posting, and henceforth throughout Albania, the journeys must be on horses hired from place to place, and adieu to Soorudjis and leather saddles. In the present instance the horses are good, but there are only pack, or wooden saddles to be procured (I, for one, think them far more comfortable than your Turkish penance), rope stirrups and bridles made of string. The route lay at first along the shore, with a green and troubled sea breaking on the sounding sands, but in two hours we left the coast and struck inland, and after crossing some low hills, the mosques of Kaváya were already in sight standing in the flattest and widest of plains. The aspect of this part of Albania is very striking; the immense plains which reach in an almost unbroken level from Durázzo to Avlóna southward, and extending to the foot of Tomóhr, and the hills of Elbassán towards the east, the sea being their western limit, may, indeed, rather be called one vast meadow.[3] Their appearance from the neighbourhood of Kaváya - perfectly green and dotted with numberless herds and flocks - is as novel as beautiful, while northward the long promontory of Durázzo resembles an island on the water's edge.

Kaváya is the most southern town of the Gheghes on the coast, and the entrance to it by a long dirty street was not prepossessing, or prophetic of a comfortable dwelling; there were two or three more than ordinarily picturesque mosques, and long bazaars matted and roofed as usual to the jeopardy of the heads of the incautious. The khan stood beyond the town, and in our way to it, I met the Governor with a suite of some twenty guards, taking that minute portion of exercise which these people call their afternoon walk. Remotely considered, the khan was not a bad khan, but on a near inspection, it proved to be a negative abode, and quite out of the question as a lodging for the night, for there were no walls to the rooms, no ceiling, no floors, no roofs, no windows, no anything, so that I was in despair as to where to go, when a Greek Papas,[4] who had followed us, came up, and in good Italian offered me his house, which I gladly accepted, and after a tour of half the town, we arrived at a galleried picturesque place in a courtyard thronged with geese, and incumbered with

barrels. "*Camera vostra*," said the priest, showing me into a large and handsome room occupying one wing of the upper floor of the building, and I, with the utmost innocence, supposing that this offer was all hospitality such as one may find in dear old Abruzzi or Calabria, made fifty apologies and agreeable speeches to the reverend man, till I accidentally caught sight of Giorgio's knocker-like visage writhing itself into amazing contortions in the background, by way of expressing that I was quite wrong, and should have to pay full dearly for my place of refuge. So I settled myself for the night with Papa Andréa, the Ecónomos of Kaváya, taking occasion to sketch his house between falling showers - for there seems no chance of settled weather; and how Berát is to be reached, if these storms last, I know not. Meanwhile, at eight or nine o'clock, supper is brought in, composed of various dishes of fish, salad, beans, &c.; the Ecónomos (who resembles the statue of Moses in S. Pietro de' Vincolis - I mean as to his length of beard), with his son and two grandsons, continually waiting on me much more obsequiously than I could wish. Lastly, a bed and sheets are brought in by the clergyman and his descendants, but though very picturesque and antique, there were many objections to availing myself of them in preference to my own.

OCTOBER 12th

The morning is brilliant, and I make early use of it, taking an armed Kawás as well as the priest's son, to keep off intruders. Close above Kaváya there is a rising ground, whence the view is delightful, and full of rural quiet; it consists of large olive trees spreading over paths and broken banks; of lanes, mosques, and a high clock-tower; Gheghe figures, bright in black, red and white; burying grounds with sparkling tombs, garden trees anon, tower above dark red roofs and tall white chimneys; waves, of blue-green groves of olive; and then vast flat meadows stretch to the sea, with "endless flocks and herds," while a line of pale low hills to the south-west, and the blue Adriatic with Durázzo on its promontory melts tenderly into the horizon.

At half-past eight I went with Giorgio to Achmet Bey, the Governor, whose palace, though highly picturesque, is inferior to Alí Bey's of Króia. The great man sat in his corner, in a large ancient square room, gilded and carved all over so that

it resembled the inside of some gigantic toy. Blue-vested and furred Muftis, with some red and black Gheghes, composed groups of wondrous colour, and the Governor himself was all politeness. Among other matters, he wished me to see a suprisingly excellent map of London and Frangistan, in the finding of which there was much delay, and great fuss in presenting it for my inspection, Lo! it was a chart of the Japanese Seas, and a map of Java, published in Holland a century back! "*Pecche?*" said the Bey, "Is it good? Is London like?" After this morning call, I drew in the town, but with great difficulty, owing to the press of people, besides the vicinity of odoriferous slaughter-houses; for your only points for sketching in these places are sure, by infallible rules of destiny, to be close to some horror. There is a very curious burying-ground in the centre of Kaváya surrounded by numerous columns, apparently antique and mostly wanting their capitals; but I could learn nothing of whence they came (possibly from old Apollónia, or Dyracchium). While sketching this, there was a hum and hush among the crowd, "*Gynaike, gynaike!*[5]" said some of them to me, and all retired to the side of the street, allowing room for some twenty ghost-like females to pass, shrouded in dark *feringhis* with white head-wrappers. It seemed an etiquette with the world of Kaváya to look another way while the fair procession was near us.

The patriarchal family of the Ecónomos had prepared an unnecessarily sumptuous repast against my return; but the horses which his reverence had procured for us were not in harmony; all four were in evil condition, yet no others were to be had. We started at noon. Berát I cannot hope to reach tonight, but Leustri,[6] six hours hence, is to be aimed at, and the weather seems to favour the possibility.

The great meadow-plains of Kaváya, bounded by low down-like hills, clothed with growth of olive trees, were most pleasant to look on; and in consequence of the baggage horse falling, by which all the *roba* was disarranged, one had the more time to contemplate the oxen and buffaloes without number, and the sheep and geese that enliven the wide green surface. Throughout the extent of flat country great flocks of geese are taken out to pasture every morning by a goose-herd; they are carefully watched from sunrise to sunset, for fear of vultures by day and wolves by night; and are then driven home to their respective villages, after the fashion of goats in Italy. We met many peasants, but the gay Gheghe colours are giving

place to white costume. They all furnish a bad account of the great river of Elbassán, the Skumbi, which is to be crossed, and which they say is, rising rapidly in consequence of the mountain rains. About three we met a bridal party - the bride being conveyed on horseback to the future husband's house; she seemed to be a strange thing, like a large doll - so closely swaddled and wrapped up that neither face nor figure were visible, while a tall sprig of rosemary, which finished off her head-dress, gave her the appearance of some exotic plant in process of careful conveyance to a gardener's ground.

Several times we turned towards the river, but always retreated at the approach of peasants who exclaimed: "*Yok, yok!*" "*Mir ist!*"[7] said some Albanians, pointing to the sea, so on we went for two hours - the plain becoming more and more beautiful as the sun sank lower in the horizon, and the great monarch Mount Tomóhr, frowned in purple grandeur amid cloud and storm. At last we arrived at the formidable river - one too broad, deep, and rapid, to be forded, while the bridge, a long and narrow structure of a shaking and incoherent nature, presented wide gaps through which you saw the rushing stream between the loose wattles that formed its floor. The transit was really not a little dangerous. I felt relieved when the last man had passed over it, each leading his horse very slowly from end to end before the next put foot on the crazy fabric, which would not have supported two parties at once. If the river continued to rise, we must assuredly have been the last who ever made use of that bridge as a medium of passage.

For half an hour we returned eastward on the left bank of the river, and then proceeded by broad lanes, deep in thick black mud, to the village, or scattered collection of hive-like thatched huts, called Tjermí. I have now left Ghegeria, and am in the land of the Tóskidhes - a new tribe; the people, at least these of Tjermí, seem a poorer and more squalid race; their dress is white - even to their little skull-caps; but dirt and squalor of the outer, and timid wretchedness of the inner man, seemed the characteristics of these pauper-beings, who arose from the ground in their rags as I passed, and saluted me with looks of terror - widely differing from the haughty gaze of the crimson-coated Gheghe. Here, too, the defeat of the last Albanian movement under Zuliki, is recorded in the absence of arms, as well as in the appearance of the peasantry.

I never saw grander landscape than that of these plains, as majestic Tomóhr grew grey in the waning light. It was dusk when we arrived at the khan of Tjermí - a place far short of our original destination, for it is in reality only three hours distant from Kaváya, though it has taken six to reach it, owing to the long detour the swollen river has compelled us to make. Khan Tjermí is a wretched looking den, standing all alone on the wide waste, yet its little loft to which one climbed by a ladder, possessed at least a new floor, clean walls and mats, and wooden window shutters.

Four Délvino Greeks, or Epirotes, had arrived before me, but there was still a corner, and the fire was by no means disagreeable, either from its heat, or from calling up many pictures of light and shade so often remarked in these night-scenes. Giorgio, who expected to have been unable to pass the Skumbi, or possibly to have fallen through that alarming bridge, is in great glee and makes a capital supper. They talk of nine or ten hours from here to Berát.

OCTOBER 13th

A fearful night of wind and storm-rain. Doubts passed through my waking thoughts if we should not all be carried away into the river, khan, Epirotes, Frank, and dragoman, by one of those thunderful gusts which swept over the plain at intervals with terrific force. In the pauses between the rage of the tempest, all the surrounding country seemed alive with dogs, whose howling and barking added point to the furious din of the elements.

"Water, water, everywhere, but not a drop to wash in," for, in spite of the pouring rain, the supply of fluid within reach was of the smallest, and that little was seized for coffee - breakfast versus cleanliness. Long before sunrise the four Delviniotes should have set off, but the utter blackness of the tempest confined us all to the circle round the embers, waiting till daylight should bring better times.

The Khanji, an emigrant Acharnanian, diverted me by his scraps of polyglot discourse: "*Bavarese nichts gut - τίποτες, - Ingliz, Franciz, χαλα, χαλα, Moscoffs nichts, Bavarese πολυ wein drinkt, ολιγον wasser,*" &c. At six the rain ceased, and the scowling clouds curtained themselves into gloomy folds, so, hoping for the best

(though assuredly my Albanian journey does not prosper at present), I was again at half-past six on my way towards Berát, over plains surrounded by the roots of hills, whose heads were hidden in cloud, excepting a low, bare, ill-outlined range on the left, which was ugly enough to have been obscured without any loss. Farther on, the downs on the west sink into the plain, and a lake stretches out almost to the shore. Perseverance through mud and water brought us to Leustri at half-past ten; but hoping to arrive at Berát I did not halt, except to rest horses at a wayside khan; its floor was occupied by a Skódra merchant, who was making himself as comfortable as circumstances permitted - considering that neither bread nor water could be obtained, and that the rain came through the roof plentifully. To have lingered in such a place would have been folly, so hey for Berát once more at eleven. They said it required but five hours to reach it, so in spite of fresh falling deluges, I persisted in advancing, though never was there less inducement to do so, for, apart from the vexation an artist feels who knows that he is surrounded by beautiful scenery, the only chance in his life of seeing which is so adversely destroyed by unlucky weather, the physical annoyance of sitting hour after hour in drenching rain and high wind, on a stumbling horse advancing one half-mile per hour (at the quickest pace) through thick mud and over-inundated meadows - this is no trifle, added to the loss of time and money, from such unprofitable pastime, which is very trying to purse and temper. During this part of the day our late host, the Ecónomos of Kaváya, was regarded by Giorgio with the most acrid feelings of disgust (that reverend man of Ghegheria having charged us unseemly prices for steeds which were positively next to useless), and the recollection that I had so foolishly fancied the priest a hospitable man, who was offering his home for the use of me as a wanderer and foreigner, embittered the oppressed dragoman to such a degree, that at each stumble of his horse, strong expressions escaped from him to the prejudice of Papa Andréa, and Greek Papades in general.

After three hours of this miserable work, feeling that there might be six or eight more at the rate we advanced to Berát, and as the track became undistinguishable from the increasing rain, I gave in, the rather, that Giorgio was hurt by the last fall of his horse, and seemed unwilling to proceed. So having passed the fast-rising Beratino[8] by a bridge opposite to the khan Tchúka - a large

building on a rising ground above the river - here we halt for the night. "Do I lie on a bed of roses?" was the substance of my remonstrance to Giorgio, who grumbled for awhile with deep groans about all this "*soffrire per niente*" [9] but the worthy Fanariote soon came to himself as we bustled to secure the two sides of the fireplace in the huge lofty-raftered khan-stable; first come first served being khan-law.

The difficulty of changing all one's wet clothes (and to escape fever this precaution is always most requisite) can only be appreciated by those who have made their toilette under similar circumstances; but this done, a good dinner of rice, pilaf, and kabobs, with coffee and a cigar, are beyond description refreshing; and the wayfarer soon forgets the inconveniences of travel while recording with pen or pencil its excitements and interests. Truly, in such weather as this of the last week, there is little pleasure in travels even where better accommodation exist: so to Ioánnina, unless times grow better, must be my direct path.

At three the storm cleared, and then came the pleasing reflection, that had I proceeded, I might have reached Berát, though possibly it was more prudent to stop here. I go on to the bridge - the river rolls furiously below, and heaps of purple and golden-edged clouds hang over the shaded base of Tomóhr.

Midnight, - O khans of Albania! Alas! The night is not yet worn through! I lie, barricaded by boxes and bundles from the vicinity of the stable, and enduring with patience the fierce attacks of numberless fleas. All the khan sleeps, save two cats, which indulge in festive bouncings, and save a sleepless donkey, which rolls too contiguously to my head. The wood-fire, blazing up, throws red gleams on discoloured arches within whose far gloom the eye catches the form of sleeping Albanian groups. Bulky spiders, allured by the warmth, fall thick and frequent from the raftered ceiling. All is silent, except the horses champing straw within, and the gurgle of the rapid river chafing without.

OCTOBER 14th

The principal event of the night was the donkey's walking unexpectedly into the fire-place, thereby causing a confusion in my nocturnal arrangements, only to be remedied by a complete decamping. By half-past four, therefore, coffee is taken,

the horses are ready, and I am once more on my way to the unreachable Berát. There was a brilliant full moon, but big clouds are flitting over it, and the road is now in bright light, now dark as Erebus; nor is it too warm at this early hour, the more, that wet apparel is as yet barely dried. The wild Gheghe guide from Kaváya insists on loading Giorgio's tumbledown horse with the baggage, and all we can do in opposition is fruitless, as the mind of a Gheghe, when once arranged, is immovable. So on we advance by the strange flickering moonlight. Presently clouds gather, and down comes rain as usual.

We are crossing the great plain of Berát, and following a sort of track two feet deep in mire and water; when lo! the baggage-horse falls, as I foreboded, but gets up again, which I did not look for. An old sick Albanian on his mule joins us, and we jog on slowly for an hour. When losing the right path, that wretched baggage-horse falls plump into a ditch, and no art can extract him. This is not a pleasant matter in a tempestuous moonlight night, but there is no help for the evil but unloading the oppressed beast and transferring his burden to another. During this operation, the contrast between the conduct of Giorgio - who, knee-deep in water, and suffering from a fall yesterday, spake never a word - and that of the Kaváya guide, who swore himself into convulsions, is edifying. The priest, of whom the horses had been hired, seemed the chief object of his eloquence, as the word *prift* (Albanian for priest) was frequently heard among the clatter of strange monosyllables - Dort beer, dort bloo, dort hitch, hitch beer, blue beer, beer chak, dort gatch, with other musical sounds. During this delay the sick Albanian was reposing on a knoll of turf (rather a damp bed) raised above the water; and when at length we were ready to start, in getting up he missed his footing, and rolled down into the very ditch whence we had just extricated the steed; so there was a fourth halt to pull out and set up this feeble old man of the mountains.

A very breakdown procession did we make, slowly plodding through quagmire and stream, when at last we were fairly under way and right glad was I when cocks crew, dogs barked, the moon faded, and grey day coldly and slowly came, unveiling "vast Tomóhr" a long way off beyond a weary expanse of plain. Yet over that have I yet to go, for Berát lies immediately at the foot of the mountain. About the third hour the journey became interesting, for Tomóhr is a

noble mountain, and the multitudes of sheep scattered over the wide, shrub-dotted meadow-plains formed beautiful features in the landscape.

At length the celebrated fortress of Berát appeared - dark blue, and diminutive, on a pointed hill. Approaching the capital of Central Albania - a place I had so long desired to see - every step leads into grander scenes. The river Apsus or Beratino is repassed on a stone bridge, and the road winds over the plain on the banks of the wide stream, through a tract of country of the finest character; the high form of Tomóhr, here seen from end to end, being the principal feature throughout. I do not remember to have known a finer specimen of a simple river scene than this - it combines the broad white-channelled serpent-stream, with its broken and reed-clad banks varied by sheep, goats, kine, and buffaloes; while above rises the giant mountain's single form, wrinkled into a thousand furrowed chasms, towering aloft over the uninterrupted and decided lines of the plain in grand simplicity.

Owing to the deep mud, it took us two long hours to ride from the bridge over the Beratino to that in the town; and at ten A.M. we entered this magnificently picturesque place, which, much as I had imagined of its grandeur, far surpassed my expectations.

Berat[10] is situated in a narrow gorge or pass of the Beratino, which seems to have forced a passage through the tremendous rocks on either side, leaving merely a narrow space between the cliff and the water. The great Tomóhr fills up, as it were, all the eastern end of the pass; and to the west and south the mountains through which the vale of the Beratino winds, seem equally to enclose this singular place, though the fortress height looks over the plains to a great distance.

The city is placed chiefly on the right bank of the river, as also is the Acropolis or castle-hill which rises immediately above the town - the houses and mosques are piled one above another on the steep ledges of rock which slope from the frowning fortress and its stupendous cliffs down to the water's edge, and constitutes a view that combines Tyrolese or Swiss grandeur with all the pretty etcetera of Turkish architecture.

Passing below the cliffs of the gorge, and entering the street of bazaars which runs quite through the town, I was at once struck by the entire change of costume in this district - that of the Tóskidhes. Instead of the purple frock, scarlet vest,

black waistcoat, and short kilt of Ghegheria, here all is white, or spruce fluffy grey cloth, with long, many-fluted fustianelles, while the majority, instead of the red fez, wear white caps. Beyond the bazaars, which are extensive and well filled, is a wide open space by the river, whence the view of the dark gorge of the Beratino, the town and castle are truly wondrous. On one side of this piazza or market-place is a large new khan, and here I took possession of a corner room looking out on to the busy scene that extends to the foot of the hill - a space in which hundreds of figures sat continually before me for their pictures without suspicion or restraint. This was a khan-arrangement which pleased me not a little, besides the comfort of the room, which was new and clean, and had well-glazed windows. Nothing could be more amusing than the variety of life below. There was the dervish with high white or green caps - the Mohammedan, as well as most of the Christian women, in loose blue *feringhis* and closely veiled - while infinite numbers of carts drawn by coal-black buffaloes - Greeks, Turks, Albanians, mingled and moved in profusely changing groups.

Having a letter to the Pasha (Berát, with Skódra and Ioánnina, are the three existing Pashaliks of Albania), I sent Giorgio with a request for a Kawás, who shortly arrived, and after early dinner I began to sketch (there is no time to be lost in places so full of interest) on the river-side below the castle, hundreds of people pouring forth to see my operations; but all were violently repelled by the active guardian Kawás with a stick, which he threw with all his force at the legs of such unlucky individuals as pressed too closely on me, or interfered with the view. When this club was ejected from the incensed authority's hand, the rush to escape was frightful, and the yells of those who received the blows very disagreeable to my feelings. After a time my guard got tired of his work, and sitting down calmly to smoke, delegated his power to a young pickle of a boy, who took infinite delight in using his temporary dignity to the utmost, greatly to the disgust of his elders, who durst not complain.

Towards evening I walked through the town and over the bridge to that part of Berát which is built on the left bank of the Beratino; but the best general views are from the side on which the castle stands.

Chapter IX

Visit to the Pashá of Berát - Energetic guardian and castigation of the populace - Dress of the women - Pine views of Mount Tomóhr - Interesting character of the scenery of Berát - Singing of the Tóskidhes - A day on the banks of the Beratino - Departure from Berát - The Greek Económos and his house at Kadipashá - Meadows of the Mizakia - The hill and Monastery of Ardhenitza - Sunrise from the convent - Mount Tomóhr and the plains of Apollónia - Descent to the plain of the Beratino - Greek church and school of Kosma - Papa Zacaria of Khimára - Route continued across the plains - High wind - Arrival at the Monastery of Apollónia - Its melancholy and ruined condition - Bad accommodations, goats, and Albanian melody - The solitary column - Beautiful flat green fields of the Mizakia - The enraged shepherd and his dogs - Ferry over the Viósa - Scenery of Avlóna - Arrival at the town and accommodation at Herr J.'s plan of visiting the Khimáriote villages - The accursed bit of Indian-rubber and the two Gheghes.

OCTOBER 15th

The mountain Tomóhr is nearly clear; I draw figures from the window till eight; then putting on "society dress," I go with Giorgio and a Kawás to make a morning call on Hussein, Pashá of Berát. A most picturesque palace is his residence; galleries and courtyard full of the pomp of attendant guards as usual, and in the reception-room is no lack of secretaries and officials, among whom a Cadi in white turban and long brown gold-embroidered robes shone resplendent. The visit was much like other Turkish visits. The Pashá was agreeable in manner; and the conversation, by the aid of continual pipes and coffee, dragged its slow length

along. The cholera at Saloniki being touched upon, Husséin Pashá asked Giorgio to inquire if I had known in that city (where he, the Pashá, was educated), an English Bey called "Jim," who resided there, and used to take the Pashá out hunting, with "*cani magnifici*," and "*fucili stupendi*" [1] but I, never having heard of "Jim" could give no information. I made a point of asking for good horses, for the journey from hence to Avlóna, remembering what I had suffered by those of the Kaváya priest; and his Highness ordered the matter to be looked to instantly, for he said: "It is a pleasure, as well as a duty, to assist an Englishman; *Inghilterra* and his master, the Sultan, loved each other, and so should all the subjects of both countries." After this visit, I employed two hours by sketching from the door of the khan, supported by the Kawás, the crowds gazing at a respectful distance; not that this self-restraint on their parts saved them from disgrace and evil, for a huge Bolubáshi (or head of the police), casually passing, and being seized with an extemporaneous conviction of some impropriety requiring castigation, thereupon he rushed wildly into the midst of the spectators with the energy of a Sampson, dashing his stick at their legs, heads and backs, and finally dispersed the unresisting crowd. After this, the enraged guardian of public manners gave my Kawás a blowing up for allowing the slightest symptom of interruption, and finally committed two large staves to some lively juveniles, with a stern charge that they should use them well and frequently. This unnecessary harshness grieved me, and on finding my remonstrances were unheeded, I gave up my sketch. Of all the numerous Beratini so unceremoniously struck, I observed but one who did not exhibit great signs of fear and dismay; this man remained steadily till he was twice hit, when he picked up a stone and walked away scowling and muttering suppressed anger. A pleasant land to live in! Sketching on the bridge and on the west side of the town occupied me for two or three hours.

The women of Berát are all veiled. They wear a close-fitting, dark blue cloth vest, or pelisse, not at all unbecoming; and their very thin muslin "face-cover" is so well and cleverly adjusted, particularly by the younger and pretty part of the female population - and these are numerous - that the outline of the features can easily be distinguished.

Towards evening, the lines of purple Tomóhr were exquisitely fine. Every wrinkle and chasm in its vast sides is perfectly delineated; and from the market-

place (that is, in fact, at this season, the dry bed of the river, which does not rise so high until much later in the year), the broad foreground of yellow sand, covered with a never-failing succession of reposing groups, was charming. A great part of the people sit about and smoke by tens and twenties, after the indolent fashion of the Albanians; and the community seemed to enjoy keenly the pranks of a little imp whom they called Móostafa. Long mounted lines of elderly men on asses were returning to Berát from vineyards or village gardens higher up the river; and as they passed by, Móostafa teased the old-men-bearing-quadrupeds to a fearful degree, by pulling their tails, avoiding, with will-o'-the-wisp activity, all the blows aimed at him by the incensed riders. At length the furious victims dismounted, when behold little Puck was running away like lightning; and the exasperated ancients, knowing all hope of chase to be out of the question, remounted slowly and sullenly, to find their graceless persecutor at their backs in two minutes, when the same scenes occurred again "*da capo.*" All the crowd, of four or five hundred spectators, were greatly interested at these gambols, and yelled with delight at each of Móostafa's exploits, though they nearly ended by a kicking horse putting the little buffoon's head in jeopardy.

As for me, I finished the day in a cemetery eastward of the town, whence the fortress and river were extremely grand. There was an air of seclusion and sternness about the pass of Berát which made it certainly one of the most interesting of scenes. Home to the khan early, to try if, by getting some more sleep, I could have a longer day tomorrow. But oh! the way in which cats bounced and tore about these places all night long, and then the mode of singing adopted by the Tóskidhes Albanians all through the dead hours of darkness! There was a large party of them in the next room to mine: four began to form a sort of chorus; one made a deep drone or bass; two more led the air; and the remainder indulged in strange squeaking falsettos, like the whining of uneasy sucking-pigs.

OCTOBER 16th

As this day was to be passed on the banks of the Apsus, for the purpose of sketching Tomóhr, I awoke and rose at three, and by daylight the mountain sparkled like clear crystal. A sketch of the palace, and a visit to Hussein Pashá's

brother, Achmet Bey (an hour of pipes and coffee), and ten o'clock is arrived. A Kawás and horses were ready, for I had planned to go some miles from the city, and was soon on my way upon a white charger, most gorgeously bedecked, with my armed guide on another, trotting (for the deep mud of last week's rain is already dry) by the river-side as far as the bridge, by which I had arrived on the 14th. The Kawás put up his horses at an hut, and I drew very satisfactorily till it was time to return; and although a grey sirocco had thrown a cloud over all the beauty of colour, yet the form of Tomóhr is in itself a picture, combined with the broad Beratino in its stony channel and cliff banks, and the distant fortress of Berát perched on its rocky hill. My ever-smoking guide, too, is now and then meeting a fellow-rider, when the two guards greet each other by rushing forwards impetuously with drawn swords in attitudes of wrath, as if the last moments of one or both had come, firing off their pistols, and closing with their hands at each other's throats as if for mortal combat. Below the fortress a company of Turkish cavalry were exercising, wheeling about, discharging fire-arms, and charging full speed into the low ground by the river. Such incidents, united with the scenery, were wildly picturesque.

I was back at Berát by four or five, and rode over the castle-hill, whence there is a superb view of the mountain, with the valley of the Beratino at its feet, and the minarets of the town in the near foreground.

OCTOBER 17th

Rain, hail, and thunder all night long, and at daybreak small chance of starting. Weary of this bad weather, I could half bring myself to go straight hence to Tepeléni, and thence to Ioánnina, giving up Avlóna and Acroceraunia. Gleams of sunshine burst forth at nine, and the arrival of the horses decides me in favour of Apollónia, which I cannot, however, reach today owing to my start being so late. So, at half-past ten, declining the escort of six foot guards sent me by the polite Hussein Pashá, and taking a mounted armed Kawás, we set off. We were soon out of the gorge of Berát, and I could not help regretting having left a scene of such great magnificence; for an artist may go easily enough at any time of his life to Rome or the Rhine, Matlock, Constantinople, Jerusalem, Killarney or

Calcutta, but Berát and Illyria are not easy places to re-visit. The horses are good. Two of them belong to the sick old man whom we call the Filosofo, by reason of his remaining so placidly in the ditch on the morning of the 14th, he being on a return journey to Avlóna. The other two belong to a man of Berát, who walks by our side (if you hired fifty horses of fifty men in this part of the world, you would have all the fifty owners for company, because in Albania nobody lends anything to anybody). Our party is farther illuminated by a Greek priest in his blue dress, black cap, and floating hair and beard, and by a friend of his, a lean, tortoise-necked Albanian, in a brand-new capote and white cap; these, with my Kawás, who glittered in blue and gold, made a picturesque caravan, and we all galloped over the plain, which, at a little distance from the first bridge (for we must retrace our steps as far as the second bridge), was capital ground. The plains of Berát, dotted over with infinite flocks of sheep, and spotted with clumps of dark reeds or briers, were beautifully cheerful; the sun shone brilliantly across their wide expanse, and light clouds climbed around the highest rocks of Tomóhr.

At half-past two we reached Khan Tchúka, re-crossed the Beratino, and following its right bank, quitted the road by which we had come from Kaváya and Leustri on the right hand. The priest and his friend advise me to go for the night to the Greek convent of Ardhénitza, which, say they, is but three or four hours from Apollónia, and stands on a high hill commanding a view of all the world. Meanwhile he tells me a marvellous story of his having travelled here with a party of six friends some years back in a violent thunder-storm. The horses took sudden fright at the lightning while passing along the narrow path we are now upon, and one and all fell into the river; swimming over to the other bank with the seven riders holding fast, when all of them landed safely and undamaged, excepting that one of the party became entirely deaf, and has ever since remained so. The history, if true, is uncomfortable to hear just now, because the path is so slippery and narrow that I contemplate the ducking, if not the deafness, as extremely probable occurrences. At half-past three we came in sight of a long, low, isolated hill, a dark spot on the highest part of which is pointed out to me as the convent trees; but though another hour was passed in wading through mud in uncultivated places, where now and then remote from every other sign of life, a

tranquil young buffalo peered calmly out of a pool of black water, yet still Ardhénitza on its hill seemed "never the nearer."

At half-past four we passed Ghóurza, a village of detached thatched houses, in gardens, and full of furious dogs; here we had intended to stay the night had it not been resolved to go to the convent. A little father on is Kadipashá, our companion priest's residence, and at a most picturesque little spot, embosomed in plane and abeles, we halted. It was the courtyard surrounding the Greek church, and over the gateway leading to it were two rooms, the abode of our reverend comrade. And very glad was I to rest there awhile, for galloping in short Turkish stirrups is not refreshing to the gasterocnemii muscles, nor is a small cup of coffee sufficient support from four A.M. to four P.M. Some capital cheese, less salt than the generality of that of Greek manufacture, and wine less savouring of resin, were by no means disagreeable additions to the repose on the cushions of the hospitable priest's little room. Before we left him, he showed me some old *bassi-rilievi* on the walls of his church, where numerous ancient bits of material bore witness to some pre-existing building of days by-gone; several twisted columns also, and a remarkably hideous St. George and the Dragon were part of this antiquarian feast, after which we set off to Ardhénitza once more. Beautiful green meadows like those of Kaváya, stretch on all sides (indeed, from Durázzo to the Viósa is one continued meadow), unbroken by any division. Sheep, geese, and turkeys whitened these plains, the goose-herds and turkey-drivers sitting by their charge. The sheep have bells; and now and then a song, not unlike the yodelling of the Swiss, breaks the quiet of these placid meads, or a huge dog rushes to attack the Albanian *pietone*.[2] The bright sun was setting behind the hill of Ardhenitza as we arrived at its foot, and having passed another village we began to wind upward to the summit, by paths through pleasant underwood, where the monastery, a plain building, stands among cypresses and ilex. The interior of this, the first Greek convent I have seen, is picturesque; and a painter is ever sure of a group of bearded brethren in the foreground.

The view, as might be supposed from the isolated position of the hill, is truly stupendous - it includes the meadow-plain to Durázzo - the far mountain ranges of Tyrana and Skódra - the near majesty of Tomóhr and its dependent heights, and the plain again to Apollónia. At dusk I was taken to a most comfortable little

room surrounded with sofas, where for two hours or more I awaited the reverend
household's performances in cookery, though I had much rather have had a
simple meal at once. But at eight the chief Papas, with five or six others, entered
with dishes unnumbered; pilaf, roasts, boiled, fried - fish and fruit - honey, cheese,
walnuts and wine. As soon as I could, I begged to dispense with my host's
attendance, and as Giorgio and the Kawás had, like myself, fasted since sunrise
(the refection at Kadipashá excepted), I was glad to hear the festivities of supper
beginning in the priestly halls on the opposite side of the corridor, whence the
old Protopapas' voice resounded in hearty laugh through the monastery - a
cheerful noise in these days of living among Turks, who hardly ever laugh at all.
After supper they paid me a visit, and inculcated Romaic Sentences, *το χρασι
ειναι χαλιτερον απο τον νερόν*[3] with other similar moral apothegms. One old
gentleman entreated, as some of the Albanians at Króia had done, to be taken to
England, the protection of my signoria being all he desired for the rest of his life.
Giorgio describes the supper in the refectory, as "*un pranzo di paradiso*,"[4] and says
that the Protopapas means to accompany me to a church and school on the way
to Apollónia tomorrow, there to give me a roast lamb at the archiepiscopal
residence; an ecclesiastical attention not fully appreciated by me, as I want time
to sketch at Apollónia.

OCTOBER 18th

The clear and glorious sunrise from Ardhénitza was a sight never to be forgotten.
I drew for an hour or two. "*Scroo, scroo, scroo,*" I heard the Albanian servants
saying, and well they may wonder what I write down so much. The Ecónomo or
Protopapas also, Papa Lazus, was a magnificent subject for a sketch, and in return
for his likeness, he begged me to give him a little memorandum recording my
reception at the convent, that he might show it to Hussein Pashá, to prove how
devoted a servant of his Highness he delighted to be. Poor people, naturally
enough they seek to win golden opinions from any one having the least
communication with their rulers.

The Protopapas and his servant accompanied me, at half-past ten, down the
pleasant hill of Ardhénitza, and in an hour we arrived at the ferry over the

Beratino, to cross which was a work of time, as the boat was small, and the horses having to be unloaded could go but one at once. The day was warm, but sirocco wind began to rise, dimming the colour of the beautiful prospect, which from a little height above the river greatly resembles that from Richmond Hill - olives (for hereabouts there is much cultivation, under the auspices of the monastery) being placed in the picture instead of elms. On the southern side of the Beratino we at first crossed a marshy flat tract, with scattered shrubs, throughout which concealed dogs rushed out with unpleasant abruptness from innocent looking bushes. There are few peasants to be seen, saving here and there some women laden with implements of husbandry, for throughout the whole of Albania, females are a hardly-worked race. We now advanced towards a group of low hills - the site of ancient Apollónia - once more over rich smooth meadow land, and about twelve reached a little wood of plane trees, with exquisite creepers falling in long festoons from their branches, and overshadowing a convent and church built by that arch-dodger, Ali Pashá, in the days when it suited him to buoy up the hopes of the Greek Christians, as well as to support those individuals among them from whose care and cultivation of all these rich plains more advantages accrued to his interests than could have arisen had they been dispossessed of their lands for the sake of less industrious Mohammedans.

This Greek church, forming one side of a quadrangle, the remaining three being composed of a convent and stables, with two lines of cloistered arches, the whole shaded by the high trees which hung over them, bending with wild-vine, is as pretty a picture as may be found.[5] A little village is scattered in the heart of this quiet wood scene; and a school, a rural building, supported by a long row of arches, and shaded by feathery trees, stands by the church; some thirty or forty children were sitting in a row learning to read, or chanting in a low tone. Many of these are the children of Papades resident in the villages of these plains, and others the offspring of "well to do" peasants; they were a bright-eyed, cheerful set of little ones, and added much to the interest of this new scene. The ground below the trees is perfectly carpeted with that beautiful little flower - the cyclamen - in full bloom. While I am sketching, Papa Zacaria, who resides at this village, comes to inform me that the fathers of Ardhénitza are roasting a turkey, a duck, and a fowl for my lunch, and that the repast will (like that of Beau Tibbs in "The

Citizen of the World") be ready in two hours at farthest. This, to me, is not agreeable news, as I fear to lose daylight for drawing Apollónia by the delay; but, as the compliment is well meant, I cannot refuse it, and so I wait patiently till the dishes are served, Papades Lazus and Zacaria keeping me company during the entertainment. The former is one of the Vlachi - a tribe which in this part of Albania is generally found wandering as shepherds, but in the recesses of Pindus exists in several large settlements. Papa Zacaria is a Khimáriote by birth, and gives me a good deal of information about Acroceraunia, which, if it be possible, I am resolved to visit. About half-past two P.M., I left these courteous people, and their establishment in the wood, and set off through deep mud surrounding the village (for the flocks of sheep, and herds of buffaloes, efface all vestige of a road), and thence over a wilder and less mead-like tract of flat ground, towards the hill of Apollónia; but the sirocco wind which is making earth and sky of one uniform grey, is now blowing so furiously that the afternoon ride is anything but agreeable. At the foot of the hills - which give no prospect of beauty, so dreary and dull do they seem - we halted at the little village of Pollina, which, with the convent above, is all the representative left of the old city. It was desirable to re-establish the baggage, shaken by the terrific wind, and to allow the old Filosofo to have some wine, but for this, when Giorgio offered a small coin as payment, the proposal was received by the villagers with an unanimous groan, and a small child who made a snatch at the lucre, was buffeted and snubbed severely. A short ascent led us to the monastery of Apollónia, enclosed within walls, and standing on the highest part of the hill, the inconsiderable height of which did not prevent its command of a most extensive view, owing to its isolated position in so level a country. The exterior of the building offered nothing picturesque - but inside the walls, the large courtyard strewn with ruin and overgrown with grass is very striking - everywhere evidences of past ages meet the eye - a strange mixture of ancient Greek stones, Roman columns, mediaeval cornices and capitals, later Greek brickwork, and Turkish galleries. The church, in a ruinous condition, occupied the centre of the quadrangle, and the rooms of the convent formed one of the sides - if those could be called rooms which were merely two half-roofed barns over a great stable, the abode of numberless goats. Meanwhile the wind continued to rise, and it was well if the "rooms" did not take flight altogether. To

hold a sketch-book became impossible, and after I had with difficulty drawn the church, I strolled out on to the hill among extensive remains of what seemed the walls of the great Illyrian city. From this spot I perceived the solitary column on the low rising ground to the south, of which a drawing is given in Dr. Holland's work. But the sun sank into a red bank of cloud beyond the western sea, and I returned with the goats to the convent.

One of the barn-apartments was allotted to me, the other to Giorgio, and what he dignified by the name of my "*seguita*"[6] (namely, the Filosofo, the *pietone*, and the Kawás), shared with two very poor Greek monks. Certainly, the night's lodgings were not obtrusively luxurious, though there was a romance in these solitudes, and their want of accommodation, which contrasted pleasantly with the annoyances of the populous Gheghe towns, whose appearance led to infer greater expectations of comfort. Here one anticipated none and consequently was not disappointed. The loft was wide and dark; the planked floor was full of holes, through which came up a perpetual jingling of goats' bells, and their sneezings and coughings - they are very asthmatic goats; and it was difficult to keep a lamp burning owing to the blasts which circulated on all sides. Verily these were not cheerful phases of existence and, what is worse, I feared rain for tomorrow. However, from seven to ten, the lay-friars of the Apollónian establishment were most musical, and together with my "*seguita*," did all they could to enliven the dullness of an Illyrian city in the nineteenth century by singing their monotonous wild airs. The melody indeed was little varied, but the harmony of the voices taking different parts was pretty.

OCTOBER 19th

In spite of all those superfluous goats below, not a drop of milk was to be had; but this I have long observed to be a general rule in Italy, as well as in Greece. The more goats, the less milk.

Taking a peasant from the convent as guide, I went at sunrise to the single Doric column, the only remaining token of Apollónia above ground. It stood on a dreary little hill, covered with long grass and brambly thorn, and a more lonely and forlorn record of old times could not well be contemplated. The pillar was of

coarse sandstone, and all the marks and dimensions of cella and temple were distinct, though the remaining columns had been transported by some Pashá to adorn Berát. On every side of this single relic of grandeur, how noble were the objects in the distance. Eastward and northward, the mighty Tomóhr, the convent of Apollónia, and the hills of Durázzo; and southward, the smooth green plains stretching to the very foot of the Acroceraunian range. Descending from this interesting spot about nine, I was joined by Giorgio and the Kawás, and for two hours rode over the greenest of pasture land without a single undulation. The morning became perfectly fine (contrary to expectation), and the clang of our shovel stirrups resounded merrily as we galloped over the plain.

The great flocks on these beautiful quiet tracts would inspire the stranger with a complete idea of peace, were they not always attended by huge guardian dogs, who rush out like enraged demons at the horses and threaten the riders' legs. One company of these angry brutes was particularly outrageous, and although the Kawás repeatedly shouted to the wild shepherd, as he lay on his shaggy cloak, he merely looked up and neither checked his hounds by voice or gesture. The neglect cost him dear, for as the horse on which the Kawás rode became unruly from the persevering attacks of some eight or ten of the dogs (who gathered at the sound of battle from all parts of the plain), the man of arms lost patience, and galloping straight to the peasant, thundered over his shoulders with his *kourbatch*[7] till he yelled. This, however, did not mend the matter, for the beaten man showed signs of fight, by setting on all the dogs at once, and threatening the Kawás with an immense club, so that I momentarily expected to see my Berát escort suffer the end of Actaeon, when suddenly he changed weapons, and pointing his gun at the enemy, reduced him to terms. The dogs were called off, and the club thrown away, and the shepherd was left to reflect that resistance to armed Turks and setting dogs upon travellers, is unprofitable pastime.

At eleven A.M. we reached the Viósa,[8] here very broad and rapid, ere it joins the sea; and as current and wind were both against us, it was some time before we reached the opposite side, both men and horses were stowed away in a ferry-boat, resembling a magnified washing-tub. Hence we went on again, over plains, sometimes marshy, sometimes greensward, and alive with still greater multitudes

of sheep. Thirty or forty immense flocks were frequently in sight at once, and all guarded by lion-like dogs; and by degrees the plain became gradually bare, and white with salt; and the sea-view, as we neared the hills of Avlóna, was shut out by the long island of Sázona. A most beautiful amphitheatre of olive-covered heights surrounds Avlóna, whose silvery mosques peep out from deep green foliage, while Kánina, a town majestically placed upon an eminence beyond, finishes one of the prettiest of pictures. Full of artistic incident is the town itself (where I arrived before four). You have mosques, and bazaars, storks' nests,[9] and picturesque desolation; for Avlóna is but a poor place now and, having suffered in the latest Albanian (or Zuliki's) rebellion, exhibits a mournful air of decay.

Passing through the town, I made my way to the residence of a merchant, Herr J., who, with Herr S., a doctor of quarantine in these coasts, lives in a two-storied wooden house overlooking town, plain, and sea; and by means of a walled courtyard, a broad verandah, a gallery, and some inner rooms, has made himself a very comfortable place for such an out-of-the-way part of the world. I was received, on presenting a letter from Signor Bonatti of Skódra, with courtesy, though with an eternity of fuss and compliment I would have dispensed with. A good room, used as an office, was given me to abide in, but the difficulty of attaining the usual degree of travelling cleanliness was greater here than at the houses of either Greeks or Turks, seeing that the masters of this continually came in and out, and scrutinised with infantine curiosity all their guests' acts and property. Having read with avidity some German papers conveying the latest intelligence of the past six weeks (news of the most extraordinary events occurring throughout all Europe), I sat with my hosts till their supper-time, conversing about parts of Albania, especially Acroceraunia or Khimára, with which the doctor is well acquainted. They advised me to visit that coast and its unknown villages, and offered their servant as guide - a trustworthy Khimáriote, who spoke Italian well and was known throughout his native territory. At supper time, Herr S. held forth on German and European politics with alarming enthusiasm. Prophecy succeeded prophecy, as to all the royal and noble heads to be cut off; and the plates and salt-cellars jingled to the thumps which accompanied each denunciation of tyrants, and each appeal to liberty. Not thinking it well-bred to expostulate with my host on the length of his monologue, and not quite agreeing

with all his sentiments, I wished he was a silent Turk, and entreated to retire to sleep.

OCTOBER 20th

The perfection of an autumnal clear day! After early coffee, I went out with Anastásio, the Khimáriote domestic, or rather Kawás (for, as a servant of government, he carried arms). He said I could go through "his country," weather permitting, in five or six days, and that, as he was of one of the best families in Vunó, everybody knew him and he knew everybody. This seems an opportunity of seeing Acroceraunia not to be lost; and I shall undertake the adventure - leaving Giorgio Kozzachi at Avlóna until I return from those unexplored lands.

Avlóna lies in a recess or bay of the mountains, which here leave a level space of two miles or more between their base and the sea. The town is built for the most part at the foot of a crescent of rock, but the sides are dotted with houses; and at the two horns of this natural amphitheatre stand many conspicuous dervish tombs of pretty architecture, surrounded by groves of cypress. From hence the eye looks down on Avlóna in its garden of plane and olive trees, its principal buildings, the fine palace of its late Bey, and some good mosques, which stand out in beautiful relief from the wide salt plain and gulf beyond. The gulf - shut in on one side by the long point of mountain called La Linguetta, and on the other by the island of Sázona - has exactly the appearance of a lake, so that the effect of the whole picture is most complete and charming. Having drawn assiduously till twelve, I returned to the Casa J., where the renewed vehemence of my host's political ebullitions, joined to the attacks of numberless flies infesting their room, made me rejoice when the midday meal was over.

In the afternoon we were to ride somewhere, Herr S. being well acquainted with all the ins and outs of the neighbouring landscape; and in the meantime I drew the portraits of two Mohammedan Gheghes of Elbassán, who came to visit my hosts. No sooner were these good people squatted in the little wooden gallery, with their garments, faces, and pipes in complete arrangement for my drawing, than a bit of Indian-rubber fell from my book, and making two small hops upon the ground, as is the wont with that useful vegetable substance when dropped

accidentally. This caused indescribable alarm to the two orthodox Gheghes, who jumped up and hissed at it, saying, "*Shaitán! shaitán!*" and trembling with horror as the little imp remained close to their feet. Nor did my taking it up calm their fears; and when I put it in my pocket, their disgust was increased at such ostentatious truckling to the comforts of a familiar demon. So as I found they could not be again induced to remain tranquil enough to be sketched, I seized a moment when they were not looking at me, and bounced the offending caoutchouc on the planked floor, when up it flew to such a degree that the unhappy and tormented Mohammedans screamed aloud, and shrieking out "*Shaitán! shaitán!*" jumped off the accursed platform and fled away.

At four, horses being brought, we set off in quest of the picturesque, attended by a black slave Margiánn, in full-armed costume. Paths such as none but very sure-footed horses could climb, narrow slippery ridges along the brink of deep ravines, ascend from Avlóna, through groves of large thick olives like the slopes of Tivoli. At a distance of two or three miles we reached the top of an eminence whence, looking down on the valley of the Viósa on the one side, the great mountain of Kúdhesi near at hand, and Tomóhr ever towering in the distance, with the ruined fortress town of Kánina, forming the opposite interest of the picture, I confessed the taste of my host in matters of landscape, and passed an hour gladly in sketching those views. By sunset we returned to Avlóna.

Chapter X

*Departure from Avlóna - Ascent to Kánina - Its ruined fortress - Anastásio Kasnétzi -
Quiet cove of Kria Néra - Wild Khimáriotes - Ugly paths along perpendicular precipices -
Beautiful view of the approach to the Khimáriot or Acroceraunian mountains -
Warnings concerning the dogs of Khimára - Magnificent wild scenery on the ascent to
Draghiádhes - Arrival there at dusk - Extraordinary dress of the women - Wonderfully
savage appearance of the town and people - First evening in Khimára - Zinani's house -
The supper, and arrangements for sleeping - Precautions against dogs - Anastásio's
remonstrances - Departure from Draghiádhes - Storm of wind - Mountain pass - First
view of Dukádhes - Its singular position - Arrival there - Labourious life of the women -
Wild scenes in the valley - Life in a loft - A "soirée" in Khimára - Select society -
Harmonious blacksmiths - The idol-gipsy - Unveiled Mohammedan ladies - "Bo, bo-bo-bo,
bo-bo-bo, bo-bo-bo, BO!"*

OCTOBER 21st

A bright sun and clear sky seem to foretell prosperity in the beginning of my
Khimáriote journey, the most romantic as well as the most novel of my own (or
anybody else's) Albanian wanderings. I shall have six days for the excursion:
longer than that I must not stay, for by the 30th I should be at Arghyró Kastro,
or at least, Tepeléni; and on the 7th of November at Ioánnina, a plan of
arrangement necessary by way of timing steamers for Malta.

Messrs. J. and S. having politely volunteered to accompany me as far as
Kánina, I waited for them till past ten, grieving over the loss of what I always

consider the best part of the day. Hours, moreover, are valuable in a tour of this kind, apart from the loss of mountain shadows when the sun is high. After unpleasant potterings and fussings, horses brought without saddles, &c. &c., we at length moved off, attended by Anastásio my Khimáriote guide, and the black Margiánn, whose employment was to supply his masters with pipes unlimited. After having passed a ruined fort by the seaside, and the outskirt olive-grounds south of Avlóna, a strong and steep pull brought us over evil ledges of precipitous ascent to Kánina. But the journey was not rendered more pleasant by my hosts, for Herr J. being very slow, stopped every ten minutes for tobacco and entreated Herr S., who was of the liveliest, not to be so rapid. Thereby arose contentions betwixt the two, and the effect of the constant jarring was to make me reflect on friends who do not dwell in unity. By degrees we reached the fortress, one of the most commanding positions I have seen in Albania. On the one hand, you have the wide sea beyond Avlóna, its bay, and the Island Sázona; on the other, Tomóhr and Kúdhesi, with inland torrents and woods, and gorges infinite. This crowning fort of Kánina[1] occupies the highest point of the hill, and has long since been a heap of ruins, though the area of its walls still remain; below stands the modern town with its two or three mosques and scattered little houses. Some of the lower parts of the wall seem of very ancient workmanship, but I grew tired of poking into all the corners of the old citadel, the brothers being full of weary tales and surmises concerning its downfall. Among other matters, they say it was long the residence of the widow of Manfred of Sicily.

At eleven we went down to the town, and therein, to the gallery of a dervish's house, where two Cogias brought us coffee and pipes, after which our sitting broke up, and my late hosts returned to Avlóna, leaving me in charge of the Khimáriote, who, with a *pietone* sent with me by the Turkish police, formed my whole retinue. Down the opposite side of the hill of Kánina we rode. A small knapsack contained all my property (the fewest articles of toilette ever known to have been taken by a great coat (for there are snowy mountains to cross), and a large stock of drawing materials. I had arranged about payment of expenses, by giving Anastásio, who is a trustworthy servant of the Casa J., a sum of money, from which he is to defray all the outlay, and account to me for the same, though

I anticipate no great prodigality, as I am to live at the houses of the natives, and go from village to village, experiencing the full measure of Khimáriote hospitality.

Before one P.M. we reached the shore, and made for a little cove (there are many like it on the coast east of Plymouth), where a spring of pure and icy fresh water gushed from the foot of a rock into the sea, and offered a natural halting place for all who travel between Khimára and Avlóna. Kria Néra is the name of this seaside station; and it was pleasant to rest on a carpet thrown down on the smooth sand beneath the high rocks which shut in this little nook. Several peasants with their horses were resting here, and Anastásio and the policeman joined them in a lunch of bread and cheese; beyond them were grey cliffs and green dun heights - a strip of white sand and the long promontory of Linguetta stretching out into the gulf; the clear splashing sea at my feet, and above all the bright streaked sky. A quiet half-hour in such a scene crowds many a reflection into the tablets of thought, but such can have no place in journals.

Of the peasants halting at this natural khan with my own party, most were Khimáriotes going to Berát or other mid-districts of Albania; others are Beratini. These wild and rugged men have in general a forlorn and anxious look, and were clad in blanket-like capotes, their caps mostly white. "Some," saith Anastásio, "two years ago were '*roba fina de' ladri*,'"[2] but now Albania is purged of danger and romance, thieves and rebellion, from end to end.

But it was past one, and time to set off once more, for there were four long hours to Draghiádhes, the first Khimáriote village. The pathway was ever along the side of the gulf, and rose far above the blue, blue water. Anything more frightful than these (so-called) paths along the iron rocks of Acroceraunia it is not easy to imagine: as if to baffle invaders, the ledges along which one went slowly, now wound inward, skirting ravines full of lentisk and arbutus, now projected over the bald sides of precipices, so that, at certain unexpected angles, the rider's outer leg hung sheer over the deep sea below. To the first of these surprising bits of horror-samples of the highways of Khimára I had come all unknowingly, my horse turning round a sharp rocky point, and proceeding leisurely thence down a kind of bad staircase without balustrades. I declined, however, trying a second similar pass on his back, and at the first spot where there was safe footing, dismounted. Meanwhile the Khimáriote who ever and anon kept shouting,

"*Kakos dromos, Signore,*"[3] fired off his pistol at intervals, partly, as he said, from "*allegria,*"[4] and partly to prevent anyone meeting us in the dire and narrow way. When we had overcome the last of the *Kakos dromos* - lo! a beautiful scene opened at the narrow end of the gulf, which lay like a still and dark lake below the high wall of Khimára territory. Draghiádhes, the door, as it were, of Acroceraunia, stands on a height immediately in front, while the majestic snowy peak of Tchika (the lofty point so conspicuous from Corfu, and on the southern side of which stand the real Khimáriote villages), towers over all the scene, than which one more sublime, or more shut out from the world, I do not recollect often to have noticed. At the sea-side I stole time for a short sketch, and then remounting, our party rode on over the sands to nearly the end of the gulf, whence we turned off to the left, and gradually ascended to Draghiádhes. Flocks of sheep and most ferocious dogs abounded as we climbed higher; and Anastsio, never wearied of injunctions as to the awful character of the dogs of Khimára, especially of the two first villages. "It is true," said he, "I am responsible for your life, but at the same time you must do just as I bid you; for if you look at a dog of Khimára, there will hardly be anything but some of your largest bones left ten minutes afterwards!" which unfettered poetical flight seemed about to become a fact in the case of the *pietone*, who shortly had to defend himself from some ten of these outrageous beasts; they assailed him spite of all manner of missiles, and the battle's issue was waxing doubtful when some shepherds called off the enemy. As we advanced nearer to the town Anastásio's cheerfulness seemed to increase. "*Mi conoscono tutti,*"[5] said he, as each peasant hailed him by the title of "*Capitagno.*" With some he stopped to laugh and converse; others he saluted after the fashion of Albanian mock-skirmishes, drawing pistols or yataghan from his girdle, and seizing their throats with many yells, and between whiles he kept up a running accompaniment of a Greek air, sung at the top of an immense voice, and varied by pistol-shots at irregular intervals. We passed the village of Radima high above us, and after I had contrived to make another sketch, the scene momentarily grew finer as the descending sun flung hues of crimson over the lonely, sparkling town of Draghiádhes, and the bright peaks of the huge Tchika.

Presently we came to the oak-clad hills immediately below the town, where narrow winding paths led upwards among great rocks and spreading trees worthy

of Salvator Rosa, and not unlike the beautiful serpentara of Olévano. I have never seen more impressively savage scenery since I was in Calabria. Evening, or early morn, are the times to study these wild southern places to advantages; they are then alive with the inhabitants of the town or village gathering to, or issuing from it. Here were sheep crowding up the narrow rock-stairs, now lost in the shade of the foliage, now bounding in light through the short lentisk - huge morose dogs, like wolves, walking sullenly behind shepherds carrying lambs or sick sheep, and a crowd of figures clad in thick large trousers and short jackets and bearing immense burdens of sticks, or other rustic materials. These last are the women of Draghiádhes, for here and at the next village (Dukádhes), the fair sex adopt male attire, and are assuredly about the oddest looking creatures I ever beheld. Worn and brown by hard labour in the sun, they have yet somewhat pensive and pleasing in the expression of the eye, but all the rest is unfeminine and disagreeable. They are, as far as I can learn, the only Mohammedan women in these regions who do not conceal their faces - whether it be that their ancestors were Christians, and turning to the faith of the Prophet, did not think it worth while in so remote a place as Khimára, to adopt articles of such extra expense as veils, I know not, but such is the fact, and they are the only females of their creed whose faces I ever saw. "But," said Anastásio, "when we have passed Tchika, and are in true Khimára, out of the way of these Turks, then you will see women like women, and not like pigs. Ah, *Signor mio!* these are not women! - these are pigs, pigs - Turks - pigs, I say! For all that, they are very good people, and all of them my intimate friends. But, Signore, you could not travel here alone." And, although Anastásio certainly made the most patronising use of his position as interpreter, guide, and guard, I am inclined to believe that he was, in this, pretty near the truth, for I doubt if a stranger could safely venture through Acroceraunia unattended. Assuredly also all the world hereabouts seemed his friends, as he boasted, for the remotest and almost invisible people on faraway rocks, shouted out "*Capitagno*" as we passed, proving to me that I was in company with a widely-known individual.

At length we reached Draghiádhes, the houses of which were by no means pretty, being one and all like the figures of "H was a House," in a child's spelling-book. Alas! for the baronial castle or the palazzo of Italy! the whole place had the

appearance of a gigantic heap of dominoes just thrown down by the Titans. Sunset had given place to shadowy dusk as we passed below two of the very largest plane trees I ever beheld, where, in the centre of the village the trouser-wearing damsels of Draghiádhes were drawing water at a fountain - a strange, wild scene. Many came out to greet Anastásio, and all saluted me in a friendly manner, nor was there the least ill-bred annoyance, though I was evidently an object of great curiosity. Sending on the horses to the house we were to sleep at, we first went to one of Anastásio's friends, who would take it as a "*dispetto*"[6] if he did not visit him. I sat on the steps outside and sketched: the rocks of Calabria, with figures such as are to be seen only in Albania, gathered all around. How did I lament my little skill in figure drawing, and regret having so much neglected it! The long matted hair and moustache, the unstudied and free attitude, the simple folds of drapery, the expression of the individual, the grouping of the masses, all heighten the inconceivable originality of these scenes. Let a painter visit Acroceraunia. Until he does so, he will not be aware of the grandest phases of savage, yet classic, picturesqueness, whether Illyrian or Epirote, men or mountains; but let him go with a good guide, or he may not come back again. Acroceraunia is untravelled ground, and might not be satisfactory to a solitary tourist.

It was dark when we returned to the upper part of the town, and I was ushered into my host's house for the night - a large room on the ground floor - all rafters above and planks below, with a fire-place and fire in the middle of one end, and with carpets and cushions (of no very inviting appearance) on either side of the hearth. On to one of these I threw myself, and waited patiently for all further occurrences. Presently our host (whose name is Achmét Zináni, and who is a tall, thin, ancient Mohammedan, clad all in red, save a white kilt) having made me a speech profuse of compliments through Anastásio, brought two cups of coffee, and supper was supposed to be about to follow. Dirty and queer and wild, as this place is, it is far better than those Gheghe holes, Tyrana and Elbassán. At least the novelty and fine subjects for painting all about one, and the friendly relation in which the stranger stands with regard to the natives, makes him prefer Khimára, even at the outset. Previously to supper Achmét Zináni prayed abundantly, going through the numerous genuflexions and prostrations of

Mohammedan devotion in the centre of the room. After this the meal commenced.

The plan of Khimáriote hospitality is this: the guest buys a fowl or two, and his hosts cook it and help him to eat it. We all sat round the dish, and I, propping myself sideways on cushions, made shift to partake of it as well as I could; but a small candle being the only light allotted to the operation, I was not so adroit as my copartners, who fished out the most interesting parts of the excellent fowl ragout with astonishing dexterity and success. The low round plate of tin was a perpetual shelter for eight or nine little cats, whom we pulled out from beneath by their tails at momentary intervals, when they wailed aloud and rushed back again, pleased even by feeling the hot fowl through the table, as they could not otherwise enjoy it. After the ragout had nearly all been devoured, and its remains consigned to the afflicted cats, there came on a fearful species of cheese soup, with butter, perfectly fabulous as to filthiness; and after this, there was the usual washing of hands, "*à la turque*," and the evening meal was done. Supper over, we all sat in a semi-circle about the fire. Some six or eight of the townsmen came in - a sort of soirée - and drinking cups of coffee was the occupation for some hours. Albanian only is spoken, and very little Greek understood here. About ten or eleven, all but the family gradually withdrew; the old gentleman, Achmét, and the rest of the Albanians rolled themselves up in capotes, and slept. Anastásio placed himself across my feet, with his pistols by his side; and as for me, with my head on my knapsack, I managed to get an hour or two of early sleep, though the army of fleas, which assailed me as a newcomer, not to speak of the excursion cats, who played at bo-peep behind my head, made the rest of the night a time of real suffering, the more so that the great wood fire nearly roasted me, and was odious to the eyes, as a wood fire must need be. Such are the penalties paid for the picturesque. But one does not come to Acroceraunia for food, sleep or cleanliness.

OCTOBER 22nd

Before daylight all were on foot, and Anastásio had made a capital basin of coffee and toast, an accomplishment he had learned of Giorgio. Anxious to see the

bright sun after the night's penance, I ran to the door; but hardly had I gone three steps from it, when I felt myself violently pulled by the collar, and dragged backwards, before I had time to resist; a friendly assault on the part of Achmét and Anastásio, the motion of which was adequately explained by a simultaneous charge of some thirty immense dogs, who bounced out from the most secluded corners, and would straightway have breakfasted on me, had I not been so aptly rescued; certainly the dogs of Khimára are the most formidable brutes I have yet seen, and every wall and lane here seems alive with them.

"O *Signore!*" said Anastásio, in a tone between anger and vexation, "*tanto sciocco vuoi essere! Ti dico - sarai mangiato - amazzato - e se non vuoi far a modo mio, e tutto cio che ti dico di far quì in Khimára, sei morto; non voglio andar più in avante così; non andrai mai più fuor di vista mia!*"[7] So I promised I would in future be obedient, for after all it was plain that the Khimáriote was in the right.

I decided on making a drawing at Draghiádhes, before starting for Dukádhes, the next village, where I was to sleep tonight; for beyond that was the great pass of the Tchika mountain, which shuts in the Khimára coast, and to arrive at the further side of it would require more time than could be found today without hurrying. So I sat above the huge planes, and drew the view towards the gulf, very Poussinesque and fine; some twenty picturesque fellows sitting smoking round me, all infinitely polite. One of them who spoke Italian, volunteered a list of the Khimáriote villages in their consecutive order, from Draghiádhes. All of these I cannot hope to see; but I would fain get as far as Khimára, which gives its name to the whole district.

About nine we left Draghiádhes, and began to ascend towards the hill of Dukádhes, first through a tract of low wood, and then by an uninteresting gorge, down which the wind came with frightful force, making it very difficult to keep a footing on the loose stones of the watercourse, which was our road. Higher up in the pass, the violence of this sudden and furious mountain storm was such that both Anastásio and myself were knocked down more than once, and towards the summit we could only advance by clinging from rock to rock.

At the highest part of the pass a most singular scene opens. The spectator seems on the edge of a high wall, from the brink of which giddy elevation he looks down into a fearfully profound basin, at the roots of the mountain. Above its

eastern and southern enclosures rises the giant snow-clad Tchika in all its immensity, while at his very feet, in a deep, dark green pit of wood and garden, lies the town or village of Dukádhes, its houses scattered like milk-white dice along the banks of a wide torrent, which finds its way to the gulf between the hill he stands on, and the high western ridge dividing the valley from the sea.[8]

To this strange place, perhaps one of the most secluded in Europe, I began to descend, and as we slowly proceeded, halted more than once to sketch and contemplate. Shut out as it stood by iron walls of mountain, surrounded by sternest features of savage scenery, rock and chasm, precipice and torrent, a more fearful prospect, and more chilling to the very blood I never beheld - so gloomy and severe - so unredeemed by any beauty or cheerfulness. After a weary ride over rugged places in the bottom of this hollow land of gloom, we stopped at length at one of the houses of the village - standing, like every dwelling of Dukádhes, in the midst of a little garden or courtyard. Its general appearance was very like my last night's abode, only that we had to climb up a very odious ladder to the family "reception-room" which, besides being several shades dirtier than that of Achmét Zináni, had not the advantage of being on the first floor. Most of these houses consist of two stories, the upper floor, divided into two or three chambers, being allotted to the women of the family, the lower being a single large room serving for general purposes. It was half-past one when we arrived, and before I went out to sketch, Anastásio cooked a lunch of eggs roasted and fried in butter, of which he partook with the *pietone*.

This last accomplished person does not indulge in shoes, and I observe that when his hands are occupied, he holds his pipe in his toes, and does any other little office with those, to us, useless members. Throughout the whole of the day's journey I have seen numbers of women carrying burthens of incredible size and weight. From one hundred and fifty to one hundred and eighty pounds, I am assured, is no unusual loading. These poor creatures are indeed little like women in appearance, for their faces are worn into lines and furrows of masculine hardness by excessive and early toil; and as they labour pitifully up the rocky paths, steadying their steps with a staff, or cross the stony torrent beds, bent nearly double beneath their loads, they seem less like human beings than quadrupeds. A man's blood boils to see them accompanied by a beast of a

husband or brother, generally on horseback, carrying - what? - nothing but a pipe! And when he is tired of smoking, or finds himself over-clad, he gives the women his pipe to hold, or throws his capote over her load! The ponderous packages of wool, grain, sticks, &c., borne by these hard-worked creatures are hung to their neck by two strong straps; their dress is dark blue, with a blue handkerchief on the head, dark full trousers, no petticoat or apron, and red worked woollen gaiters. They are short and strongly made in person, with very light hair. Their eyes are almost universally soft grey, and very pretty, but the rest of the face, apart from the worn and ground-down expression, is too broad and square in form to be prepossessing.

In the afternoon I made drawings of Dukádhes, a gloomy sky and threatening storm adding to the inherent melancholy of the landscape. The lines around the town were on too gigantic a scale, and its houses too destitute of the picturesque, to supply much employment for the pencil; and the chilling sullenness of this dreary abyss of terror did not incline me to devote much time to its ungracious qualities. I was accompanied in my researches by Sulio, the *pietone*, Anastásio being engaged in finding mules for the morrow's ascent, since horses go no farther than this place - the threshold of Khimára; and I gave the last hour of daylight to delineating a tree full of Albanian idlers who sat smoking tranquilly on the gnarled wide-spreading branches of a huge ilex, which hangs over a precipice - as wild a piece of poetical painting as Salvator might wish for. At sunset, the indescribable dark terror of this strange place was at its full; yet unwilling to retreat to my night's prison till the last moment, I lingered on a rock in the middle of the ravine, while crowds gathered round me, saying, "Scroo, scroo, scroo," after their fashion, and were greatly pleased at my drawing them. At length it became quite dusk, and I went reluctantly to my second night-home in Khimára. The loft had a more comfortable appearance by fire-light than by day, inasmuch as its mysterious and suggestive gloom was more prepossessing than its bare walls. A rug was, as before, laid for me in the farther corner, fitting in between the wall and the wood fire, which is always made on a square sort of hearth projecting into the room. Two pillows, also, were in readiness; but mistrusting these adjuncts to luxury, I wrapped myself in plaids and coats, with my knapsack under my head. It is needless to say, the traveller reposes by night in

the same dress he wears by day, for it is by no means possible to change it on all occasions. Vunó, however, Anastásio's native town, is held out to me, with what degree of truth or poetry I know not, as a sort of metropolitan abode of the luxuries and graces, which are to atone for all privations endured previously to reaching that favoured spot. Meanwhile he informs me, that supposing I am desirous of seeing as much of Khimáriote manners and society as is possible, he has asked two gipsies (!) to pass the evening with us, they being great performers on the guitar, which they accompany with the voice; and as not improbably we might have a dance also, he had invited a Christian, one of his own friends (from Arghyró Kastro), staying at present in Dukádhes, to dine with us, a gentleman whose long dishevelled hair fell most dramatically over his shoulders, and who, like the rest of the "society," rejoiced in bare feet and gaiters. In fact, my arrival at Dukádhes seemed the signal for a sort of universal soirée; and I was to promote the general hilarity by the gift of an unlimited quantity of wine, an arrangement I willingly acceded to for the sake of witnessing "life in Khimára."

In an hour or two came in the usual round tin table, preceded by napkin and water, precursors of a good dish of hashed mutton, and a plain roast fowl, which, with tolerable wine, made no bad supper. After the repast is done, a process of sweeping always goes on, a mere form, but never neglected by these people; unwilling to incommode me, they swept all round me carefully, and now there was nothing to do but to announce the visitors.

Presently the company came, and queer enough it was! The two Messieurs Zingari, or gipsies, are blacksmiths by profession, and are clad in dark-coloured garments, once white now grey-brown; the contrast between them and the Albanians round them, all of whom nearly have light hair and florid complexions, is very striking. The gipsy, all grin and sharpness, who plays second fiddle, is continually bowing and ducking to me ere he squats down; but the elder, or first performer, is absolutely one of the most remarkable looking creatures I ever beheld; his great black eyes peering below immensely thick arched brows, have the most singular expression of cunning and ferocity, and his black moustache and beard enclose a mouth which, when shut, argues all sorts of tragic obstinacies, but, on opening, discloses a grin of brilliant ivory from ear to ear.

Take him for all in all, anything so like a diabolical South Sea idol I never yet saw living.

At first the entertainment was rather slow. The gipsies had two guitars, but they only tinkled them with a preparatory coquettishness; till another friend dropping in with a third *mandolino*, a pleasing discord was by degrees created, and increased to a pitch of excitement that seemed to promise brilliant things for the evening's festivities. Anastásio, also, catching the melodious infection, led the performers by his own everlasting Greek refrain - sung at the full power of a tremendous voice, and joined in by all present in the first circle - for now, many more than the chorus had entered the room, remaining seated or standing behind, and the whole formed, in the flickering light of the wood torches, one of the most strange scenes imaginable. Among the auditors were the *padrona* of the house (a large lady in extensive trousers), her daughter (a nice looking woman), and two pretty little girls, her grandchildren - all unveiled, as is the mode in Dukádhes. As the musical excitement increased, so did the audience begin to keep time with their bodies, which these people, even when squatted, move with the most curious flexibility. An Albanian, in sitting on the ground goes plump down on his knees, and then bending back, crosses his legs in a manner wholly impracticable to us who sit on chairs from infancy. While thus seated, he can turn his body half round on each side as if on a pivot, the knees remaining immoveable; and of all the gifted people in this way that I ever saw, the gipsy guitarist was pre-eminently endowed with gyratory powers, equal almost to the American owl, which, it is said, continues to look round and round at the fowler as he circles about him, till his head twists off.

Presently, the fun grew fast and furious, and at length the father of song - the hideous idol-gipsy - became animated in the grandest degree; he sang and shrieked the strangest minor airs with incredible accompaniments, tearing and twangling the guitar with great skill, and energy enough to break it into bits. Everything he sang seemed to delight his audience, which at times was moved to shouts of laughter, at others almost to tears. He bowed backwards and forwards till his head nearly touched the ground, and waved from side to side like a poplar in a gale. He screamed - he howled - he went through long recitatives, and spoke prose with inconceivable rapidity; and all the while his auditors bowed and rocked to and fro

as if participating in every idea and expression. I never saw a more decided instance of enthusiastic appreciation of song, if song it could be called, where the only melody was a wild repetition of a minor chorus - except at intervals, when one or two of the Tóskidhes' characteristic airs varied the musical treat.

The last performance I can remember to have attended to, appeared to be received as a *capo d'opera*. Each verse ended by spinning itself out into a chain of rapid little Bos, ending in chorus thus: "Bo, bo-bo-bo, BO! - bo, bobobo, BO!" - and every verse was more loudly joined in than its predecessor, till at the conclusion of the last verse, when the unearthly idol gipsy snatched off and waved his cap in the air - his shining head was closely shaved, except one glossy raven tress at least three feet in length, the very rafters rang again to the frantic harmony: "Bo, bo-bo-bo, bo-bo-bo, bo-bo-bo, bo-bo-bo, BO!" - the last "BO!" uttered like a pistol shot, and followed by a unanimous yell.

Fatigue is so good a preparation for rest, that after this savage mirth had gone on for two or three hours, I fell fast asleep, and heard no more that night.

Chapter XI

The horrors of a night in Khimára · The murder · Shrieks for the dead · Departure from Dukádhes · The mountain of Tchika · Its pine forests · Descent towards the sea · Distant view of Corfu · The Strada Bianca women considered relatively · Village of Palása · Anastásio and his history · Marriage among the Khimáriotes · Magnificence of the village of Dhrymádhes · A visit to "my aunt and uncle" · Village of Lliattes · Sunset, and arrival at Vunó · Superior accommodations of the Casa Kasnétzi · Anastásio's family · The marine bishop · Beautiful situation of Vunó · Its church and priesthood · Present circumstances of the Khimáriote villages · Customs of the Khimáriotes · Crying for the dead · Kasnétzi cousins · Marina Kasnétzi · Visit to the town of Khimára · Village of Pilieri · Acuteness of sight and hearing among the Albanians · Approach to Khimára · The eagles and fowl · Ascent to the town · The exile · Life in Khimára · Papa Nestore · Departure from the town, and return to Vunó.

OCTOBER 23rd

I am awaked an hour before daylight by the most piercing screams. Hark! - they are the loud cries of a woman's voice, and they come nearer - nearer - close to the house. For a moment, the remembrance of last night's orgies, the strange place I was lying in, and the horrid sounds by which I was so suddenly awakened, made a confusion of ideas in my mind which I could hardly disentangle, till, lighting a phosphorus match and candle, I saw all the Albanians in the room, sitting bolt upright, and listening with ugly countenances to the terrible cries below. In vain I ask the cause of them; no one replied; but one by one, and Anastásio the last,

all descend the ladder, leaving me in a mystery which does not make the state of things more agreeable; for though I have not "supped full of horror" like Macbeth, yet my senses are nevertheless "cooled to hear so dismal a night shriek."

I do not remember ever to have heard so horrid and deadly a sound as that long shriek, perpetually repeated with a force and sharpness not to be recalled without pain; and what made it more horrible, was the distinct echo to each cry from the lonely rocks around this hideous place. The cries, too, were exactly similar, and studiedly monotonous in measured wild grief. After a short time, Anastásio and the others returned, but at first I could elicit no cause for this startling the night from its propriety.

At length I suppose they thought that, as I was now irretrievably afloat in Khimára life, I might as well know the worst as not; so they informed me that the wailings proceeded from a woman of the place, whose husband had just been murdered. He had had some feud with an inhabitant of a neighbouring village (near Kúdhesi) nor had he returned to his house as was expected last night; and just now, by means of the Khimáriote dogs, whose uproar is unimaginable, the head of the slain man was found on one side of the ravine, immediately below the house I am in, his murderers having tossed it over from the opposite bank, where the body still lay. This horrid intelligence had been taken (with her husband's head) to his wife, and she instantly began the public shrieking and wailing usual with all people in this singular region on the death of relatives. They tell me this screaming tragedy is universal throughout Khimára, and is continued during nine days, commonly, in the house of mourning, or when the performers are engaged in their domestic affairs. In the present instance, however, the distressed woman, unable to control her feelings to the regular routine of grief, is walking all over the town, tearing her hair, and abandoning herself to the most frantic wretchedness. These news, added to the information that it is raining, and that the weather may probably prevent my leaving this delightful abode throughout this, or who knows how many more days, are no cheerful beginning for the morning, for one may be fixed here for some time, since the Tchika pass is impracticable in stormy weather. But towards eight the rain ceased; and although a drizzling mist still continued to fall, the *roba* was packed under lots of covers, and we started on mules, with bad saddles and packthread stirrups.

Bidding adieu to the hareem until my return, I was soon out of Dukádhes, spite of the multitude of dogs ready to devour me, at every garden and wall. A rude tract leads across the valley, ascending gradually, now over undulations of uncultivated turf or rich fern, and now dipping by rough ledges and slanting paths into tremendous chasms, which convey torrents from the northern face of Tchika to the river of Dukádhes, west of the valley.

Advancing nearer to the pass, the giant Tchika appeared more formidable at each approach - its pine-clad sides black in the sullen misty cloud; but as we descended the last cliff-walled abyss at the foot of the ridge or spur of the mountain which closes eastward the valley-plain of Dukádhes, driving clouds came furiously down, and thenceforth, to my great vexation, no more of the pass was visible. Toilfully we wound upwards, for an hour or more, among rocks and superb pines, now and then a cloud rolling away to disclose vistas of cedar-like firs deep below or high above in air. It would be difficult to see a finer pass even for foreground objects: such variety of crag and shrub - such huge pine-trunks slanting over precipices, or lying along the side of the path like ante-mundane caterpillars crawling out of the way of the deluge. At the top of the pass the driving fog became thinner, the "shrubless crags seen through the mist" assumed their distinct shapes, and we entered magnificent forests of beautiful pine and undergrowth of grey dak, with here and there a space of green turf and box trees, where great black and orange lizards were plentifully crawling.

At half-past ten we began to descend, and soon emerged from the clouds into bright sunlight, which lit up all the difficulties of what is called the Strada Bianca, or Aspri Ruga - a zigzag path on the side of the steepest of precipices, yet the only communication between Khimára and Avlóna towards the north. The track is a perfect staircase, and were you to attempt to ride down it, you would seem at each angle as if about to shoot off into the blue sea below you; even when walking down, one comes to an intimate knowledge of what a fly must feel in traversing a ceiling or perpendicular wall. Half way down the descent the long flat island of Fano, north of Corfu, is visible, and soon afterwards the end of Monte St. Salvador in Corfu itself: - a merry sight, and something of a foreshadowing of England in this far-away land. Immediately below the Strada Bianca lies a long tract of land between sea and mountain, showing the position of nearly all the

Khimáriote villages, the whole territory between the Adriatic and the western wall of hill being known generally as "Khimára." Lower down in the descent a migration of Khimáriotes - the most restless of people - met us; some eighty or one hundred women laden as never women were elsewhere - their male relations "taking it easy" up the mountain - the ladies carrying the capotes as well as babies and packages.

"Heavens!" said I, surprised out of my wonted philosophy of travel, which ought not to exclaim at anything, "how can you make your women such slaves?" "*O Signore,*" said Anastásio, "to you, as a stranger, it must seem extraordinary; but the fact is, we have no mules in Khimára, that is the reason why we employ a creature so inferior in strength as a woman is (*un animale tanto poco capace*). But there is no remedy, for mules there are none, and women are next best to mules. *Vi assicuro, Signore,* although certainly far inferior to mules, they are really better than asses, or even horses." That was all I got for my interference.

These Khimáriote women were of all ages, and many of them very pretty; their dress was a full white petticoat, with an embroidered woollen apron (worn behind, and not before!) The men were white capoted, strong-looking fellows, walking along with all that nonchalance and air of superiority so characteristic of Albanians; almost all the individuals spoke to Anastásio as a general acquaintance: - the whole party is on the way to Avlóna to work in the olive grounds there through the winter.

After having cleared the descent of Strada Bianca - a weary penance, the last part of it a little shortened by a steep flight of stairs cut in the perpendicular rock - we arrived at that extraordinary torrent which, descending in one unbroken white bed from the very mountain top down its seaward face, is known by mariners as '*il frame di Strada Bianca,*' or Aspri Ruga. Without doubt, this is a very remarkable scene of sheer mountain terror. It presents a simple front of rock - awful from its immense magnitude - crowned at its summit with snow and pines, and riven into a thousand lines all uniting in the tremendous ravine below, which, though now nearly dry, is in winter a torrent of destructive magnitude.

Crossing this great watercourse, our route lay at the foot of the hills, through ground more and more cultivated and cheerful, and about one P.M. we reached

the village of Palása.[1] Here we halted, after a good morning's work, in a sort of piazza near a disreputable looking church, sadly out of repair,

A few Khimáriotes were idling below the shady trees, and Anastásio was soon surrounded and welcomed back to his native haunts, though I perceived that some bad news was communicated to him, as he changed colour during the recital of the intelligence, and clasping his hands exclaimed aloud with every appearance of real sorrow. The cause of this grief was, he presently informed me, the tidings of the death of one of his cousins, at Vunó, his native place, a girl of eighteen, whose extreme beauty and good qualities had made her a sort of queen of the village, which, said Anastásio, I shall find a changed place, owing to her decease. "I loved her," said he, "with all my heart, and had we been married, as we ought to have been, our lives might have been most thoroughly happy." Having said thus much, and begging me to excuse his grief, he sat down with his head on his hand, in a mood of woe befitting such a bereavement. Meanwhile I reposed till the moment came for a fresh move onwards, when lo! with the quickness of light the afflicted Anastásio arose, and ran to a group of women advancing towards the olive trees, among whom one seemed to interest him not a little, and as she drew nearer I perceived that she was equally affected by the chance meeting; - finally, they sat down together, and conversed with an earnestness which convinced me that the newcomer was a friend, at least, if not a sister, to the departed and lamented cousin of Vunó. It was now time to start, and as the mules were loading, the Khimáriote girl lingered, and I never saw a more exquisitely handsome face than hers: each feature was perfectly faultless in form; but the general expression of the countenance had a tinge of sternness, with somewhat of traces of suffering; her raven tresses fell loose over her beautiful shoulders and neck, and her form from head to foot, was majestic and graceful to perfection; her dress too, the short, open Greek jacket or spencer, ornamented with red patterns, the many-folded petticoat, and the scarlet embroidered apron, admirably became her. She was a perfect model of beauty, as she stood knitting, hardly bending beneath the burden she was carrying, her fine face half in shade from a snowy handkerchief thrown negligently over her head. She vanished when we left Palása, but re-appeared below the village, and accompanied Anastásio for

a mile or more through the surrounding olive grounds, and leaving him at last with a bitter expression of melancholy which it was impossible not to sympathise with. "*Ah, Signore*," said Anastásio, "she was to have been my wife, but now she is married to a horrid old man of Avlóna, who hates her and she hates him, and so they will be wretched all their lives." "*Corpo di Bacco!* Anastásio, why you told me just now you were to be married to the girl who has just died at Vunó!" "So I was, Signore, but her parents would not let me marry her, so I have not thought about her anymore - only now that she is dead I cannot help being very sorry. But Fortina, the girl who has just gone back, was the woman I loved better than anybody." "Then why didn't you marry her?" "*Perchè, perchè*," said the afflicted Anastásio, "*perchè*, I have a wife already, Signore, in Vunó, and a little girl six years old. *Si signore, si.*"

So much for the comfortable arrangement prevalent throughout this country[2] - of marriages being arranged beforehand by the parents of the parties, independently of the individuals most concerned in the matter, for the refusal of a bride by the bridegroom, if the lady be once brought so far as his house, is strongly resented by her family: - notwithstanding which, Anastásio, by his own account, greatly rebelled against orthodox Greek rules, and told his parents that if his bride (a girl of Arghyró Kastro, and a relative of his mother's kinsmen) were not sufficiently agreeable or good-looking, he would not have her at all; and therefore they were obliged to connive at their wilful son's seeing his betrothed ere they set out, lest the chiefs of the bride's house should be outraged by a refusal at the eleventh hour. This occurred at Délvino; and his account of being permitted to look at the lady through the opening of a door was amusing, - how she was sitting down, and how he said, "*O, Signora, camminate! Camminate, per l'amor del cielo; - perchè voleva vedere se non zoppicasse.*"[3]

From Palása to Dhrymádhes (the next in the line of Khimára villages) the route is comparatively uninteresting, except inasmuch as the great features of the Khimára country - the bright blue sea on one hand, and the high mountain-wall on the other, were always attractive. About half-past two we arrived at another deep fissure or torrent-chasm, cloven from the heart of the mountains to the sea, and here, perched and thrust in all possible positions among the rocks of the ravine, stands Dhrymádhes, more magnific in its situation than any of the

places I had hitherto seen in Acroceraunia, and not a little resembling Atrani, or Amalfi, or Canalo in Calabria, though the beauty of architecture in those Italian places is ill-supplied by the scattered and formless collection of houses that hangs on the brink of the craggy gorge, through whose narrow sides remote peeps of the lofty summits of Tchika are visible.

Sending on Anastásio and the mules to a house he indicated on the further side of the ravine, I remained behind to sketch, and was soon surrounded by curious observers; all, however, treated me with the greatest good breeding, and one old gentleman begged me, in Italian, to favour him by taking some coffee in his house. The Khimáriotes are in the habit of using the Italian tongue more than any natives of Albania, a practice induced by their wandering lives and frequent intercourse with Corfu, Naples, &c.

To sketch Dhrymádhes hastily was impossible; so, trusting to draw it on my return, I hurried onward round the head of the gorge, and found Anastásio at the house of one of his uncles - a quiet, unpretending dwelling, reminding me of many at Sorrento, or other Italian places. The civilization of this part of Albania seems indeed (speaking of the indoor enjoyments of life) far beyond what I have yet seen; and my surprise was great on observing the clean white-washed walls of the rooms I was taken to, - the rows of jugs, plates, &c., on shelves, the chairs and four-post bedstead, with tidy furniture, and every other comfort in proportion.

"*Zia mia!*"[4] said Anastásio of a nice-looking, middle-aged woman, and "my uncle" was a fine specimen of a Palikar, in appearance venerable, perfectly gentlemanlike in manner, and speaking Italian fluently. All Khimáriotes have great store of adventures to tell you, and one might collect a good book of anecdotes from these roving people. "My uncle" was one of the Khimáriotes taken by Ali Pashá as hostages, and was long imprisoned at Ioánnina; he was also in the French-Neapolitan service, and more lately, one of Lord Byron's suite at Missolónghi, so that he had seen a variety of life. Promising if possible to stay with these good-natured people on my return, and having partaken of some very tolerable wine, I left them, and as the mules were to go back hence to Dukádhes, the little *roba* I had with me was strapped on the backs of two women (according to Anastásio, the best mode of conveyance in default of better), and sent onward to Vunó.

Rapidly as a traveller but glances at a country in this mode of journeying, the pencil conveys a far better idea of it, and in a few lines, than an inexperienced pen can hope to do with any amount of description; it is sufficient, therefore, to say that all Khimára is full of picturesqueness, well worthy the study of a landscape painter. A wild tract of rugged nature succeeds to Dhrymádhes, and in one hour I reached Lliáttes, the third village. It consists of a little knot of houses, standing in gardens of olives; an oasis of cultivation which seems a rare exception to the general barrenness of this part of Khimára, though closer to the sea there appears to be a considerable portion of more fertile land.

After a halt of ten minutes at Lliáttes, where some of Anastásio's invisible friends brought us some fresh water at his call, I am again walking over rock and plains of lentisk, till I reach the last ravine, previously to arriving at Vunó, a deep chasm between red cliffs, much like those in the neighbourhood of beautiful Civita Castellana, and which, according to Anastásio, runs widening to the sea, and renders all progress by land impossible, except by the track we are now pursuing, at the very root of the mountains. The view of Corfu, above this long perspective of ravines, is exceedingly beautiful, and tempted me to linger till the setting sun warned me to hasten.

The bright orb went down like a globe of red crystal into the pale sea, and the fiery hued wall of jagged Acroceraunian mountains above us on our left grew purple and lead-coloured, yet there was still half an hour's hard walking to be accomplished; and before I turned the angle of the little ravine of Vunó, there was only light enough to allow of a vague impression of a considerable town filling up the end of the gorge, without being able to discern the numerous excellencies of a place, of which Anastásio was constantly remarking in a triumphant tone, "*Ma, Signore, quando si vede Vunó!*" as if Paris or Stamboul were nothing to it. We passed what seemed a large building, which my guide said was "*casa di babba,*" the house of his uncle, who was head of the family (his father having been a second son), and soon came to the paternal roof, now the property of his own eldest brother; for Anastásio is a *secondo-genito*, and obliged to get his living "*à la Khimáriote,*" as he can. His mother still resides in her deceased husband's house, as do Anastásio's wife and child, besides Kyr Kostantino Kasnétzi, the eldest brother, with his children, he being a widower.

All this domestic crowd, joined to a great variety of nephews and cousins, was waiting to receive us as we entered a courtyard, from whence we ascended to a spacious kitchen, where the females of the family saluted me with an air of timidity natural to persons who live in such oriental seclusion. The manners of Anastásio towards this part of the community appeared to me to savour a good deal of the relation between master and slave; and now that my guide is at home, he walked about with a dignified and haughty nonchalance very different from the subdued demeanour of the domestic in the Casa J. at Avlóna.

I was led again up stairs to a large octagonal room, panelled and closeted, and fitted up with sofas, &c., in the usual Turkish style; but the presence of many et cetera announces a people of very different habits to those of the wild Gheghe, or rude inhabitants of Dukádhes. A small four-post bedstead stands in one corner; half a dozen side tables adorn the sides of the room, with intervening chairs; the walls are whitewashed; there are chests of drawers; the centre of the ceiling is tastefully ornamented with dried grapes, hung in patterns; and round four sides of the chamber, shelves, thickly covered with jugs and other crockery-ware, complete the list of domestic small comforts. The windows are very small, and several loopholes in the exceedingly thick walls allude distinctly to the days of predatory warfare, when people shot their enemies out of the first floor window. No sooner was I settled, glad enough to rest on the low sofa, than Anastásio's little girl, an exquisitely pretty child of three years of age, with eyes like black beads, came into the room, very cleanly and nicely dressed. Down she sat, and taking my hand in hers, began to sing in the prettiest manner possible, with as little shyness as if she had known me all through her short life. Next came the *capo di casa*, the eldest brother, Kostantino, a rough but prepossessing fellow, with moustache enough for ten. He spoke no Italian, so our converse was confined to Greek common-places, while Anastásio talked in his stead, and assured me that his brother was a man of extreme wisdom and attainments, and by profession a doctor. "*O Signore! è un uomo chè sa assai - per Bacco! sa tutto! E medico.* Two years ago, there was a boy of Vunó who threw a stone at another little boy. He broke his head and filled it full of bones; full, I say! *pieno, pieno, dico, di osse; osse grande ed ossi piccole, pieno, pieno*; but the learned man (*tanto dotto è*) pulled them all out

- *tutte, tutte - si, Signore -* every one! and the little boy lived for ever afterwards in great health and prosperity."

After the usual preliminary coffee, two or three Vuniote cousins came in, and among them one who had been at Corfu and Vido, where he had picked up some very lively and energetic samples of the English language more surprising than proper, with which he seasoned his broken Italian oddly enough. His stories were numberless, and there was no help but to hear them. One of the least comprehensible was of a lord, a *grandissimo mylordos*, who had a *cootter con tanti marinari: e con questo cootter il gran lordos sempre girava il mondo ogni anno - e sempre aveva un vescovo dentro il cootter*; but the name of this circumvoyaging lord, or that of the marine bishop, I could not learn.

Supper consisting of a fowl excellently boiled and stewed, was brought in by Anastásio and his brother, and they waited while I ate; but I gave them decidedly to understand, that I would take my meals with the family while in their house, for as I had been hail fellow well met with all the gipsies and dirty people of Draghiádhes and Dukádhes, I did not see why I should be more magnificent in Vunó, especially as I had here a chance of seeing somewhat of decent Khimáriote ways.

OCTOBER 24th

The comparative luxuries of Vunó, the clean bed and quiet room, &c., can only be duly valued by those who have passed such nights as my last two in Albanian villages. Soon after sunrise I set off with book and pencil, accompanied by ten or fifteen of Anastásio's cousins, and soon found enough below the town to occupy me for three or four hours. Like the village of Dhrymádhes, Vunó is placed fronting the sea at the base of the mountains, in a sort of horseshoe-formed hollow at the head of a ravine. A series of rock terraces support the houses, behind which the hills rise magnificently in a bay or semicircle, and towards the sea the land slopes rapidly to the level tract of ground, which is, perhaps, broader below Vunó than at any part of the Khimára country I have passed. I was surprised at the extent and character of the buildings at Vunó, some of which, those of the Kasnétzi family in particular, were more like *palazzi* in many Italian provincial towns than

dwellings in Albania; and the whole village has an air of neatness and regularity for which I was quite unprepared. The spot where I sat was bright in the morning sun; groves of thin olives and small oak threw a pleasant shade over the meadow. Several of the picturesque people of the village were playing at quoits near me, and the quiet repose of the scene was a great treat after the unrest of the last few days. Close by stood the only apparent church in the place, and that was a very small one. Indeed, the state ecclesiastical does not seem very nourishing at Vunó, for on my inquiring of Anastásio how many priests there are in his village, he answers: *"Due: uno x'e ammalato; e l'altro non si sa dov' è."*[5]

At eleven I returned to the Casa Kasnétzi; and it is worth remarking, that one of the most pleasing points of civilization in Vunó, consists of the possibility of walking about this compact town where the stranger pleases, without fear of being torn to pieces by rabid mountain dogs, as he infallibly must be in Dukádhes and Draghiádhes, where the dwellings are scattered in gardens, and where flocks are the great commodity of life, instead of wine and corn - not that there seems too much of that - produced by the Khimára strip of plain.

Anastásio's warbling little girl came and amused me till noon, when dinner was served on the usual tin table, in the shape of a good substantial meal of rice soup, boiled and stewed mutton, with the best wine I had tasted in Albania. It would be most interesting for a person well versed in Romaic (which nearly all here speak, or at least understand), to travel through Khimára, and by remaining there for some time, glean detailed accounts of the habits of life among these primitive people. As for me, I could only arrive at snatches of information by means of Italian, which many of the Vuniote men speak. On my asking Anastásio if his wife and mother were not coming to dinner, he replied that the women never eat with the men, but that his wife, Marina, would come and wait on us at supper, as by that time she would have less *vergogna*[6] of a stranger, an uncommon sight to Khimáriote females.

Since the days of Ali Pashá, the great puller-down of all high persons and places in Khimará (for up to his time it had existed as a set of little republics, nominally dependent on the Porte, but willing at any time to join its enemies), the villages of the Khimáriote district pay certain taxes to the Turkish Government through the Pashá of Délvino, in whose pashalik their territories are included; but

no Turk, or rather, no Mohammedan, resides in any of the towns (I do not include Draghiádhes, Radima or Dukádhes as within Khimára), and they may be said still to enjoy a negative sort of independence, though their power of union in resistance, as a body of Greek Christians, is virtually as much gone as that of Parguinote or Suliote, whose habitations, and almost names, have passed away.

Anastásio relates that two years back a Turkish Bey, with troops, came on a recruiting tour through this territory, and quartered one hundred men in the house of his father and uncle, during whose stay, the "*spavento*"[7] of the Khimáriote women and the "*rabbia*" of the men was unbounded. For four days the women were shut up under lock and key in closets and cellars, and the Bey nightly intoxicated himself with rakhee, making a horrible row, and amusing himself by firing off pistols all about the room and through the ceiling, the damage done by which facetious diversion is visible enough to this day as proof. One of these pistol-balls nearly killed the wife of Kostantino Kasnétzi, and he and Anastásio thereupon confronted the Bey, who finding his own men disposed to take part against him, consented to evacuate Vunó on the morrow. But, with the exception of such rare visits, or the passing through of the Pasha of Délvino's guards in search of some criminal, Khimára is a tranquil place, though its inhabitants are forbidden to bear arms; and in consequence of various modes of depopulation - such as wandering abroad, enlisting in the Sultan's armies, &c., They are now but a thinly scattered and broken people.

While this conversation was proceeding, there arose the wail for the poor girl, the cousin of the Kasnétzi, who died three days ago. It was, as at Dukhádhes, a woman's cry, but more mournful and prolonged, with sobs between nearly each cry; and when the first wail was over, a second female took it up in the same strain. Nothing can be more mournful than this lament for the dead; yet there seems to be a sort of pride in executing the performance well and loudly, for when I spoke of the sadness of the sound - "Ah, Signore!" said Anastásio, "*ci sono altre chi piangono assai meglio di quella!*"[8] The death of this cousin led the eldest brother to apologise much for the curtailed hospitality which iron custom compelled them to show to me under the circumstances. They should have killed a sheep, they would have had a dance, and all sorts of fêtes, &c., &c.; but on the decease of near relatives, no *allegria* is ever permitted for nine days. There was much

131

animated conversation at dinnertime relating to the domestic affairs of an uncle and aunt of the Kasnétzi. The latter was lately remarried to a Khimáriote, and he was already tired of his bride, and inclined to leave her. "*E perchè?*" said Anastásio; "*E divenuta sorda! ed eccovi tutto!*"[9] But although the party agreed that the *povera donna* had no other fault but a growing deafness, still they were equally of accord that the uncle might purchase a separation from the bishop of the diocese by means of so many dollars, even for no sufficient reason. Anastásio concluded the discourse by saying, that if his aunt was forsaken legally or not, he should "*amazzare*"[9] the *zio* forthwith. The Khimáriotes appear to have a code of some very severe laws, and all tell me that they know no instance of their ever having been broken through. Those for instance for the punishment of conjugal infidelity insist on the death of the woman, and the cutting of ears and nose of the other offending party. Two of three instances have occurred among the various towns in the memory of my informers, and one gentleman whose head is unadorned with ears or proboscis, I have myself seen. Another was pointed out to me today, as a man who made a great disturbance in Vunó by destroying the peace of one of its best families. The wife was instantly put to death, but her paramour escaped and remained abroad for two years, when he returned, and is now settled here. "But," said I, "how did he remain unpunished?" "Because he escaped." "But why, since your severity in these cases is so extreme, why was he allowed to return?" "Because we killed his father instead of him!" "O, *cielo*, but what had his father done?" "*Niente! Ma sempre ci vuol qualcheduno ammazzato in queste circonstanze; e così, abbiam preso il padre.* Somebody must have been killed. *E lo stesso - basta così*"[10] - an obliquity of justice alarming to parents with unruly offspring.

After drawing some of the innumerable cousins of the house of Kasnétzi - each of them a picture (though from their sense of mourning I could not get sketches of any of the females) - I went out, and drew Vunó from the north, until sunset, surrounded by groups of Khimáriotes, a naturally well-behaved set of people, whose conversation was intelligent and various, and whose interest in my drawing reminded me of Abruzzi and Calabria.

At supper, when a dish of beef fried in batter was placed on the table, Marina, the wife, waited with water and towel. We were a select party of her husband and his brother and three cousins - so that she was able to overcome her

vergogna sufficiently to remain in the room. It is not surprising that Anastásio locked her up while the Turks were in the house - for a more lovely creature it is impossible to imagine. Her face was perfectly Greek in outline and form, and her eyes of the softest dark blue imaginable. Her figure was thoroughly graceful, and her expression so simple and pure as to resemble that of a saint drawn by one of the early masters; at present being in mourning, her dress was dark grey, unornamented in any manner, but on a festal day I could have liked to see her in full Greek splendour of costume.

Tchibouques and conversation made the hour of rest a late one. Even now, after the lapse of so many years, a foreigner perceives that the awful name of Ali Pashá is hardly pronounced without a feeling akin to terror. I am most curious to see the places where his great genius and power were so conspicuous.

OCTOBER 25th

Long before day, two women at once had begun their mournful wail for the dead in the house immediately adjoining this. The sun was not yet up, and Corfu, like an island of opal seemed to float on the pale grey sea at the cloudless pink horizon. At half-past seven, I set out for Khimára - the town so called is considered as the capital of this district, to which it gives its name - although Vunó is now by far the most flourishing of all the villages. Anastásio, and a "*Germano*,"[11] with a "*mosca*," which, Albanitically speaking, means a mule - were my suite; but I preferred walking to jolting on those wooden quadrupeds, over such break-neck places as our track passes.

For more than an hour after we left Vunó, we followed paths crossing sandy chasms. We then approached a most savage pass in the mountains which here advanced close to the sea. Above, in clouds and air, hung one of the Khimáriote villages, Pilieri, and on all sides were inaccessible precipices - inaccessible at least to any but Khimáriote women, who, in their daily avocation of gathering sticks and brushwood for firing, climb to the most fabulous spots. I watched some who were throwing down great bundles to their companions in the ravine below from sheer rocks of stupenduous height; and ever as we walked on, numbers of these Vuniote females emerged from chasm and cliff, appearing like animated trees, or

great balls of black wood - all crouching beneath portentous burdens of boughs or green brushwood, and each answering to Margaritas or Marinas as my guides called to them from incredible distances. The acuteness of sight and hearing in Albanian mountaineers is beyond description prodigious, and their faculty of conversing at great distances almost supernatural. The ordinary obstacles which under such circumstances mortals find to communication, seem in their case entirely removed.

The whole of this pass was of a thoroughly wild character, and the paths through it worse than any which I had seen in Khimára, and consisted of mere shelves or ledges of crumbling earth halfway down perpendicular rocks, or fallen masses of stone. The broad watercourse, or ravine, in which the pass terminated, widened out gradually between lower hills, and shortly opened in a view of the formidable Khimára itself - perched on a high isolated rock, the torrent running below it to the sea, with Corfu forming the background of the picture. Khimára is now a ruined place, since its capture by the overwhelming Ali Pashá, but it still retains its qualities of convenient asylum for doubtful or fugitive characters: for what force can penetrate the fastnesses by which the rock is surrounded, without time being given to the pursued to escape beyond the possibility of capture?

At the foot of this celebrated Acroceraunian stronghold I sat down to sketch, before scaling the height. Several Khimáriotes descended to speak with Anastásio, among others the priest of the town, in a tattered blue robe, flowing black beard and red fez. There came also two old women, with the hope of selling some fowls, which they incautiously left on a ledge of rock a short way above us, while they discussed the terms of the purchase with Anastásio. But behold! two superb eagles suddenly floated over the abyss - and pounced, carried off each hen. The unlucky gallinaceae screamed vainly as they were transported by unwelcome wings to the inaccessible crags on the far side of the ravine, where young eagles and destiny awaited them. Hereupon the two old ladies set up a screeching wail, almost as loud as that in use for the departed relations, and were only to be quieted by being presented with the price of the hens (about twopence each), which had been carried off so unsatisfactorily to all parties excepting the inmates of the eagle's nest. The sketch done, I began to ascend the rock, which was only easily accessible on the eastern or mountain side, and numbers of the inhabitants came

down to salute and examine so novel a creature as a Frank, for by the accounts of the people - how true I know not - I am the second Englishman who has been here. From Avlóna hither, I do not find that any English traveller has yet penetrated; no great wonder, considering the nature of the country.

The houses of Khimára are all of dark stone, and bear signs of having seen better days. On every side were heaps of ruin and a great extent of rubbish, with walls of different dates proclaiming this remarkable Acropolis to have been once a considerable place.[12] The people of Khimára are all of Greek origin and speak Romaic, though those of the towns I have passed on my way, although Christian, are all Albanian with the exception of a few families such as the Kasnétzi. The Khimáriotes of this place declare that the town contains vestiges of sixty-two churches. There are some remains of fifteen or sixteen on the lower part of the rock, but all in a state of total ruin, and the appearance of the Ecónomo of Khimára is in complete accordance with that of his native ecclesiastical edifices.

As I walked slowly up the zigzag path to the entrance of the town, I had leisure to examine my numerous new acquaintance, whom I thought by far the most wild and most typical of Albanian character that I had yet seen. The men wear their hair extremely long, and walk with the complete strut of Albanian dignity - the loftiest and most sovereign expression of pride and independence in every gesture. As for the females, I saw none, except a few of the heavy stick-laden, who were toiling up the hill, clad in dark blue dresses with red aprons (worn behind), and red-worked hose. Guided by Anastásio, who seemed here, as elsewhere, a general acquaintance and was greeted with excessive hilarity, we proceeded to a house, where, in a dark room of great size, a mat and cushions were spread for me, and there was no lack of company. A very aged man, more than a century old, occupied a bed in one corner. A screaming baby in a cradle on the opposite side illustrated another extreme point of the seven ages of the family. Two or three women, retiring into the obscurest shade, seemed to be knitting, while circles of long-haired Khimáriotes thronged the floor.

Many of these, both outside and in the house, extended their hands for mine to shake, I supposed from being aware of Frank modes of salutation; but among them, three or four gave me so peculiar a twist or crack of my fingers, that I was struck by its singularity; though it was not until my hand had been held

firmly for a repetition of this manoeuvre, accompanied by a look of interrogation from the holder, that the thought flashed on my mind, that what I observed was a concerted signal. I shortly became fully aware that I was among people, who, from some cause or other, had fled from justice in other lands.

Of these was one who, with his face entirely muffled excepting one eye, kept aloof in the darker part of the chamber, until, having thoroughly scrutinized me, he came forward, and dropping his capote, discovered to my horror and amazement, features which, though disguised by an enormous growth of hair, I could not fail to recognize. "The world is my city now," said he: "I am become a savage like those with whom I dwell. What is life to me?" And covering his face again, he wept with a heart-breaking bitterness only life-exiles can know.

Alas! henceforth this wild Alsatia of the mountains - this strange and fearful Khimára - wore to my thoughts a tenfold garb of melancholy, when I considered it as the refuge, during the remainder of a weary life, of men whose early years had been passed in far other abodes and society.

This specimen of "life in Khimára" had taken away my appetite; and when the dinner, long preparing, was set before us, in the shape of a substitute for the eagle-devoured hen, I could not eat what would otherwise have been a welcome refreshment. Accordingly I originated a move to visit the western or seaward side of the town, glad to shake off mournful feelings in the gay sunlight; nor was it to be forgotten that the same daylight was wearing away, and it was yet far to Vunó.

Papa Nestore led the way, up narrow, dirty, shattered streets, to what he called the *fortezza*, three or four tiers of regular Hellenic architecture, mixed at intervals with superadded structures of modern times. The lower part of these ancient fortifications was extremely massive and strong. We then went down, on the west side, to a platform overlooking all the territory belonging to the town, from the foot of the rock to the sea, including apparently a good tract of cultivated land. Hence the view of Khimára, backed by the mountains, forms a most magnificent scene, and I sat down to "*scroo*" it, with some thirty or forty wild Khimáriotes crowded around me; after which, resisting the importunity of our morning's host to return to his house, I set out on my retreat to Vunó, followed by adieux in several languages, shouted to me from this home of the homeless. I would fain visit the farther villages in the line of the Khimára coast; but if I am

able to do so, the journey must be made from Délvino. We hurried on to the entrance of the gorge leading inwards to the hills, and soon were shut out by the pitiless rocks from all sight of Khimára.

Far up the ravine there was a detached rock, covered with Greek inscriptions; I mean modern names, inscribed in Romaic. "*Tutti scrivono,*" said Anastásio, "*scrivete anche voi!*"[13] so as I defaced nothing by the act, I added my name to the visitors' book of the Pass of Khimára, the only Englishman there, and it will be long before there are many more. Much time must elapse ere Khimára becomes a fashionable watering-place, and before puffing advertisements of "salubrious situation, unbroken retirement, select society, and easy access from Italy" meet the eye in the daily papers of England. In the stony river-bed, we fell in with three armed Albanians of Délvino, and they instantly commenced a sham fight with Anastásio, as did the Kawás of Berát, by seizing throats, firing pistols, laughing and screeching uproariously. I left them at this pastime, and wound up the path of the ravine, whence, looking down, I perceived the men of war examining my three-legged sketching-stool, carried by Anastásio, with every kind of experimental sitting.

The sun was low by the time all the precipices and chasms were past, and as we entered Vunó, it seemed, by comparison with Khimára, a city of palaces. Coffee and pipes, administered by the charming Marina, were well earned after a hard day's walk; and after little Alessandra Kasnétzi had sung her usual melodies, supper and conversation ensued - Kostantino, the brother, eating nothing, because it was a fast day, which Anastásio heeded not, saying he was on a journey. All the family looked over my drawings, until bed-time, and were delighted with the people delineated.

The poor woman next door is still wailing, filling the air with her monotonous cry.

Chapter XII

OCTOBER 26th

Daybreak and wailing; wailing at night, wailing at morn. Shrieks and Khimára will ever be united in my memory. Some clouds are gathering over the sea, but the hills are as clear as they have been for two days of cloudless sunshine. I would we could pass that formidable Tchika today, but we must halt for the night at Palása. About eight I left Vunó, on my return to Avlóna. All the Kasnétzi family

assembled to take leave of me, and I shook hands with the mother and Marina, a proceeding greatly diverting to the whole household. A more agreeable and respectable set of people, as far as I have seen during my short stay among them, it is long since I met with. So, Anastásio fired off his pistol at the last point of the rock where the town was visible, and I went on my way to dine and draw at Dhrymádhes, which I reached at half-past ten. After making a polite call on the *zia*, the sister of Dhimitri Kasnétzi of Vunó, and wife of the gentlemanly one-eyed Palikar, I drew constantly till noon, the magnificence of this place being inexhaustible. Several of the villagers squatted round me; and while Anastásio was gone away for a time, some of them asked me "If I had an order from the Sultan to write down this town?" So constantly and not very unnaturally is the idea of political espionage ever associated with the act of topographical drawing.

The Dhrymádhiotes also inform me that snow is sent in great quantities hence to Corfu, and that it is gathered from the summit of Tchika, now glittering above me, by women of the village. There are but few good houses in Dhrymádhes, and it seems far below Vunó in the scale of general comfort and civilization.

At one, dinner was served at the aunt's, in the same manner as throughout all these villages - plain boiled fowl, bread and cheese, being the principal articles of food. The *zio* relates that up to Ali Pashá's time, the Kasnétzi family was not only the first in Vunó, but in all Khimára; but the Vizier took all their plate and goods and thoroughly ruined them, with all the other proprietors of the district - a statement quite consistent with his known levelling policy, and the extent of his genius for grinding and oppression. The golden age of Khimára's liberty seems to have been in the days of the Pashás of Avlóna, before Ali had swallowed up all Albania; but since his reign, this restless race is withered and broken. "We serve the Sultan," say they, but if asked whether they are Albanians, Christians, or Turks, they say - "Neither; we are Khimáriotes."

We had left the clean and comfortable dwelling of the aunt and uncle, and were threading a little lane, before we had turned the end of the deep ravine which divides Dhrymádhes into two portions, when a frightful shrieking burst forth from the upper room of a house immediately over us. Anastásio became fixed as a statue as another house took up the cry, and then another, and so on

till the echoing chasm of Dhrymádhes, with its scattered dwellings above and below, resolved itself into one dismal howl.

"It is my uncle's brother," said Anastásio, the man of many relatives, "I heard he was ill, but did not know he was in such danger. That is his house, and he has died there just this very minute. That was his daughter who first began the death-shriek, and as all Dhrymádhes are more or less nearly related to his family, you see, *Signore*, the wailing is general. *Ringraziamo Dio*," he went on to say, "let us thank Heaven that we have dined! For if this old gentleman had died ever so little earlier - *una mezz'ora piu presto* - we could not have had anything to eat, for the Khimáriotes dress no food on the day a near relative dies. *Dunque, Signore mio, ringraziamo Dio che abbiamo gia pranzato!*"[1] After this novel reflection on the death of his aunt's brother-in-law, we passed over to the further side of the ravine, and I had time for a large sketch of this surprisingly grand place. "*Sentite! O sentite, Signore!*" said Anastásio, "*quella e la mia zia che piange! -* my aunt has now heard of her brother-in-law's death, and that loud cry is hers! *Piange davero, come piange bene!*"[2] as if this fearful shrieking, so characteristic of Khimára, were the most charming of accomplishments, any excellence in the performance of which was greatly appreciated.

There was a group sitting near me all the time I was drawing, formed of an aged man, weeping plenteously, who appeared with much energy to oppose a host of reasoners and advisers of all ages, and among them a pretty girl, who might have been his granddaughter, that were sympathising with and trying to console him by caresses. Unluckily they talked Albanian, so the tragedy was a riddle to me, until Anastásio explained to me that the old man's son had just been seized, by mistake, at Berát, for a robbery; and although the real culprit had been subsequently captured, yet by some error of the judicial authorities the innocent victim was not yet liberated. The old man's friends were advising him to bribe some of the grandees of Berát, but he, setting forth his poverty, became at last so angry with his Job's comforters, that he stamped and raved in fury, and finally strode away with an air like that of a distraught seer. We reached Palása just as the sun was setting, and went to one of the few detached houses of the place - a long, low boarded loft of one story in height, belonging to one Dhimitri, who had once been a policeman in Corfu. I was soon established for the night on the usual mat

by the fireside. Our party was increased from Vunó by the addition of one of Anastásio's interminable nephews on his way to see life at Avlóna; and after supper, the priest of the village, in blue gown and black beard,[3] came in, when we sat talking and smoking until late. But the night was so lovely that I was glad to sit on the outside of the hut, and exchange its atmosphere of tobacco for cool freshness, while I gazed on the clear sky spangled with myriad stars, and on the solemn mountains calm in silence.

OCTOBER 27th

A more bright and cloudless morning could not be desired; so at least this time the Pass of Tchika may be visible throughout. We were off soon after sunrise, and had not gone far from Palása when, behold once more the beautiful Fortina carrying my knapsack and the capote of Anastásio, who had been suddenly seized by a great compassion for the mules, and thought fit to diminish their luggage; and since so it was to be, there was Fortina (by the merest chance in the world), perfectly unoccupied, and too glad to have the means of gaining a few piastres by this division of labour. So the fair Khimáriote, with the small nephew and the *mosca*, went round by the horse-track to the Strada Bianca, while I, after making a drawing of the great ravine and ascending by the steps or *scortatura*, rejoined them during the ascent.

Slight mists began to gather as we toiled up the Strada Bianca. Anastásio and Fortina, during a halt we made on the sides of this great mountain, held rather a prolonged discourse with two women, so they said, very high up in the gorge on the Palása side. They might have been talking to anyone in the air for aught I could see or hear, yet, at so immense a distance can these people communicate with each other, that it was no wonder I could not discern the other half of the conversationists, since even Anastásio said, "*Appena si puo sentirle.*"[4] At the summit of the Strada Bianca the mists cleared away and the Pass of Tchika[5] commenced in all its unhidden majesty. The huge sides of the mountain are wrapped in pine forests, and the bare snowy peaks above stood forth in the utmost magnificence. The groups of trees are most beautiful and resemble

feathery cedars; indeed the whole Pass throughout is a noble scene of mountain beauty.

About eleven we had reached the little fountain in that world of dark pines; and the beauty of the place was increased at this moment by the arrival of fifty or sixty Khimáriotes, on the way to find work during the winter about Avlóna and the Berát district. All rested to drink at the pure stream and sat in parties at the foot of the clustering pines, or on the top of the rocks, in varied groups which I could not resist trying to sketch, though there was little chance of fixing any, for they soon rose and in their sweeping style of progress rushed through the forest.

We also soon followed down the steep-clothed sides of the Tchika towards the gloomy Dukádhes, and after one of the most beautiful walks I have ever enjoyed, arrived there an hour before daylight, not without a regular fight with the troops of dogs which hastened to attack us.

The family at whose house I had spent so festive an evening on the 22nd, were away at a farm, or *vigna*, on the hills, and it was some time ere it was certain where I was to pass the night; but by the time I had "*scroo'd*" a few figures, the key of the lower part of the house we last lodged in was found, and we took possession of that vast barn with its earthen floor; and by the time the fire was lighted in its centre, the daughter of my late host, with his wives (numbers two and three) had arrived, and preparations for supper began. After the evening meal, entertainment appeared in the shape of the idol gipsy and his guitar (his follower, from having committed himself by drinking too much at the last soirée, having been forbidden polite society), and the singing and swinging to and fro were as energetic as on my first visit. About midnight we dismissed the performers, and became a more select circle, though for my own part I was writhing under the attack of myriads of ants (not at the time supposed to be such innocent creatures). They infest every part of the mud floor; indeed, from being a constantly inhabited part of the dwelling, entomology would have been a thriving study. Sleep was impossible, and I watched the strange scene by the dying embers. The daughter of the house (who had a new pair of grey trousers on), chose to sit up all night, and was particularly animated and loquacious, devoting herself to my instruction in Greek and Albanian phraseology. "Ah! *quella porca*

turca!" said Anastásio irreverently, "*non vuol lasciarci dormire?*"[6] On the other side of me sat the sad Fortina.

OCTOBER 28th

Long before daylight the wail for the man murdered on the day of my last visit commenced; while crowing cocks and howling dogs added their mites also to the morning melodies of Dukádhes. The "upper chamber" where I abode on the night of the 22nd, was the perfection of repose compared with this usual home of the family, which seemed to abound in every parasitical enemy to humanity.

Before sunrise, as they were baking their large flat cakes of bread by the fire, Fortina came in and stood for awhile, with the red light shining on her most beautiful features, saddened with the keenest expression of sorrow. She took leave of Anastásio in a very few words, and turning to me, wished me with a half-broken voice, "many happy years of life," and then wrapping her handkerchief closely over her head, went out rapidly, and by the time the sun rose, must have been already far on her journey towards Palása.

Long also ere the sun had risen above the frowning cold walls of the gloomy mountains circling Dukádhes, we also had recommenced our journey. I had hired two diminutive mules, with a *pietone* to take us back to Avlóna, all the good beasts being away at vintage or harvest in the Campagna.

Avoiding the gorge of Draghiádhes, we descended the bed of the Dukádhes river, which after passing through the deep basin where the town stands, emerges from its narrow boundaries and flows through a widening vale to the gulf. The journey by its banks, between high-wooded hills, possesses nothing of remarkable interest, though the cool, broad shadows of morning, and the groups of Dukádhes' peasants returning to the town, added variety to the scene; the women were all clad in immensely clumsy capotes and large breeches, and were driving mules laden with Indian corn.

Below Draghiádhes the stony white river channel was our tedious route, and heartily glad was I to regain the little stream where, on the evening of the 22nd, I had stopped to draw, and further on to arrive at the bright gulf, into whose

waters I eagerly rushed, recovering in their coolness from the tortures of last night's dormitory.

To this succeeded the ugly crag-paths, and lentisk and myrtle-covered precipices below Radima, and at noon we had regained the quiet little cove of Kria Néra, where we halted to lunch. At two we began to ascend towards Kánina. Turning the corner of the path, I came suddenly upon a most magnificent eagle, sitting majestically not four feet from me, on a rock, whence he soared away deliberately to higher points. There was time to make two drawings at Kánina ere the sun was sinking low, and we left it by the descent to Avlóna. One view of it has a striking background: the great sea-level of the Avlóna plain, with a curious peninsula, shaped like a forceps; the pincers holding, as it were, the island of Aghia Marina, in an enclosed space of water, all but a perfect lake. Anastásio's nephew, a boy who had never before been out of Khimára, was horribly alarmed at the sight of the Kánina women, who are all masked *"à la turque."* *"O! Aghio Janni! O! Aghio Dhimitri!"* said he, and crossed himself at each goblin face we met.

One hour after sunset saw me again in Avlóna at the Casa J., having made one of the pleasantest of excursions, and rejoicing in my good fortune as to weather, and in the number of new ideas and sketches I had obtained.

OCTOBER 29th

Alas! for the integrity of Khimára! A new coarse waistcoat and trousers which I had taken in my knapsack have disappeared; whether by the hands of the Dukádhes' muleteer while I was bathing, or by those of the fair, forsaken Fortina, with or without the connivance of Anastásio, can never be learned. I had rather impute the theft to the former of the two; but the clothes were gone, and there was no remedy. I said nothing about the loss, for one hates to make odious memories of squabbles. On the whole, the trip through Acroceraunia has greatly rewarded me, and I have been particularly satisfied and pleased with the constant good-humour and attention of the Khimáriote Anastásio. As for Giorgio Kozzachi, my hosts were full of complaints against that luckless dragoman, who they declared was *"immer besoffen"* - always intoxicated from morning to night; though with me he had hitherto shown no signs of intemperance. On the other

side, Giorgio thanked his fate that he was not to remain at Avlóna, where he vowed the usage of the domestics was worse than that of any slaves he had known in his wide travels.

At sunrise I went down into the plain with the black Margiánn, and drew Avlóna from the level ground near the sea, returning to dinner before noon. At this meal, the overbearing and violent political thunderings of Herr S. against all monarchs, tyrants, kings, autocrats, &c. (they had received new gazettes from Austria), was so profoundly disagreeable, that I was rejoiced to know that two horses had arrived, with which, the black being my guide, I was to visit the monastery of Aghia Marina di Svernez, in a little island about two miles from Avlóna.

We had soon passed the border of olives that surround the town, and were trotting over the wide plain, almost impassable with mud when I had arrived, but now hard and dry; and beyond this, always making for a little woody peninsula which projects into the sea, we came to the salt works. Here they take a sort of mullet, from which is prepared the roe called "*bottarga,*" for which Avlóna is famous. As we skirted these salt lagunes, I observed an infinite number of what appeared to be large white stones, arranged in rows with great regularity, though yet with something odd in their form not easily to be described. The more I looked at them, the more I felt they were not what they seemed to be, so I appealed to Blackey, who instantly plunged into a variety of explanations, verbal and active; the chief of which consisted in flapping his arms and hands, puffing and blowing with most uncouth noises, and putting his head under one arm, with his eyes shut. As for his language, it was so mixed a jargon of Turkish, Italian, Greek and Nubian, that little more could be extracted from it, than that the objects in question ate fish and flew away afterwards. So I resolved to examine these mysterious white stones forthwith, and off we went, when - lo! on my near approach, one and all put forth legs, long necks, and great wings, and "stood confessed" so many great pelicans, which, with croakings expressive of great disgust at all such ill-timed interruptions, rose up into the air in a body of five or six hundred, and soared slowly away to the cliffs north of the gulf.

These birds frequent the coast around Avlóna in great numbers, breeding in the rocky inlets beyond the bay, and living on fish and refuse in the salt lagunes.

Pleased with these ornithological novelties, hitherto only seen in zoological gardens, or at Knowsley, I followed the faithful Margiánn (who nearly fell off his horse with laughter at my surprise at the transmutation of the white stones), through levels of deep sand, by tracts of sedge and rushes, and groups of salt-kilns, till we reached the foot of the low hills beyond the isthmus which I had drawn yesterday from the hill of Kánina. Here a pleasant fountain, glades of green, and tufts of thick olives, contrasted delightfully with the sand I had passed. At the top of the hill is a small scattered village, and beyond it, the track descends through a perfect little park slope to the shore of the lake, in the centre of which stands the monastery, half hidden in its island by cypress and plane foliage. A charming object is that solitary building in its quiet isle. Beyond, Sázona and the great summits of Tchika add to the beauty of the scene; but the sun was setting, and I was desirous of making a drawing of Avlóna from the salt works, with a foreground of pelicans, wherefore, as Aghia Marina contained in itself nothing remarkable, and as a long time would have been occupied in ferrying thereto and back again, I turned my horse, and on my way over the sandy plain, obtained three sketches of that singular scene; the last when the sun was throwing its latest red ray over the beautiful form of lofty Kúdhesi and the glens of Avlóna. Then we galloped across to marshy sand waste, pursued now and then by ravenous howling dogs, and by half an hour after dark were at the gate.

The party there was increased by a Vuniote, who had been one of Lord Byron's guards at Missolónghi. He told me some anecdotes of the poet, but on such slight authority, I write them not down. As for my hosts, the news of the Emperor's flight from Vienna had made them more full of political excitement than ever. Between their pipes they thumped their table destructively, predicting with sinister glee all sorts of bloodshed and downfall of tyrants. In vain did I attempt to change the current of discourse, but when they proceeded to some long and violent tirades against "England and the English," I broke through my role of passive listener, and having much the advantage of my hosts in fluency of Italian, took the liberty of telling them what I thought of their ill-breeding in thus victimising a guest who might by possibility not quite agree with all their opinions, requesting earnestly that we might henceforth talk about pelicans, or red mullet, or whatever they pleased, so that we eschewed politics.

Tomorrow I intend to start for Tepeléni, and hope to sleep at Kúdhesi, but as yet it seems no horses have been procured, so, early starting appears out of the question.[7]

OCTOBER 30th

To Kúdhesi, to Tepeléni, and Ioánnina! But the horses? Seven, eight, nine, ten o'clock came, and none arrived. At eleven, after frequent messages from Giorgio, they were driven into the yard, and saddles and luggage were about to be fastened on, when a dire dispute arose, the owners insisting on being paid the whole of their bargain (i. e. as far as Arghyró Kastro, three days' journey) before starting, and Giorgio very properly refusing to do what would probably prevent our moving at all. He offered half the money, but all or none was the word; and anxious as I was to start, I could not interfere with the experienced dragoman, who said that if they received all their payment, there would be no hold on their fears, and they would in all probability, desert us at Kúdhesi tonight. He never had paid all beforehand, in fifteen years' dragomanship, and so help him St. Dhimitri! he never would. The Casa J. interfered on the side of the men of Avlóna, and said they always paid the whole sum for horses before leaving home; but this, as Giorgio replied, was no precedent for us, who were not known in the land, and who would cut but a miserable figure if left in the lurch tonight or tomorrow. So, as neither party would yield, off went the owner of the horses with his steeds, and Giorgio repaired to the police, leaving me aghast and disconsolate, and moreover exposed to the triumphant consolations of my hosts, who assured me I should now probably remain there for an indefinite period: "it might be for years, and it might be for ever."

In half an hour Giorgio returned in fierce anger. The police had procured two weasels, quoth he. Horses? - mice, starved mice. So as a last resource, and in spite of Herr J.'s growlings, he rummaged out the Sultan's Boyourldi (never yet used in my behalf), and declaring that we would and should go to Kúdhesi this night, rushed forth in a frenzy, my hosts still professing to doubt the probability of my ultimate departure. But the inflexible dragoman knew his business, and presently returned, saying that he had been to the Bey of Avlóna, and had

terrified him horribly with the sight of the Boyourldi, by virtue of which he had demanded instant attention, and had left him, vowing that if horses - and good ones - were not forthwith supplied, a message should be sent off to the Pashá Kaimakán of Berát, the results of which step he would not like to contemplate.

Immediately, all Avlóna was in a hubbub, and shortly after, horses and mules of all kinds came rushing into the courtyard of the Casa J. in the most ludicrous numbers, driven by frantic emissaries of the alarmed Bey, who had seized and imprisoned various dodging natives who had sworn to having no quadrupeds. Of this confused assemblage of beasts we chose three, and by twelve were off, with a Zafti, or armed footguard.

As I left the courtyard, the black Margiánn took my hand and kissed it after slave-fashion, and surprised me by suddenly sobbing and crying as if his heart would break. Poor fellow! He had told Giorgio that he would go away with me if he could, and was greatly vexed by being informed that I could take no more servants, even though he offered to go all over the world for no wages. What a suite one might be travelling with, if all the offers of service so lavishly made had been accepted! From the olive-hills above Avlóna I went on my way to the birthplace of the wondrous Ali Pashá. The day's journey was not at first very interesting, though bright sun and fresh air made it pleasant: there was a long, winding, narrow vale, and a stream to cross, then an interminable hill, from the top of which one looked over the broad Viósa hurrying to the sea, between cultivated hills on whose sides frequent villages glittered - Grádista, Karbonára, &c. (scenery not unlike that of Abruzzo Citeriore), while towering over all rose the great Tomóhr. By four, we had crossed a level tract at the summit of this hill, and descending thence towards the northeast, the view was strikingly magnificent. The Viósa pours through a narrow gorge in the rocks at the foot of Mount Kúdhesi, and above this dark outlet rise the detached and finely-formed mountains of Trebushin and Khórmovo. Immediately below the spectator is the great extent of stony river course, along which the Viósa, no longer confined in its straitened limits - its dark waters sparkling like so many winding threads on a dazzling white ground - rushes in broad freedom, and many-channelled, to the sea.

Numerous scattered hamlets cluster round the sides of Kúdhesi, and are all called by the mountain's name. To one of these, on the banks of the Viósa, we

descended, after I had made a drawing, as there was a little khan there where a night's lodging might be hoped for. Reaching it before sunset, we found by great luck two little rooms unoccupied and clean. Supper, and journal written by the light of a tiny Albanian lamp hung to a nail, completed my day. In the stable below, the Zafti and his two friends sung half "the live-long night."

OCTOBER 31st

It is yet half an hour before sunrise. Breakfast is over, and all things are packed for starting. The pure, cloudless sky is of the palest amber hue over the eastern mountains, whose outlines are dimmed by a few filmy vapours; and all is still except the formidable Viósa murmuring in its white stony channel. It was too chilly to ride, even had the mule-tracks - rudely-marked ledges or broken paths by the side of precipices - tempted me to do so. The route ascends the Viósa to the dark gorge, which is so narrow as to allow only of the passage of the river, and when that is swollen, it must close this communication altogether. But though grand and gloomy, I did not think the scenery so fine as others of the sort I have seen (for instance, the pass of the Sagittaria at Anversa in Abruzzo Ulteriore); although, in one or two spots, where the cliffs rise perpendicularly to a great height above the stream, or where the path mounts by a corkscrew ascent over the rocks, and the eye looks down on the abyss below, the effect is very imposing. The whole morning passed in threading the winding vale of the Viósa, through scenes of wild grandeur, but possessing no particular quality of novelty or beauty. The mountain of Khórmovo, ever in view, gave the chief character to the walk, delightful as it was from the exquisite autumnal weather.

Nearer Tepeléni we met many peasants, all in white caps and kilts, and of a more squalid and wretched appearance than any I had yet seen. The whole of this part of Albania is indeed most desolate, and its inhabitants broken and dejected. Their rebellion under Zuliki seems to have been the last convulsive struggle of this scattered and disarmed people, and the once proud territory of Ali Pashá is now ground down into a melancholy insignificance, and well nigh deprived of its identity. It was nearly three P.M. ere the last tedious windings of the valley disclosed the great mountain Trebushin, and its neighbour of Khórmovo visible

now from base to summit - each calmly towering in bright purple below peaks of glittering snow. Beneath them the junction of the two rivers Viósa and Bantja forms the long promontory of Tepeléni,[8] whose ruined palace and walls and silver-toned mosque give a strange air of dreamy romance to this scene, one of the most sublime and simple in Albania, and certainly one most fraught with associations ancient and modern.

My curiosity had been raised to its very utmost to see this place, for so many years full of the records of one of the most remarkable of men; yet it seemed so strange, after all one had read of the "no common pomp" of the entertainer of Lord Byron and Sir J. C. Hobhouse, to find a dreary, blank scene of desolation, where once, and so recently, was all the rude magnificence of Oriental despotism!

Giorgio went on to find a lodging in this fallen stronghold of Albania, and I, meanwhile, sat down above the Bantja, to sketch the town, which, on its rocky peninsula seems a mere point in comparison with the magnificent mountain forms around. Afterwards, having forded the river with the Zafti and a horse, I walked up over heaps and lines of ruined fortifications to the strong and high walls of Tepeléni, which still exist, though there are but very few buildings within their enclosure. Outside the walls is a short street of miserable bazaars, and beyond - near a green burying-ground covered with ordinary tombstones, and some of those pretty dervish tombs - stand a khan, some barracks, and a Bey's house. These are all now existing of the once celebrated Tepeléni! There was still time to make a drawing within the walls, so, taking with me the Zafti guard, I went inside the gates and through a few streets - than which anything more sad and gloomy cannot be. Heaps of stones and falling walls arrest your attention as you pass along the very narrow lanes, and here and there a carved stone window, or columns at the doorway of a deserted house, and over all an indescribably melancholy air of ruin and destruction.

At the end of the space enclosed by the walls, and overhanging the river, is a single mosque - solitary witness of the grandeur of days past - and beyond that, all the space as far as the battlement terrace looking north and west is occupied by the mass of ruin which represents Ali's ruined palace. The sun was sinking as I sat down to draw in what had been a great chamber, below one of the many crumbling walls - perhaps in the very spot where the dreaded Ali gave audience to

his Frank guests in 1809 - when Childe Harold was but twenty-four years old, and the Vizier in the zenith of his power.[9] The poet is no more; the host is beheaded; and his family nearly extinct. The palace is burned and levelled with the ground. War and change and time have perhaps left but one or two living beings who, forty years back, were assembled in these gay and sumptuous halls. It was impossible not to linger in such a site and brood over such images, and of all the scenes I have visited, the palace of Ali Pashá at Tepeléni will continue most vividly imprinted on my recollection.

But the desert chambers, and the rushing wide river below, and the majestic peaks above, are grown cold and grey as the last crimson of daylight has faded. A solitary Cogia, having cried a mournful cry from the minaret opposite, sits motionless on the battlements - the only living object in this most impressive scene. Of all days passed in Albania, this has most keenly interested me.

NOVEMBER 1st

The khan of Tepeléni was a concatenation of minute cells or closets with uncloseable doors, pervious to cats and dogs, while a perverse old goat with a bell round his neck, who infested the wooden gallery, bumped and jingled up and down it all night long. The wind also howled dismally as it swept through the hollow passes of the lofty mountains, so there was little sleep - but the feeling of the deadly cold loneliness of Tepeléni was a preventative against being harassed by such common-place evils.

An hour after sunrise, I set off to draw on the eastern side of this melancholy town; but though most majestically placed amid towering heights, Tepeléni and the lines of its landscape are not easily adaptable to art. Soon came Giorgio and the horses, when the Zafti returned to his master, the Bey of Avlóna, and I commenced walking to Arghyró Kastro, which they reckon as seven hours hence.

The whole morning was employed in making way along the valley of the river Drino, which abounds in fine features, though not very drawable, or possessing any individual characteristics. The river runs in a deep bed below the road, here both broad and good, and carried on banks high above the level of the stream; and the whole valley bears a striking resemblance to that of the Anio below

Roviáno, or Cervára, on the way from Tivoli to Subiaco. One of the prettiest spots in the morning's walk was a fountain below a group of large planes. It was constructed by Ali Pashá, who was wont to halt under its shades in his progresses through this part of Albania, which it is said he used to perform in a carriage. Indeed the communication between Tepeléni and Ioánnina merits more the name of *strada carrozzabile* than any I have seen in his dominions.

At noon we arrived at the Khan Subashi, standing in the narrowest part of the valley, and exhibiting a guard of soldiers placed by the roadside to ask for *teskeres*, or passports. The Bolubáshi, or head of which guard, was authoritative and disagreeable, declaring that the muleteers of Avlóna had no regular passes, and that he had serious thoughts of detaining me accordingly. Upon this, Giorgio thought fit to make a speech about αυτος Μιλόρδος Ινγλις which favourably impressed his auditory, inasmuch as the Bolubáshi ceased his expostulations, and condescended to eat some bread and cheese in my company forthwith.

A stone bridge crosses the Drino opposite the Khan Subáshi, and I thenceforth proceeded, at half-past twelve, along the right bank of the river, which here runs through the wide valley of Derópuli. Its magnificent dimensions now opened in all their extent, the high wall of mountains on its western side displaying the city of Arghyró Kastro, yet afar off at its foot. For two hours I advanced through the rich flat meadows of this broad vale - leaving the hills of the fatal Gardhiki[10] on the right, and speculating on the distant peaks towards Pindus and Ioánnina. The lines of Derópuli are, however, pictorially speaking, rather straight and monotonous, and I was less struck with the beauty of this noble valley than I expected to be, though the sensation of freedom of breathing, the delight of leaving the close river-bed and pent-up mountain gorge, made my walk through it a charming one. All through the cultivated grounds which I have passed since I entered the vale of the Derópuli district, the costumes of the Greek female peasantry have been very pleasing and various; dark blue or red capotes, fringed and tasselled most fancifully and prettily. "These," quoth Giorgio, "are Greeks! - Greeks, Signore! We are not among Albanians now, Signore! Let us be thankful we have gone out of the reach of those *poveri disperati! qui siamo in Epiro, Signore! ringraziamo il cielo*, we are among Epirotes!" (For though the country opposite Corfu is distinctly known as Albanian, the innocent traveller who

happens to speak of its natives to one of themselves as "Albanians," finds himself in as wrong a position as if he should address Messrs. A. and B. and C., residents at the Cape of Good Hope, as so many Hottentots.)

At about four we arrived opposite Arghyró Kastro, at a bridge over the Drino, one of those parapetless, high-arched constructions which rise in the most alarming manner, till a descent quite as precipitous brings you to the opposite shore.

Many of the women were washing clothes in the stream, and two or three were pouring forth lamentable yodelling wailings for departed relatives, after the manner of the Khimáriotes. Hence we crossed the plain - for so this wide valley must be called - directly to the foot of the city.

The general appearance of Arghyró Kastro is most imposing; but the glittering triangular area of houses, which from afar appears as one great pyramid of dwellings against the mountain side, is broken up, on a nearer approach, into three divisions. The whole town is built on three distinct ridges, or spurs of rock, springing from the hill at a considerable height, and widening - separated by deep ravines or channels of torrents - as they stretch out into the plain. The town stands mainly on the face or edge of these narrow spurs, but many buildings are scattered most picturesquely down their sides, mingled, as is the wont in Albanian towns, with fine trees, while the centre and highest ridge of rock, isolated from the parent mountain, and connected with it only by an aqueduct, is crowned by what forms the most striking feature of the place, a black ruined castle, that extends along its whole summit, and proudly towers, even in decay, over the scattered vassal-houses below.

Arghyró Kastro is in fact three towns; and no place could have been more beautifully contrived for the perpetuation of the family feuds which long disturbed its harmony. Rival houses placed at the opposing edges of the same ravines could brave each other's anger, and while their inmates were distant only a space of a few yards in appearance, a real hour's descent and climb separated two seats of hereditary squabble. But after the inevitable Ali had seized on the town, the separate communities ceased to differ, and it was thenceforward reduced to the level of his other widely-scattered dependencies.

We ascended the most northerly of the three ridges, and threaded our way between thickly placed and most picturesque houses, up the dirtiest and steepest

of narrow streets, to the upper part of the town, where, at the junction of the three ravines, are lines of bazaars, placed on a considerable space of level ground. The first khan we examined was *"à la Gheghe,"* and did no great credit to Giorgio's boastings of Epirote superiority; but the second was in all ways perfection. Speaking of khans, its galleries and stairs, of bright new deal, announced a cleanliness hardly to be looked for; while its ample new-boarded corner chamber, with large glazed windows, looking out on the castle and grand trees below it, presented a luxury beyond the reach of hope to have pictured. Violent rain began to fall by the time I was settled; and as Arghyró Kastro is a halting-place for a day or two, it is a comfort to think that detention of weather can be little annoying in a lodging so tolerable within, and so picturesque without.

NOVEMBER 2nd

A very mistiferous morning, and this high part of Arghyró Kastro enjoys all the rolling mountain clouds. After the oft-repeated necessity of arranging pencil-drawings so as not to be obliterated, a duty known only to wandering draftsmen, I went with Giorgio to the serai of the Khaimakan, governor of the town. The houses in this singular place have a most independent air; scattered here and there, standing on crags and precipices, or on little isolated levels or platforms of ground, each adorned with whitewash and arabesque painting, which gives the whole building (itself pretty in form) the most pleasing character of colour and finish. The Governor's serai, as well as the visit to it, was of the ordinary class of similar places and visits. There was the usual narrow wooden stair and guarded gallery; the ante-room, with secretaries and Cogias; and the audience-chamber, with the great man in the corner. The real Khaimakan was away; but his deputy was a gorgeous object, in a fur-trimmed yellow silk vest; and when (pipes and coffee the while) I had explained my wish for a guard to enable me to sketch without molestation, and a refulgent Bolubáshi, glittering like a South American beetle, in purple and gold, had sent for a Kawás to wait on me, the visit drew to a close. It was prolonged only by the inquiring investigations of a half-witted old dervish, who was squatted on the floor, as to the nature of my three-legged camp-stool, a zeal for knowledge which led to the display of my useful travelling

companion in the centre of the chamber, and the trial of it by more than thirty guards successively with the most unlimited applause. Taking leave of the dignitary clad in sulphur-coloured silk, I went off with my attendant, and drew hard while daylight lasted. But Arghyró Kastro is a place so wonderfully crowded with beautiful bits of landscape, that knowing how few can be portrayed, even with the utmost energy, an artist is angry with himself for not being able to decide where to settle at once, that no time may be lost. Indeed, to reach various parts of the town is no easy task; for though the houses seem close together, the deep fissures between the rocks separate them widely in reality. From almost any point you may select, the views of the fortress and line of the broken aqueduct, backed by a sublime horizon of plain and snowy mountain, are as exquisite as indescribable.

Late in the day I went into the castle, at present a shell of dark mouldering walls. It was built by Ali Pashá to command the town after its subjection to him, but was dismantled and destroyed upon his fall, though its remains are witness to its former strength and importance. But of all surprising novelties, here or anywhere else, commend me to the costume of the Arghyró Kastro women! The quaintest monsters ever portrayed or imagined fall short of the reality of these most strange creatures in gait and apparel; and it is to be wondered at when and by whom the first garb of the kind was invented, or how human beings could submit to wear it. Suppose first a tight white linen mask fixed on the face, with two small slits cut in it for the eyes to look through. Next, a voluminous wrapper of white, with broad buff stripes, which conceals the whole upper part of the person, and is huddled in immense folds about the arms, which are carried with the elbows raised, the hands being carefully kept from sight by the heavy drapery. Add to these, short, full, purple calico trousers, and canary-coloured top-boots, with rose-coloured tassels; and what more amazing incident in the history of female dress can be fancied?

NOVEMBER 3rd

A day of pouring rain. A mountain tempest continued hour after hour, thunderstorms bursting at intervals, with thick cloud driving down the ravine, or

effacing the dark earth and aqueduct into so many dissolving views. Well it is that the khan is so good, and that it has such a spacious gallery, tenanted, moreover, by several Epirotes in all their plumy finery, who not being at all averse from being portrayed, gave me employment in "*scrooing*" all day long.

But hark! - wailing again! The quiet of the hill city is suddenly broken, and all the world of Arghyró Kastro is startled with the ill-omened cries!

Heavens! what howls! Is all the Epirote city going distraught? The cause of all this is, news has just been received that one of the principal Arghyró Kastriote merchants has died suddenly at Stamboul. The Cogia is chanting from the mosque opposite, a few wild notes, most impressively sad as they rise above the small tumult of little cries in the lower part of the ravine. Each note is held on for an incredibly long time, and is distinctly marked with singular power and effect. Then the immediate family of the deceased swell the chorus, yodelling and shrieking with deafening clamour and wonderful cries, half sob, half piercing howls; house after house takes up the doleful tale, and in less than an hour the melody of grief pervades the whole place, bursting forth from crags above, and resounding from depths below - shrill and solemn, bass and treble, - one general lamentation of woe. Thank goodness, none of my neighbours in the khan feel it incumbent on them to add to the wailing! for they are all travelling merchants, and share not in the three-hilled city's mourning.

From three to half-past four P.M. it was clear, and I sketched by the river at the foot of the town; but the cold-Cumberland feeling of these mountains after rain, savours too much of fever to allow of sitting long to draw. It is a pleasant thing in walking about to meet Christian women, whose faces, though coarse by early toil, are always more or less pleasing; but the oddity of the Mohammedan females is beyond belief, as half-blinded by their masks, and bungling with their awkward muffled arms, they fumble in their yellow boots among the rocks. When they perceive a man coming, they instantly rush at the nearest wall, butting at it with the crown of their heads at right angles while he passes them, staring at him, nevertheless, out of their small eye-holes, directly he is a little way from them.

A bright sunset gives hopes of a fine day for starting towards Ioánnina tomorrow. Wonderful luxuries of food are there in this city of Epirus! Turkeys

and tongues, walnuts and good wine, with other pleasant solidities and frivolities quite out of character with Albanian travel.

NOVEMBER 4th

The morning is clear, though the upper part of the town is all in mist. The tremulous and multi-vocal wailing is already in full play. The horses are here (we take three out of six, which are on the return to Ioánnina, having brought merchandise hither). The sun has not yet risen; but what with packing and arranging the "bill" at the Arghyró Kastro hotel, and a squabble with the Kawás, who gave way to the most fallacious expectations as to what I should give him for his one day's work (viz. sitting near me and smoking a pipe, for which he asked seven dollars, and I would only give him one), it was nearly nine before we crossed the head of ravine No. 1, and making a tour half round the castle or centre ridge, began to descend ravine No. 2 into the plain. The whole town was hidden from sight by dense mists, nor till we were fairly down in the great vale of Derópuli, did the mountain tops and blue sky become visible. The route lay among fields of corn and gran-turco, cultivation was on all sides. Anon there were perplexing little dykes and irrigations, with irritations on finding the track suddenly cut off - then broad, grassy routes only interrupted by deep spaces of black mud, from which our horses not unfrequently extricated themselves with difficulty. Such was my progress up the wide green vale of Derópuli, while always on the left hand the white clustering town of Libóchovo was in sight (the next place in importance in the district of Arghyró Kastro), and many other villages hung on the side of either range of mountains. But, in spite of having heard much of the vale of Derópuli, I did not feel inspired to draw any part of it; and I often thought of the bare valley of Aquila in Abruzzo, only that this Epirote vale is more decidedly simple in its outline. About noon we reached a solitary khan at the foot of the low hills, which concludes and shuts in the valley at the southern end, and gradually ascending, we reached the pretty little village and church of Episkopi at its summit. Hence I look back on all the great valley of Arghyró Kastro - a smiling and cultivated tract of land, but as landscape, deficient in many qualities; chiefly from lacking variety of form and detail in its hillsides, which are very bare of interest.

We halted at the khan of Episkopi, close to a little stream full of capital water-cresses which I began to gather and eat with some bread and cheese, an act which provoked the Epirote bystanders of the village to ecstatic laughter and curiosity. Every portion I put into my mouth delighted them as a most charming exhibition of foreign whim; and the more juvenile spectators instantly commenced bringing me all sorts of funny objects, with an earnest request that the Frank would amuse them by feeding thereupon forthwith. One brought a thistle, a second a collection of sticks and wood, a third some grass; a fourth presented me with a fat grasshopper - the whole scene was acted amid shouts of laughter, in which I joined as loudly as any. We parted amazingly good friends, and the wits of Episkopi will long remember the Frank who fed on weeds out of the water.

So various were the accounts here as to the time required to reach Delvináki, where I ought to halt for the night, that I dared not linger to draw, though the grouping of some houses and cypresses, combined with the mountains towards Délvino, strongly tempted me to do so. I longed also to sketch a little Greek church, exquisitely placed in a grove of trees on a platform of rock overlooking the whole vale below, and certainly one of the prettiest spots in the day's journey.

After coasting a hillside commanding the last view of the region of Derópuli, a barren rocky pass succeeded, and dullness reigned for an hour, till a descent brought me, as it were, into a new land, in which the hills were broken into various forms, with wood and rock, foreground and distance, in every variety. At the foot of the pass is a khan, and a dignified Bolubáshi, with attendants, made a great rout about *teskeres* and luggage, insisting upon a most minute inspection of the latter; this for a short time we resisted, until on the party in power vowing to look into all my portfolios, Giorgio told them they should do so, but after that they had exercised their authority, they should see the Boyourldi, enjoining all the Sultan's liege subjects to let my lordship pass unmolestedly; on hearing which they were seized with uncontrollable dismay, and tying up the unloosened baggage, whipped our horses, entreating us to depart from them immediately.

Infinitely beautiful is the route beyond this khan Xerovaltó. It is full of variety of form - brushwood hills, light oak woods, bare sand rocks, lines of plain, far blue mountains, and undulating meadows. But there was no time to sketch,

for it was now two P.M. and Delvináki was declared four hours distant. Moreover, the driver of the Ioánnina horses said there was no place to lodge in at Delvináki, and that we would have to go on to a khan below it, called Tzerovina.

Few human beings are encountered in these lonely regions: you meet now and then a Greek family migrating with furniture and household, a peasant or two near some forlorn hut, or a travelling merchant with laden mules and armed guards. The sun was setting as we arrived at a height overlooking the valley of the Kalamá, and caught sight of a little lake, immediately below my feet, surrounded by most beautiful scenery. I walked on alone by the side of that quiet, still water, enjoying the calm glades, and the pleasant wood of brown oak. There was a carcase of a horse, with a vulture soaring above it, and many falcons on the upper boughs of the trees, and there were numerous tombstones, and two or three dervish sepulchres in one of those quiet solitudes.

After sunset I reached the khan of Tzerovina - a solitary, walled, dilapidated building, not promising in appearance, with a distant background of the snowy Pindus range. Alas, for accommodation! All the little space of the khan was already fully crowded by a fat dervish in green and white, and some sixty or eighty Albanian guards, journeying to Berát, or Arghyró Kastro, so that no shelter remained but that of the lofty and wide stable; and even this, five minutes later had been denied me, for several parties came in, and those who could not find room in the stable slept outside. "*Bisogna adattarsi,*"[11] as the Romans say. The evening was bitterly cold and a bad shelter is better than none.

A huge fire was lighted on a sort of hearth on one side of the windy, half-dismantled tenement, and Giorgio seized upon all the khanji offers by way of supper, so that there was no danger of starvation. The travelling groups of Albanians arranged themselves in different stalls of the building, forming, with mules and horses, many a wondrous firelight scene. After their repast, they all sang furiously about Zuliki till late in the night, by which time I was fast asleep in a thick capote.

Chapter XIII

Scenery in the valley of the Kalamá - Cold and rain - Visit to Zitza under unfavourable circumstances - The monastery - Cloud and rain - Route along the plain to Ioánnina - First impressions of the picturesqueness of its position - Signor Damaschinó - Hospitalities and luxuries - Plan of discontinuing Albanian tour for the present and to reach Malta as soon as possible - Departure from Ioánnina - Ascent to Pende Pigadhia - Uninteresting morning's journey - Squabble at the khan - Descent to the plains of Arta - Arrival at that town - Signor Boro, the vice-consul - Land Turks and water Turks - Magnificent position of Arta - Departure for the sea-coast - Paved road through the marshes - Arrival at Salágora - Embark for and reach Prévyza - Home and kindness of Sidney S. Saunders, Esq. and his family - Reach Santa Maura - Farewell to Albania.

NOVEMBER 5th

Aurora was saluted by some score of geese who lived in the khan-yard, but there was no alacrity on her part to look pleased at the compliment, for nothing but a thick cloud could be perceived, and a mist or rain soon began to fall.

All the higher part of the landscape seemed hopelessly invisible for the day, but the nearer and lower scenery cleared as we proceeded and showed a rich and beautiful country through the vale of the Kalamá. All the scene appeared richly wooded and abounding in forms of dell and gentle heights with innumerable charms of broken foreground. Perhaps one of the prettiest points in the morning's ride was near the falls of the Kalamá (three hours after leaving Tzerovina), which not even the incessant drizzle of sleet, with bitter wind, could

prevent my admiring. A wearily cold ascent led up the hill of Zitza - a place I had looked forward to visiting as much as to any in Albania - and it would have been the more vexatious to reflect, that I should enjoy it so little, had not its small distance from Ioánnina held out hopes of revisiting it. All my enthusiasm regarding "Monastic Zitza," so long familiar in prose and poetry, vanished as the rain came down in torrents, and the wind blew so hard as to make sitting on horseback difficult. By the time I arrived at the door of the much celebrated convent, numbed and shivering, I had no other feeling left but that of desire for dry clothes, a fire, and luncheon.

The monastery of Zitza - a low-walled building at the highest point of the hill on which the village stands - resembles that of Ardhénitza, or most other Greek convents, as to its internal arrangement of its cloistered courtyard, galleries, and little rooms. There are now but three or four Papades living in this retreat - a place of greatly diminished grandeur - and these monks, with the schoolmaster of the hamlets below, were my hosts. Meanwhile the outer storm increased, and the little divan-surrounded room to which the Ecónomos led me was darker than it would have been otherwise - its small window and low roof allowing no great light at any time. With that pleasing and unassuming politeness so usual among these people, the priests set before me a very good meal of boiled beef, omelette, &c., during which a mixed discourse of Greek and Italian - the *didaskalos* being slenderly furnished with the latter medium of communication - enlivened our intercourse. Lord Byron was of course one of the subjects, the elder of the two priests well recollecting his stay at the convent in 1809 on his way to Tepeléni. Many questions were asked to which I could not reply, and some comments were made and anecdotes told, which slight, and perhaps unfounded in strict truth, I shall not add to the list of crude absurdities too often tacked to the memories of remarkable men.

There was a pause in the rain, so I resolved to descend to Ioánnina and to return hither at a more favourable opportunity, leaving a place I had looked forward to seeing with the greatest interest, in (be it confessed) no satisfied humour. Making due allowance for the bad weather, I cannot but feel disappointed in Zitza. The surrounding scenery, though doubtless full of varied beauty, does not seem to me sufficient to call forth such raptures of admiration,

even if selected as a spot where an imaginative poet, reposing quietly after foregone toils and evils, might exaggerate its charms. But after travelling through the daily-remarkable beauties of Albania, the view from Zitza, to speak plainly, disappointed me.

The route led through extensive vineyards, and across the little plain on the top of the hill of the monastery - the charms of which I had been so indifferently able to appreciate, and a tiresome, stony descent of an hour and a half in duration led to the plains of Ioánnina and the lake Lapsista. Thenceforth relentless torrents poured down, and the lake Lapsista was only dimly seen through intervals of shifting dark cloud - conveying a sensation of water and mountain, rather than an ocular conviction of their presence; and so amid rolling thunder and flashing lightning did I gallop on, across the treeless level, till the sky cleared suddenly, and in three hours and a half from leaving Zitza, I saw from a slight eminence the lake of Ioánnina unexpectedly spread below me.

With the keenest interest I surveyed a scene, already familiar to me from many drawings. Apart from its associations with modern and ancient records, the first feeling with which I gazed on it as a picture was nearly akin to disappointment - perhaps from the extreme bareness of the surrounding hills, and the too unbroken line of Mitzekeli, the great mountain which forms one side of the landscape.[1] There lay the peninsula stretching far into the dark grey water, with its mosque, its cypress tufts and fortress walls. There was the city stretching far and wide along the water's edge. There was the fatal island, the closing scene of the history of the once all-powerful Ali.

The approach to Ioánnina through its straggling suburbs of wooden houses, walls, and gardens, Turkish burying-grounds, &c., has nothing of peculiar interest to require description, and I was soon at the British Consulate, where Signor Damaschinó, Her Britannic Majesty's vice-consul in Albania, received me with those amiable manners, and that hospitality, which dwell pleasantly in the recollection of all Englishmen who have passed through this part of Albania during his residence in its capital. After the khans and horrors of Upper Albania, the spacious and clean rooms at the vice-consulate were delightful to repose in; and newspapers, letters, joined with all kinds of comfort, suddenly and amply atoned for all by-gone toils and disagreeables.

NOVEMBER 6th

Among my letters is one from a friend asking me to accompany him to Cairo, Mount Sinai, and Palestine, an offer not to be lightly refused; yet to avail myself of it, I must go hence directly to Malta and Alexandria. But I am the more inclined to do this, by the increasing cold of the weather, and from the small chance of making farther progress in drawing among Albanian scenes at this late season. I determine, then, if possible, to come back a second time to Albania to "finish" Epirus, before I return in the summer of the following year to England; and meanwhile resolve finally to start tomorrow for Arta and Prévyza, and so by the Ionian Isles to Malta with all speed. Meanwhile my friend, C. M. C., between whom and myself the monks of Athos drew their cholera cordon, passed through Ioánnina but two days ago; and this chance of rejoining him at Prevyza or in quarantine - not to speak of the necessity of timing one's departure by certain steamers - all contribute to my decision. Thus, therefore, I arrange the final page of my tour in Albania.

The rest of the day I pass in exploring Ioánnina under the guardianship of a black Kawás of the vice-consular household - another Margiánn. From every point the beauties of this fair spot are innumerable and increase by observation; and the difficulty would be, where to settle to draw its infinite variety of combinations with lake and mountain. The bazaars, too, are most interesting with their endless exhibition of wooden ware, national nicknacks and embroidery. But all these things I trust to see more completely on my return to these localities next year.

NOVEMBER 7th

I started before daylight in order to have as long a day as possible to reach Arta before dark. A Zantiote, on his way back to the islands with horses purchased at Ioánnina, two of his countrymen, a messenger of the Consulate, and Margiánn, the Black, joined our party; and long before sunrise we were far out of the city. Many a beautiful scene I left behind with regret, for the day's work was toilsome, and sketching could not be permitted. Beyond the long suburban street of the

capital of Southern Albania, we crossed a wide plain, with the fine forms of the Epirus mountains around; but the cold was bitter, and even by hard walking it was impossible to keep warm until the sun had risen high. At about the third hour, after passing two or three khans, we began to ascend a bare hill leading to a bleak valley equally uninteresting, whence the road ascended again to the khan of Pende Pigadhia, the half-way house betwixt Ioánnina and Arta, each of which are six or seven hours' journey from the summit of the hill on which it stood. Nothing could have been more dull and disagreeable than the walk, but the view of the Pindus range from the high ground was very noble.

The khan of Five Wells is a perfect specimen of the lonely and hopeless place of refuge in these parts. It is a large, ruinous building (though once fortified), in an extensive courtyard. Here we were to halt for luncheon, but while doing so, a first class quarrel ensued, which I thought might have ended awkwardly. A frantic, or intoxicated Albanian guard insisted on seeing the inside of every article of luggage, to which the consular officials said no - it is "*Roba Ingliz Consul.*" From words and gesticulations, pistols were drawn and the wrathful Kawás was rushing at Black Margiánn when he was seized by the Bolubáshi and others, and the struggles and yells ensuing are not to be described. Giorgio extricated the Boyourldi from the depths of the baggage, which partly calmed the affray; but the confusion was immense; and the enraged Albanian tore his long hair and foamed in a way I never witnessed in any human creature.

From this squabble we passed to a cold collation of bread and *bottarga*, and starting once more at half-past two, descended the hill to the plains of Arta, which, with many a blue pale line of Acharnanian hill now appeared far away. In another hour, however, we had become pent up in a weary river bed, nor did we reach the plain, over gravelly paths and good trotting ground, till the full moon rose, throwing long shadows from scattered trees. How tedious was that hour or two after sunset! - the long point of hill behind which Arta was placed seemed never fated to be reached. No sensation is more disagreeable than the inability to keep awake on horseback, and when the traveller is creeping a mile in the hour over a paved Turkish causeway, the wearisome disgust is intolerable.

Endless lanes and gardens seemed to environ Arta; and after having passed the great bridge over the Arachthus, we wound through dark and strange places

full of mud, among masses of building black against bright moonlight, till jaded and more fevered than I had been ever since I had left Saloniki, we arrived at the house of the British consular resident agent, Signor Boro, a Greek of Arta. I longed earnestly to retire at once to sleep, but the hiccupping flutter of a fowl in the death agony, announced, in spite of my entreaties, that a supper is in preparation. Nevertheless, this clean large house, these good rooms, and sofas, were most welcome to a way-worn tourist.

NOVEMBER 8th

More Albanian obstacles: our horses are all seized and dragged from the stables by a Turk - a nautical Turk, whose ships are at Prévyza; he, with many Mohammedan "middies" require steeds to gallop over the plains of Arta; so he takes ours, and snaps his fingers at Giorgio, and the Boyourldi of the Sultan.

"Boyourldis are for land Turks," quoth he, "I am a water Turk." Giorgio storms, the consular agent remonstrates, and both send to the Governor with an instant requisition of fresh horses for a Prince of Frangistán, desirous of going immediately to Salágora, there to embark for the country of the Franks.

Down came the Governor, Secretaries and Muftis; and away went Kawási all over the place as they did at Avlóna, so that in less than an hour three horses were in readiness. Meanwhile, I walked with Signor Boro to the ancient walls of Arta, which are fine examples of Hellenic architecture. Nor can any place be more superbly situated than this; which, with the sweeping Arachthus below the town, and the Tzumérka range beyond the plain, forms a magnificent picture. There was a very curious old Greek church too; but trusting to return to these parts of Southern Albania, I gave but little time to lionizing Arta, and at eleven we were again ready to start for Prévyza.

Threading the incommodious streets of Arta (which streets are deep gutters, or ditches, full of mud, with a raised trottoir on each side) and once more passing the lanes, olive-grounds and orange gardens, and the lofty bridge over the broad river, we came at length to the grand open plain which stretches uninterruptedly to the gulf.

No groups of mountains are lovelier than those within sight of this part of Epirus: whether the eye gazes at the Acharnanian heights beyond Vónizza, or at those of Agrafa, Tzumérka, and Pindus, or whether it turns towards the dread Suliote hills, and terrible Zálongo, the closing scene of heroism and despair.[2]

The latter part of the journey was by a high paved road over a wide, marshy ground close to the gulf, and in four hours from leaving Arta I reached the hilly peninsular eminence sheltering a hamlet of ten or fifteen houses, known as the Scala of Salágora, or port of Arta. Here we should have embarked for Prévyza, but owing to the wind, which is peculiarly perverse at the mouth of this gulf, the caique which plies between the two coasts is not come, and the khan is full. Meanwhile a Greek merchant good-naturedly gave me a lodging in a warehouse of rice till midnight, when the bark arrived, and taking our party on board, set sail to Prévyza.

NOVEMBER 9th, 10th, 11th

I pass these days at Prévyza, a place that does not possess in itself any agreeable compensation for the vexatious detention by contrary wind, which prevents my sailing across to the quarantine of Santa Maura.

But the kindness and hospitality of Sidney Smith Saunders, Esq., and all his family, would render any place an agreeable sojourn. It is delightful, after roaming over the most uncivilized places, to find a nook stamped with the most thoroughly English character in one of the spots where you would least expect it.

NOVEMBER 12th

The wind has changed, and the sea is like glass. Before sunrise I am in the consul's cutter. Every moment brings me nearer to Leucadia. The point of Prévyza, with the ruins forming part of what was once Ali Pashá's serai, lessens into one little bright speck on the water's edge. The snowy ranges of Tzumerka glitter palely in the early sunbeams and gradually fade into hazy, cloud-like forms. And so, bidding farewell to Albania, for the present I enter a nine days' quarantine at Santa Maura.

Chapter XIV

Plan to re-enter Albania and visit Suli, Athos, &c. - Andréa Vrindisi, the guide - Quit Patrás and sail to Corfu - Land at Prévyza again - Remains of Nicópolis - Its theatres, &o. - Leave Prévyza - Pleasant route to Kamárina - The rock of Zálongo and the Suliotes - Rain - The village home at Kamárina - Woods and glades of Kamárina - Nightingales - Descent to the plains - Lúro, Kanzá, Rogús - Vultures and tortoises - Arrival at Arta once more - Its magnificent aspect - Hellenic walls - Orange groves - Departure from Arta - Infinite variety of birds - Immense flocks of vultures - Pasheená's bridge and its valley of oaks - Beauty of Lake Zeró - Village of Sélovo - Freshness of early morning - Village of Kragná - Difficulties of mountain tracks - Arrive at the village of Zermi - The Primate's house and reception - Valley of Tervitzianá, and approach to the Gorge of Suli - Note on the disastrous history of Suli and its brave people - Fall of baggage-horses - Fearful glen of the Acheron - Danger, and tedious process of passing through the ravine - Arrival at the hill of Thunderbolts - Castle of Suli - The Governor - Wild and impressive scenery.

1849, APRIL 24th

After two months passed most pleasantly in Greece (the winter having been well defied in Cairo and at Mount Sinai), there are yet six weeks on my hands, ere, after having suffered from repeated attacks of Greek fever, it would be prudent to encounter the variable English spring. And now, if ever, I must endeavour to complete my tour in Albania. I long to visit that most romantic portion it - the land of the Suliotes, to make careful drawings of Ioánnina, to see Metéora and

Thessaly - even to the Gulf of Volo - and once more to attempt reaching the lonely Mount Athos.

F. L., my Greek companion, is obliged to return to Malta, so I set out alone; but first, the judicious old Andréa Vrindisi,[1] who is equally at home in the wilds of Tchamouriá as in the civilized streets of modern Sparta, and whose tongue (master of ten languages) is not less valuable than his general skill and arrangement of the domestic comforts of travel, is taken by me at the usual rate of £1 5s. daily, for an indefinite period of service.

Perhaps the best way of entering Albania from Patrás would be by crossing to Missolónghi, and thence, by a journey of three or four days' length, to Vónizza and Prévyza; but the desire to see some persons in Corfu who will not be there on my return, as well as the choice which, when the traveller is once in that island, is open to him, as to the part of the opposite coast he will first explore, these determine me on relinquishing my design of passing through Acharnania; and I have embarked in the Austrian steamer 'Elleno,' which luckily arrives and starts on the very day after the conclusion of my Greek journey with L.

For the third time I watch the high Mount Voidhiá, now glittering in a snowy mantle, and contemplate the exquisite forms of the Peloponnesian and Acharnanian hills. Then, as evening gradually covers the cloudless sky with duskier tints, Ithaca succeeds, and lastly Leucadia's "rock of woe," starlit and solemn, sleeps on the bosom of the calm sea.

APRIL 25th

> "Morn dawns, and with it stern Albania's hills
> Dark Suli's rocks, and Pindus' inland peak"

and no lines of mountain more beautiful - none more teeming with romance and interest - can be gazed on by traveller, be he painter or poet. Fast advancing through that lovely channel, we soon reach the long-descried citadel of Corfu, and delight again in welcoming scenes, than which the world has few more charming.

During the four succeeding days, time went by very pleasantly in the Government palace, where the kindness of the Lord High Commissioner and his family added one more to my many pleasant recollections of Corfu. But on the 30th, Lord Seaton offering to take me as far as Prévyza, on his way to Santa Maura, I decided to recommence my Albanian researches from that point, and joined the party in the Government steamer. We were off Prévyza at four P.M., when I once more set foot in Epirus. Signor Damaschinó, the vice-consul at Ioánnina and my acquaintance of last year, his wife, and her brother Viani, were also of the Albanian-bound party, and we were all soon heartily welcomed at the Consulate by Mr. Saunders and his ever-hospitable family.

MAY 1st

Today Andréa being employed in procuring little necessaries for the journey - I devote to visiting and making drawings of Nicópolis, which I had hastily glanced at when passing through Prévyza last year. The ruins of this city, founded by Augustus after the battle of Actium, lie not above three miles from Prévyza,[2] and the walk thither is very pleasant, through plantations of olive trees.

The scattered remains of Palaio Kastro (so the peasants call the site of Nicópolis) occupy a large space of ground and, although there are here and there masses of brickwork, which forcibly recall to my memory those of the Campagna or Rome, yet the principal charm of the scene consists in its wild loneliness, and its command of noble views over the Ionian Sea as well as of the Gulf of Arta and the mountains of Agrafa. My principal object was to obtain correct drawings from the great theatre, as well as from the Stadium and the lesser theatre; but at this season of the year I found many impediments which in the late autumn of 1848 had not presented themselves.

Vegetation had shot up in the early spring to so great a size and luxuriance that a choice of position was difficult to find among gigantic asphodel four or five feet high, foxgloves of prodigious size, briars and thistles of obstinate dignity. Nor was the passing from one point of the ruins to another, through the fields of beans and Indian-corn which cover the cultivated portions of the soil, a light task. There were snakes too in great numbers and size, so that when the sun's heat

became powerful, I found the operation of exploring the whole of the Augustan city too nearly allied with risk of fever-fits to prolong it. Great as was the destruction of Nicópolis by Ali Pashá, who carried off vast portions of it for the construction of his palace at Prévyza, there is yet abundance of picturesque beauty in what remains; and the view from the upper seats of the great theatre, looking across the Gulf of Ambracia to the hills of Acharnania and Leucadia, is one of the most noble of prospects.

Returning to Prévyza at noon, I sketched for the remainder of the day in the outskirts of the town. A student of landscape might well employ himself in this corner of Epirus for a summer. It abounds with pretty bits of foreground and peeps of the beautiful mountain forms around. But in itself, this frontier-town of Albania contains little interest. The great palace of Ali Pashá exists no more - it is utterly destroyed - and the whole place has an air of melancholy desolation, increased possibly by one's knowledge of its past history and evil destiny.

MAY 2

It is eight A.M. before the horses and *roba* are ready, and Andréa gives the signal for starting. He has ordered three horses to Ioánnina, but it is understood that I am to go thither as I please - bound to no particular route or time of arrival. Travelling on Turkish horses has led me to adopt one improvement, namely, take with me a pair of stirrups and a strap to hang them by.

These I have purchased in Patrás, and they are gilt; whereon, as I leave the town, I hear an old Greek woman remark: "This *milordos* is the son of a king: even his stirrups are of gold!"

We went through the olive woods as far nearly as Nicópolis, and then, turning to the left, reached the sea, following a route by its bright blue waves at the foot of low sandy cliffs clothed and fringed with rich fern. In three hours after starting, we turned inland towards the hills of Zálongo, but rain, long threatening, prevented any sketching, though the scenery became more interesting at every step. All nature was of the freshest green, and the luxuriant oak woods, deep dells of brushwood, gentle lawns, and vales dotted with flowering thorn, formed pleasant rural landscapes on every side.

At half-past one we reached the village of Kamárina, which stands high up on the hill, and is a straggling hamlet of white-washed houses and reed-built cabins, placed in gardens of fruit trees, or shaded by great forest timber, growing at the foot of overhanging rocks clothed with trailing, wild vines.

At three or four, in a pause between showers, I attempted to reach the rock of Zálongo, immediately above the village. This was the scene of one of those terrible tragedies so frequent during the Suliote war with Ali. At its summit, twenty-two women of Suli took refuge after the capture of their rock by the Mohammedans, and with their children awaited the issue of a desperate combat between their husbands and brothers, and the soldiers of the Vizier of Ioánnina. Their cause was lost, but as the enemy scaled the rock to take the women prisoners, they dashed all their children on the crags below, and joining their hands, while they sung the songs of their own dear land, they advanced nearer and nearer to the edge of the precipice, when from the brink a victim precipitated herself into the deep below at each recurring round of the dance, until all were destroyed. When the foe arrived at the summit, the heroic Suliotes were beyond his reach.

But this is only one of many such acts which, during the Suliote war, furnished some of the most extraordinary instances on record of the love of liberty.[3] I wished much to see the actual scene of these events, as well as to visit the remains of Cassope,[4] on the summit of the hill; but to my great vexation, such violent rain fell, that I could not even reach the rock of Zálongo, and returning to the cottage at Kamárina, I was obliged to content myself by drawing at intervals from the door of the cottage, in which Andréa had arranged my night's lodgings. It was one of those large and long rooms, usual in Greek villages, and forming the home of a whole family, which sat at the farther end, while I occupied my own allotted portion of clay floor. The inhabitants of Kamárina are all Greek Christians, and indeed throughout the south of Epirus there are very few Mohammedans. The women of the house have a mournful air, and well may they, for many of the elders among them can still remember the terrors of those evil days, in the first years of the present century. Outside this cottage of Kamárina all is delightful, so quiet is the foreground near at hand, so fair the prospect far below - the long point of Nicópolis and Prévyza, the broad bright Gulf of Arta, the scene

of the battle of Actium, and the clear hills of Greece and Santa Maura, all spread like a map at my feet. It seems a spot marked out for peace and tranquillity, nor can I remember a village more deliciously placed as a summer's retreat. The rain has made the herbs and spring-flowers around full of fresh odour, and multitudes of nightingales are singing on all sides.

MAY 3rd

I am off by half-past five. The morning is bright, and the nightingales, who have warbled all night long, are as melodious as ever. In spite of my regret at not having been able to see Zálongo or Cassope, I shall remember the green hill of Kamárina with pleasure. I descend through woodland glades, with views of the Gulf of Arta ever before me, and the peaks of its fine mountains are wrapped in rolling mist. Lower down, towards the plain, the route winds among groups of oak and walnut trees, and below them are shepherds with their flocks. In about two or three hours we reach Lúro, a scattered collection of huts, with one or two better houses at the foot of the hills, and following the track at their base, shortly arrive at clear springs, and a quiet secluded lake, fringed with luxuriant foliage, and resounding with the notes of the nightingale and the cuckoo. All the country hereabouts resembles the most beautiful park or woodland scenery in England, excepting that the variety of underwood is greater, and the creepers and flowering shrubs are such as we have not. The tall white stems of the ash and plane shooting out of dark masses of oak foliage, and reflected in the clear water below, form charming pictures.

In the midst of this delightful bosky region, at an hour's distance from Lúro, stands Kanzá, a hamlet of a few very poor thatched huts; and from hence, keeping always through a thick and shady wood, which skirts the base of the hills, the route passes onward, till it emerges (after two hours' ride from Kanzá) on to an elevated pasture land, opposite the Castle of Rogús;[5] and here I halt for midday rest.

This fortress, standing on an ancient site, forms a part of one of those beautiful Greek scenes which a painter is never tired of contemplating. Rising on its mound above the thick woods, which here embellish the plain, it is the key of the landscape; the waters of a clear fountain are surrounded by large flocks of

goats reposing. The clumps of hanging plane and spreading oak vary the marshy plain, extending to the shores of the gulf, while the distant blue mountains rise beyond, and the rock of Zálongo shuts in the northern end of the prospect. All these form so many parts, each beautiful in itself, that combine to make a composition, to which I regretted not being able to devote more time.

After a short repose, I pursued my journey across the plain in the direction of Arta, where I intended to pass the night. We soon crossed the Lúro on a narrow bridge, and so unstable as to allow of but one horse passing it at a time, and then we followed the track across the wide level. During this morning's ride I saw upwards of twenty large vultures; but now the ornithological denizens of this wide tract of marshy ground were storks, which were walking about in great numbers, and their nests were built on the roofs of the houses, clustered here and there in the more cultivated part of the district. Snakes and tortoises also were frequent during the morning, concerning which last animals, Andréa volunteered some scientific intelligence, assuring me that in Greece it was a well-known fact that they hatched their eggs by the heat of their eyes, by looking fixedly at them, until the small tortoises were matured and broke the shell.

We arrived at Arta[6] about four. The group formed by castle and town and mosques, half encircled by the broad sweeping Arachthus and the fine range of Tzumérka, struck me as even more beautiful than I had thought it on my visit here last November. The house of the consular agent, Signor Boro, is now, as then, hospitably open.

MAY 4th

At early morn I was finishing my drawing began six months ago. Few places in Albania are more magnificent in aspect and situation than Arta; and to an antiquarian its attractions are still greater than to the artist. Nothing can exceed the venerable grandeur of its picturesque Hellenic walls, and from the site of its ancient Acropolis, the panoramic splendour of the view is majestic in the highest degree. Before nine, I left Arta for the second time, and it was long before we escaped from its narrow, muddy streets, and endless suburban lanes. These, however, were less disagreeable now than heretofore, on account of the

odoriferous orange trees, all in full bloom. Arta is surrounded by gardens, and in a great degree supplies the markets of Ioánnina with fruit and vegetables.

We pursued the paved post-track to Ioánnina for nearly two hours; and as the pace over those causeways was of the slowest, I was on the lookout for incidents of all kinds, and found sufficient amusement in watching the birds which haunt these plains. There were jays and storks and vultures in greater numbers than I had supposed ever congregated together. Even the unobservant Andréa was struck by discovering, on a nearer approach, that a multitude of what we thought sheep, were in fact vultures; and on our asking some peasants as to the cause of their being so numerous, they said, that owing to a disease among the lambs, greater quantities of birds of prey had collected in the plains than "the oldest inhabitant could recollect." A constant stream of these harpies was passing from the low grounds to the rocks above the plain; and they soared so closely above our heads, that I could perfectly well distinguish their repulsive physiognomies. I counted one hundred and sixty of them at one spot, and must confess that they make a very grand appearance when soaring and wheeling with outstretched wings and necks. All the ground in this marshy part of the plain was covered with the most brilliant yellow iris in full bloom.

On leaving the Ioánnina road, we held on our course westward, and crossed the plain to the village of Strivina on the banks of the Lúro river which we followed for more than an hour. The scenery of this part of Epirus is not unlike that of the Brathay near Ambleside, but the closely-wooded sides of the hills are here and there enlivened by a Greek scattered hamlet, giving its own character to the scene. Higher up the stream, the trees are of a larger size and fringe the lower hills beautifully; and when at one P.M. we reached Pasheenás bridge, I thought I had never seen a more romantic bit of English-like scenery. It was delightful to rest below the fine old oaks and planes in this spot, whence as far as the eye could reach thick foliage gladdened the sight. Crossing the Charadrus, we started once more at two, and in one hour - the route always leading through glades and wild woodland - came to the little Lake Zeró, which I had been strongly recommended by Mr. Saunders not to omit seeing. And, in truth, it is well worth a visit, not that it has any character peculiar to Epirus or Greece (for it is more like Nemi than any lake I am acquainted with), but on account of the surpassing beauty of its

deep and quiet waters, from whose clear surface bold red rocks rise on all sides, hung with thickest ilex, and surmounted by dense woods of oak which extend to the very summit of the hills above.

There was barely time to make two sketches of Lago Zeró, ere the sinking sun warned me onward, and another hour brought us to the vale of Lélovo, a village which is built on the western side of the hills enclosing the glen. The other, as I entered the hamlet, became gloriously bright in the last rays of sunset, all the detail of rock and tree changing from red and purple, and cold grey, until finally lighted up by the bright full moon.

A very comfortable lodging was obtained at the top of the village of Lélovo, in a house which, like all in these parts, stands alone in a courtyard, and is well arrayed with galleries and stairs. Its tenants were a Greek priest (Lélovo is a Christian community) and a very old nun. They allowed me to occupy for the night, one of their rooms, a clean and good one. The scenery through which I have passed today and yesterday has greatly delighted me. It is rare in Greece to find such rich foliage combined with distant lines of landscape, and this, indeed, is a beauty peculiar to the southern parts of Epirus. Towards Ioánnina, and to the north of it, such clothing of vale and mountain is not frequent.

MAY 5th

At sunrise the vale of Lélovo is full of mist, and resounding with the lowing of invisible cows, on hearing which domestic sound, I thought, of course, there would be no milk, but for a wonder, there was. How enjoyable was the walk through the meadows as we left the village on our route to Suli. The song of birds, the fresh breeze, and all those charms of early morning which to the experienced sojourners in southern lands, mark the best hours of the day! We halted but once at a shepherd's *capanna*, for a bowl of fresh milk, ere we began a severe ascent, which in two hours brought us to Kragna, a little village among noble old oaks, whence the views extended over the Gulf of Arta with the Tzumérka and Ioánnina hills. But the people of Kragna were cross-grained and disobliging, and no offers would induce them to furnish us with another horse (that which carried the baggage not being a very strong one), nor would they show us the road to

Zermi, on the way to Suli, except for a minute's walk beyond their village. About eight we left it, and passed from dell to dell, by very difficult paths, steep, narrow and rocky, with no little fear of losing the way in places where the track was quite obliterated by torrents. We steered well, however, and finally leaving the thick oak woods, arrived at the hill of Zermi, high up on which is the scattered village of the same name, guarded by troops of angry dogs, as is the custom in these parts.

We went to the house of the Primate,[7] and found him and all his family at dinner: it was the fête of St. George, today being with them the 23rd of April. With the heartiest hospitality they insisted on our sharing their feast, which was by no means a bad one, as it consisted of roast lamb, two puddings made of Indian-corn, one with milk and herbs, the other with eggs and meat, besides rakhee. The room was extremely neat and clean, and the best in all respects I had seen in Southern Albania. But, sitting in a draught of air when heated by exercise, that premonitory feeling which indicates coming fever obliged me to quit the society almost immediately. We waited for some time in expectation of another horse, but at half-past twelve tidings came that it had escaped, and so we divided our baggage into two parts, in order to lessen the feebler steed's burden, and thus arranged, set out again.

Descending the hill of Zermi, we came in less than an hour to the vale of Tervitzianá, through which the river of Suli flows ere, "previously making many turns and meanders as if unwilling to enter such a gloomy passage," it plunges into the gorge of Suli. We crossed the stream, and began the ascent on the right of the cliffs, by narrow and precipitous paths leading to a point of great height, from which the difficult pass of the Suliote glen commences. And while toiling up the hill, my thoughts were occupied less with the actual interest of the scenery than with the extraordinary recollections connected with the struggles of the heroic people who so lately as forty years back were exterminated or banished by their tyrant enemy. Every turn in the pass I was about to enter had been distinguished by some stratagem or slaughter. Every line in the annals of the last Suliote war was written in characters of blood [8]

But my reflections were interrupted by a disagreeable incident. In a rocky and crabbed part of the narrow path, the baggage-horse missed footing and fell backward. Fortunately, he escaped the edge of the precipice, but the labour and

loss of time in re-arranging the luggage was considerable; and when we had scaled the height, and I sat looking with amazement into the dark and hollow abyss of the Acheron, a second cry and crash startled me. Again the unlucky horse had stumbled, and this time, though safe himself, the baggage suffered. The basket containing the canteen was smitten by a sharp rock, and all my plates and dishes, knives, forks, and pewter-pans which F. L. had bequeathed to me at Patrás - went spinning down from crag to crag till they lodged in the infernal [9] stream below. These delays were serious, as the day was wearing on, and the "Pass of Suli" was yet to be threaded. This fearful gorge cannot be better described than in the words of Colonel Leake:

" A deep ravine, formed by the meeting of the two great mountains of Suli and Tzikurátes - one of the darkest and deepest of the glens of Greece; on either side rise perpendicular rocks, in the midst of which are little intervals of scanty soil, bearing holly oaks, ilices, and other shrubs, and which admit occasionally a view of the higher summits of the two mountains covered with oaks, and at the summit of all with pines. Here the road is passable only on foot, by a perilous ledge along the side of the mountain of Suli; the river in the pass is deep and rapid, and is seen at the bottom falling in many places over the rocks, though at too great a distance to be heard, and in most places inaccessible to any but the foot of a goat or a Suliote."

I shall not soon forget the labour it cost to convey our horses through this frightful gorge. In many places the rains had carried away even what little footing there had originally been, and nothing remained but a bed of powdered rock sloping off to the frightful gulf below; and all our efforts could hardly induce or enable each horse to cross singly. The muleteer cried and called on all the saints in the Greek calendar; and all four of us united our strength to prevent the trembling beast from rolling downwards. There were three of these *passi cattivi*, and the sun was setting. I prepared to make up my mind, if I escaped to Acheron, at least to repose all night in the ravine.

At sunset we reached the only approach on this side of the "blood-stained Suli" - an ascent of stairs winding up the sides of the great rocks below Avariko -

and very glad was I to have accomplished this last and most dangerous part of the journey. Before me was the hollow vale of Avariko, Kiáfa, and Suli - places now existing little more than in name, and darkly looming against the clear western sky stood the dread Trypa - the hill of Thunderbolts - the last retreat of the despairing Suliotes.

Here, at the summit of the rock, Ali Pashá built a castle, and within its walls I hoped to pass the night. I reached it at nearly two hours after sunset, the bright moon showing me the Albanian Governor and his twenty or thirty Palikari sitting on the threshold of the gate. But unluckily as I had not procured any letter from the Turkish authorities at Prévyza, the rough old gentleman was obdurate and would not hear of my entering the fortress. "*Yok*," said he, frowning fiercely, "*yok, yok.*" And had it not been for the good nature of a Turkish officer of engineers who had arrived from Ioánnina on a visit of inspection, I must have passed the night supperless and shelterless. Thanks to him, men and horses were at length admitted to the interior of the fort.

I was ushered through several dilapidated courtyards to the inner serai or Governor's house - a small building with wide galleries round two sides of it. In a narrow and low room, surrounded with sofas, the military dignitary sat down with his suite of "wild Albanians" and, to be polite, I followed their example. But the excessive smoke of the wood fire, added to that of the tchibouques, was so painful a contrast to the fresh air, that it was almost intolerable. No Greek was spoken, so Andréa was called in, and they expressed their conviction that I "looked miserable - neither eating, nor talking, nor smoking" - an accusation I willingly acceded to, for the sake of rest and fresh air, and transferred my position with all haste to the outer gallery. There I had my mattress and capotes spread, and old Andréa brought me a capital basin of rice soup. It had been a severe day's labour for a man of his years and great size, and during the passage of the gorge, he had more than once been unable to advance for some minutes. Yet, with his wonted alacrity, he had not only prepared my bed as usual, but had exercised his talent for cooking withal.

I gazed on the strange, noiseless figures about me, bright in the moonlight, which tipped with silver the solemn lofty mountains around. For years those hills had rarely ceased to echo the cries of animosity, despair and agony. Now all was

silent as the actors in that dreadful drama. Few scenes can compete in my memory with the wildness of this at the Castle of Kiáfa, or Suli Kastro; and excepting in the deserts of the peninsula of Sinai, I have gazed on none more picturesque and strange.

Chapter XV

Sunrise at Suli - Tremendous grandeur of its gorge - Descent to, and passage across the
Acheron - Endless views of Suli - Village of Potamiá - Perplexing paths - Andréa loses his
way - Arrival at nightfall in the hamlet, of Splántza - Moonlight, frogs, and fireflies -
Route along the cliffs - Vast olive-grounds - Beautiful appearance of Párga - Its most
melancholy history - Italian character of its scenery - Route to Margariti and Paramythia
- Magnificent position of the latter town - Its unsatisfactory accommodations -
Uninteresting route in a river bed - Arrival at Bagotjús - Unpropitious weather - Great
theatre of Dhramisiús - Arrival at Ioánnina once more - Three days in that capital -
Beauty of the surrounding scenery - Description of its variety and of the streets, &c. -
Unsettled state of the weather in these lofty mountains at this season - Resolution to visit
Thessaly and Athos.

MAY 6th

Before sunrise everyone was on foot, but the military duties of the garrison were
interrupted by the circumstance of my being obliged to wash my face in public.
Unlike the Turkish Mohammedan, the Albanian prefers satisfying curiosity to the
maintaining of dignity. Officers and men came hastily, on the report of the
Frank's extravagance, to gaze at the extraordinary proceeding. I believe they
thought it a species of water-worship.

I passed some hours on the rock of Trypa, and a more mighty scene of
grandeur can hardly be conceived. On each of the jutting ends or horns of the
hill, which is semicircular in shape, there was formerly a fortress. These are now

destroyed, but from their ruins the view is most characteristic, and seems as it were a part of the sad Suliote history, so darkly and terribly magnificent. One little peep towards the east showed the Gulf of Arta with its hills beyond the stern precipices of the Acheron, that to the west looked onto the plain of Fanári and the Ionian Sea, while in each picture the deep, deep river rolls far below in its close and wooded gulf.[1]

At eight, the baggage having gone before, I took leave of the cross old Governor. I had distributed some coffee to his men, but he nevertheless asked for several articles for himself, begging I would send to Suli from the next large place I came to, a mirror, a good telescope, four wine-glasses, and a cut-glass bottle for rakhee; pistols, scissors, and English cloth; all of which things Andréa said, in Albanian, that I would forward on the first opportunity, which lavish promises, as I did not hear them made, I did not feel bound to observe. The descent westward to the Acheron was a difficult narrow path, in some places of extreme steepness, but of course not like the route of yesterday, which was never intended for horses. At the bottom of the ravine, they forded the deep rapid torrent, while I went on to a point beyond the junction of a stream where the Acheron is crossed by a bridge. But what a bridge! The river, confined between two very narrow perpendicular crags, boils and thunders below them, while the space between is connected by two poles, over which branches of trees are laid transversely, and over all a covering of leaves and earth, by way of pavement; an awkward structure, and one well calculated to render the approach to Suli, even on this side, a matter of difficulty. Slowly, on hands and knees, and holding the poles, I passed this bridge over the river of Pluto, its oscillations being far from pleasant. But the huge Andréa manifested much solicitude ere he ventured his heavy frame on the slight support, throwing his shoes and most of his dress over to the other side, before he attempted to cross. On the left bank, the road thenceforward became a little less difficult; and after following several windings of the stream, sometimes at a great height above it, finally left the tremendous gorge of the Acheron for the level plain of Fanári, on which I was once more glad to welcome the familiar lentisk and clumps of squills.

Shortly we again forded the Acheron, here in the vicinity of the ruined church of Glyky, a broad and considerable river; the Albanians who accompanied

me breasting the rapid waters on foot, hand-in-hand. At every turn of the gorge, through which the river escapes, there are views of Suli most varied and magnificent, but from this point its general aspect is most strikingly noble.[2]

Anxious to reach Párga ere night, I did not visit the ruins of Glyky, but pursued the route in the plain, through rice-grounds, to the village of Potamiá,[3] where at midday we halt. I could well have liked to have made many studies of these wild homes of Tchamouriá, but the difficulty of drawing during the whole of the day was great, especially at this period, when the heat began to be oppressive, and a little neglect and idleness was excusable, though often afterwards regretted. After an hour and a half of repose, below large vine-hung willow trees, lulled by the murmur of innumerable bees, and always jealously watched by a score or two of the ferocious dogs which guard these villages, it was time to proceed once more, and we again rode on towards the sea.

A good deal of time was devoted to picking our way among the ditches and irrigations of the rice-grounds, which were very extensive in this part of the marshy plain of Fanári. The paths among them formed a perfect labyrinth, and much labour was lost in making useless detours. At length, however, we crossed the Vuvo[4] by a bridge, and leaving the Acherusian plains, took a course eastward towards Párga.

Another hour was wasted by the muleteer persisting in the descent of a ravine, which conducted to no place whatever. There were new cuts of mule tract also, which evidently greatly puzzled poor old Andréa, who had not been here since 1833; and by the time we arrived at the hills on the coast looking towards Paxós, the sun was very low, and there were no symptoms of Párga. It was so late, that as this new broad track seemed necessarily about to lead to some village, an experimental retrograde move was objectionable, so we went onwards, though by the winding of the path over cliffs to the south. It was evident to me that Párga was not to be my home tonight.

At length we entered a thick wood, and began to descend rapidly, when lo! once more we were in sight of the Acherusian plains, with the port of Fanári or Splántza at our feet. The route we had followed by mistake was a new one, lately made from that increasing village to Párga and Paramythia; but the discovery of his error threw poor old Andréa into great distress.

182

"Old age is coming upon me, and my memory is going," said he. "I never missed my way before, and now for the first time I perceive that I shall be unable to act as guide any longer. I, my wife, and my daughter, shall all die of starvation."

In vain I declared, in order to comfort him, that he had done me a great service, for I particularly wished to have a drawing of the ancient port Glykys Limen, which in reality is a beautiful scene. The poor old fellow was inconsolable, so I sent him onward with the baggage, and remained until the sun had set, sketching the quiet little bay and its village, at the edge of the marshy plain, with the beautiful island of Leucadia forming the background.

It became dark ere I reached the edge of the thick wood; and in places where the track divided, the Albanian who led my horse, felt (for it was too dark to see) for the freshest traces left by the horse's shoes, on the edges of the flints in the path. I left the thicket, and on rounding the hill which overhangs the marsh, I saw Andréa and the horses far on the shore, "lit by a large low moon;" and following the edge of the Acherusian swamp, that sparkled with myriads of fireflies, I reached the sands of the calm bay, and the hamlet of Splántza, where I found lodging provided in the large room of a Greek family, agents to the people whom I knew at Prévyza, and who were glad to make any arrangement for my comfort.

Late at night I strolled on to the bright sands, and enjoyed the strange scene. The air seems peopled with fireflies, the earth with frogs, which roared and croaked from the wide Acherusian marsh. Low-walled huts clustered around. Albanians were stretched on mats along the shore. Huge watchdogs lay in a circle round the village. The calm sea rippled, and the faint outline of the hills of desolate Suli, was traced against the clear and spangled sky.

MAY 7th

Long before sunrise we were away from Splántza, and taking another guide to insure certainty in reaching Párga, I bade adieu once more to the plain of the Acheron and dark Suli, as we followed the track which led us in less than two hours to the spot we had reached last afternoon, and thence for some distance along the high cliffs above the bright blue sea, through underwood of lentisk and thorn.

About nine we arrived at beautiful and extensive groves of olive, for the cultivation of which Párga is renowned. They clothe all the hills around, and hang over rock and cliff to the very sea with delightful and feathery luxuriance. At length we descended to the shore at the foot of the little promontory on which the ill-fated place and its citadel stood Alas! what now appeared a town and castle consisted of old ruined walls, for Párga[5] is desolate. A new one built since the natives abandoned the ancient site is, however, springing up on the shore, and with its two mosques is picturesque. This, with the rock and dismantled fortress, the islands in the bay and the rich growth of olive slopes around, forming a picture of completely beautiful character, though more resembling an Italian than a Greek scene. But it is impossible fully to contemplate with pleasure a place, the history of which is so full of melancholy and painful interest.

A dark cloud hung over the mournful spot. Would that much which has been written concerning it were never read, or that having been written, it could be disbelieved! A lodging was found me in a very decent house, and shelter against the heat of midday was grateful. In the afternoon and evening I made many drawings from either side of the promontory of Párga. From every point it is lovely, very unlike Albanian landscape in general, and partaking more of the character of Calabrian or Amalfitan coast scenery. But in spite of the delightful evening and the sparkling white buildings that crowned the rock at whose feet the waves murmured, the whispering olives above me, the convent islets, and the broad bright sea beyond, in spite of all this, I felt anxious to leave Párga. The picture, false or true, of the 10th of April, 1819, was ever before me, and I wished with all my heart that I had left Párga unvisited.

MAY 8th

About seven I retraced my steps to the road communicating between Paramythia and Splántza, and throughout the route leading over the hills which surround the Párguinote territory there was but little interest, excepting some Hellenic remains on the right, which I did not leave the track to examine.

Before eleven we reached Margariti. It stands in a close valley surrounded by hills, the outline of which is not possessed of much beauty, but, as in many other

instances, the frequency of interesting detail that forms, as it were, numerous small pictures, atoned for the want of general effect. Along the hillside are scattered great numbers of detached Turkish houses situated in gardens. One or two small minarets glitter above the fruit trees, and fine groups of plane shade parts of the vale below.

Margariti, still a considerable place, was once extensive and powerful, and one of the last which held out against the power of Ali, but in the end it shared the fate of its neighbours. A cottage received me for repose and refreshment until the heat of noon was over. At half-past one P.M. we began to ascend the range of high hills which divide the territories of Margariti and Paramythia, and to toil over a tract of ground as barren of herbage as of interest and beauty. Near the summit of the height, however, is seen the extremity of Corfu, and higher up to the south lies Santa Maura. The day being very sultry, there was a pleasant breeze which partly compensated for the absence of charm in the landscape. Nor was there long to wait for this worthier scene, for we shortly began to descend into the green and pleasant plains of Paramythia, the town and castle of which are situated at its northern end, backed by magnificently formed mountains. Every step across the plain of the Cocytus increases the beauty of the appearance of this fine place, without doubt one of the most grandly situated towns in Albania.

The mountains which enclose the valley on every side prevent any distant view, but the interest of the hill of Paramythia is in itself sufficient to employ an artist for a long space of time. The summit of the rock, on the sides of which the houses of the town are built, is crowned with a castle, and below it are scattered the picturesquely grouped dwellings intermingled with cypress and all kinds of foliage, while streams, stone fountains, Greek churches and mosques - a second castle, that rises above what may be termed the lower town, large tufts of lofty trees in the vale, and the fir-clad mountain above, add to the charm and splendour of the scene.[6] I lingered long on the banks of the Cocytus drawing this beautiful place. The costume of the Greek women here is one of the prettiest I have seen; and as a party passed me on its return to the town from a neighbouring wedding, I had a good opportunity of observing several of them.

On arriving in that part of Paramythia which is most thickly inhabited, the narrow and dirty streets present a strange contrast to the beauty of the town when

seen from below, and although we discovered a khan to which some of the peasants had recommended me as "*troppo polito!*" it was so dismal and filthy an abode that we tried to find a substitute in some Greek Christian's house. After some search, however, I was forced to relinquish the idea of comfort and remain in a close and foul cell for the night (a place little better than some of my Illyrian lodgings), and listen to the wild octave-singing of the Albanians below, till the arrival of midnight, silence and sleep.

MAY 9th

In these holes, miscalled rooms, light there is none, and it is only by the sudden and simultaneous clattering of storks, twittering of swallows, bleating of goats, and jingling of mules' bells, that a man is advised of the coming day. Starting at seven, two hours of toil brought us to the top of a rocky and uninteresting pass, at a place called Eléutherokhório, one of the often-contested spots in the wars between Ali and the people of Paramythia, Margariti and Suli.

Here passports were demanded by a guard of Albanians, a matter more of form than use, as Andréa hardly deigned to exhibit my Boyourldi. Hence we descended into the bed of a torrent, whence we remained making weary way among low planes, not yet in leaf, so much colder is the temperature in this district than on the southern and western side of the mountains, where all was brilliant verdure. By one P.M. we had already crossed this tiresome stream forty times. Rain began to fall, and the day was gloomy and cloudy, so that, growing colder every hour, I grew every moment more weary of a day's journey, in which there was little beauty, novelty or interest.

About three we turned to the right leaving the road to Ioánnina, which we had hitherto followed and, ascending the sloping base of Mount Olytzika arrived about half-past four at the village of Bagotjús, where we halted to pass the night. It was too late to visit the theatre of Dhramisiús, so after drawing some of the scenery from the door of the priest's house where I was to lodge, I passed the evening as well as I could. The ceiling of my night's home was hung with pendant Indian corn, and great globes of raw cotton. Outside, the view was peculiarly interesting: infinite clumps of fine trees clothed the sides of the hill, or were

dispersed in the pasture-land below. Some of these sheltered the village church in a very pleasing manner, as is the usage in these countries.

MAY 10th

To my great disappointment, it was raining hard at sunrise, and the clouds did not give any promise of holding up. Nevertheless, resolved to see the ruins of Dhramisiús, I walked thither with a guide, as they were not above twenty minutes' distance from the village of Bagotjús. In spite of the driving cold rain, which nearly hid Mount Olytzika from view, it was impossible not to be greatly struck with the magnificent size and position of the great theatre, which ranks in dimensions with the largest ones of Greece: Sparta, Argos, Athens, Megalopolis, &c.,[7] its total diameter being four hundred and sixty feet.

It is supposed that these extensive remains belong to a hierum and place of public meeting of the Molossi: "a place of common sacrifice and political union for the use of all the towns of that division of Epirus."[8] I greatly regretted not being able to make such drawings as I wished at this interesting spot, though I did get one; but, had it been fine, the vale below the immense theatre, with the great peaks of Olytzika above, the immense clumps of trees at its base, would have tempted me to pass a day there.

On Andréa joining me with the horses, we made the best of our way to Ioánnina in pouring rain, which never ceased until we were near the lake, when Pindus, glittering in silvery snow, peeped forth from clouds, and all the wide meadows south of the city were flocked with numberless white storks.

Before eleven I reached Ioánnina, and was once more at the hospitable vice-consulate, where Signor Damaschinó and his family had arrived a few days back from Prévyza.

MAY 11th, 12th, 13th

Three days passed at Ioánnina, but with constant interruptions from showers. The mornings were brilliant, but clouds gathered on Mitzikéli about nine or ten, and from noon to three or four, thunder and pouring rain ensued. The air was

extremely cold, and whereas at Párga I could only bear the lightest clothing, I was here too glad to wear a double capote, and half the night was too cold to sleep. Apart from the friendly hospitality of the Damaschinó family, a sojourn at Ioánnina is great pleasure, and were it possible, I would gladly have passed a summer here. It is not easy to appreciate the beauty of this scenery in a hasty visit. The outlines of the mountains around are too magnificent to be readily reducible to the rules of art, and the want of foliage on the plain and hills may perhaps at first give a barren air to the landscape. It is only on becoming conversant with the groups of trees and buildings, picturesque in themselves, and which combine exquisitely with small portions of the surrounding hills, plain, or lake, that an artist perceives the inexhaustible store of really beautiful forms with which Ioánnina abounds.

During these days time passed rapidly away, for there was full employment for every hour. One moment I would sit on the hill which rises west of the city, whence the great mountain of Mitzikéli on the eastern side of the lake is seen most nobly. At another, I would move with delight from point to point among the southern suburbs, from which the huge ruined fortress of Litharitza, with many a silvery mosque and dark cypress, form exquisite pictures, or watch from the walls of the ruin itself, the varied effects of cloud or sunbeam passing over the blue lake, now shadowing the promontory of the *kastron* or citadel, now gilding the little island at the foot of majestic Mitzikéli. Then I would linger on the northern outskirts of the town, whence its long line constitutes a small part of a landscape whose sublime horizon is varied by mountain forms of the loftiest and most beautiful character, or by wandering in the lower ground near the lake. I would enjoy the placid solemnity of the dark waters reflecting the great mosque and battlements of the citadel as in a mirror. I was never tired of walking out into the spacious plain on each side the town, where immense numbers of cattle enlivened the scene, and milk-white storks paraded leisurely in quest of food, or I would take a boat and cross to the little island, and visit the monastery, where that most wondrous man Ali Pashá met his death, or sitting by the edge of the lake near the southern side of the *kastron*, sketch the massive, mournful ruins of his palace of Litharitza, with the peaks of Olytzika rising beyond. For hours I could loiter on the terrace of the *kastron* opposite the Pashá's serai, among the

ruined fortifications, or near the strange gilded tomb where lies the body of the man who for so long a time made thousands tremble! It was a treat to watch the evening deepen the colours of the beautiful northern hills, or shadows creeping up the furrowed sides of Mitzikéli.

And inside this city of manifold charms, the interest was as varied as it is fascinating. It united the curious dresses of the Greek peasant, the splendour of those of the Albanian, the endless attractions of the bazaars where embroidery of all kinds, fire arms, horse gear, wooden ware, and numberless manufactures peculiar to Albania were exhibited, the clattering storks, whose nests are built on half the chimneys of the town and in the great plane trees whose drooping foliage hangs over the open spaces or squares. These and other amusing or striking novelties which the pen would tire of enumerating occupied every moment and caused me great regret that I could not stay longer in the capital of Epirus. And when to all these artistic beauties are added the associations of Ioánnina with the later years of Greek history, the power and tyranny of its extraordinary ruler, its claim to representing the ancient Dodona, and its present and utterly melancholy condition, no marvel that Ioánnina will always hold its place in memory as one of the first in interest of the many scenes I have known in many lands.

Of the people of Ioánnina[8] I saw nothing except in the streets. I went about perfectly unmolested, nor was there any curiosity shown as to my drawing. Once only some Turkish officers observing my work on grey paper, sent for an interpreter to tell me that what I was using was not good London paper, for it was not white. Margiánn, the black Kawás of the vice-consulate, accompanied me everywhere, and smote the little red-capped children hither and thither if they came too near me. Among the women I observed none very pretty, and several were painted (as I remarked also at Paramythia) in the coarsest manner, quite to the eyes and roots of the hair.

The unsettled state of the weather, which characterises the spring and early summer in this place, prevented my even being able to obtain such sketches of the city and its neighbourhood as I had wished; and the same cause made me very undecided as to pursuing my journey eastward. Yet it seemed hard to return to England without seeing Metéora, Tempe, Olympus, and Athos; and when on the 13th the wind changed, and there were all sorts of atmospherical signs of

permanently fine weather about to set in, I finally resolved on crossing the Pindus into Thessaly, and ordered horses for the morrow.

Chapter XVI

Kastritza or Dodona - Ascent of Mount Dhrysko - View of the Lake of Ioánnina - The midday khan - Tedious ascent of the Métzovo branch of the Arta - Gorges of the Métzovo ravine - Arrival at the villages of Métzovo - Vlákhiotes and their habits - Scenery about the town - Upper Pass of Métzovo, or the Zygós - Scenery of the Pindus range of mountains - Khan of Malakássi - The river Salympria, and its banks - Plane trees - Albanian frontier passports - Amazing rock of Metéora - Kastráki and its crags - The monasteries of Metéora - Their inconceivable strangeness and picturesqueness - Arrival at Trikkala - Half-and-half costume of Thessaly - High road halting-places - Plains of Thessaly - Their innumerable beauties and objects of interest - Village of Nomi - Immense extent of meadows - Distant views of Pindus, Olympus, Ossa and Oeta - Ornithology - Increasing heat - Want of beauty in the wilder plains towards Lárissa - Arrival there.

MAY 14th

The morning promised well, and we started as early as half-past five. It was bitterly cold at this early hour and the paved Turkish road forbade other than a very slow pace. At the southern end of the lake, the passage between it, or rather a tract of marsh, and the hill of Kastritza was merely wide enough to admit of this causeway, the high road from Ioánnina to Constantinople.

The ancient remains on the hill I reserved for a visit on my return, when I hoped to make drawings to aid at a future day in some poetical illustration of Dodona, for with that ancient city the site of Kastritza[1] is considered by Colonel Leake to be identical; the fortress peninsula of the present city of Ioánnina he

suggests as the position of the Dodonean temple. The cautious research carried on for so long a time in Epirus and the great learning brought to the aid of such careful personal observation offer very weighty reasons for putting faith in Colonel Leake's suggestions as to the sites of antiquity, but apart from these, I feel determined to believe that his arguments concerning Kastritza are correct. And until I see a more beautiful Dodona I will believe, and it is a harmless even if an ill-founded credulity, that Dodona and the temple did stand at Kastritza and Ioánnina.

Crossing the plain of Barkumádhi, where there is a roadside khan, I began to ascend Mount Dhrysko - a part of Mount Mitzikéli, or the ancient Tomarus, arriving about nine at the top of the ridge, thence looking back on the lake, peninsula and island. Descending on the eastern side of the ridge, the prospect shows the two great branches of the Arachthus or river of Arta: that on the west coming from the hills of Zagóri, and that on the east from the mountains of Métzovo. Above, the vast forms of the Pindus range tower amid snow and forests of pine. Woods in dense array clothe the hill-sides, and below the river winds in many a serpentine detour.

Passing a khan, not twenty minutes in descending from the ridge of Dhrysko, we continued the downward route to a second khan near a bridge which crossed the Zagóri branch of the river. Here we made the midday halt. There is ever something pleasing in these moments of repose, if the weather permit them to be enjoyed out of doors. You have the rustling plane tree shading the galleried khan, around whose steps a host of little kids are sleeping, nightingales singing on all sides, purple-winged dragonflies gleaming in the sun, and unseen shepherds pouring forth a pleasing melody from rustic pipes. All these are matters of interest, though the actual scenery around me has rather a cumbrous air with undefined forms of hugeness not very adaptable to paper.

Half an hour after noon we again set off and, crossing the bridge, begin the ascent of the Métzovo branch of the Arta. Disliking the continual necessity of fording the rapid stream, I essay to follow the road, which is carried along the right bank of the stream; but soon finding it entirely broken down by torrents, we are obliged to retreat and descend to the bed of the river.

To those who are pleased with the operation of river fording I strongly recommend the ascent of the Métzovo mountain, as insuring a greater portion of

amusement in that line than any other equal space of ground. No fewer than forty-seven times had we to cross and re-cross the tiresome torrent ere we reached our evening's destination. I had hoped to lodge at Triakhánia, where there are, as the name implies, three khans, but we found on arriving there, as late as four P.M., that none were inhabited, and owing to last year's inundations, one was carried away and the other two left roofless and dilapidated.

Meanwhile the scenery was becoming more alpine and tremendous in character as we advanced into the darker gorges of the ravine, and the picturesqueness of the pass was much enhanced (though my chances of getting a night's lodging were proportionably diminished) by the passage of a regiment of Turkish cavalry with led horses. As the route occasionally leads at a considerable height from the river, while crossing from one ford to another, the long lines of soldiers dashing through the stream added great life to the picture.

Disappointed of our resting place at Triakhánia, there was now no alternative but to pass on to Métzovo, and after much tedious splashing through the roaring stream, we passed the military detachment, and hastened onwards, hoping to secure some part of a khan before they arrived. After much labour and hurry over roads which skirt the edge of precipices overhanging the torrent, we reached Anilio, the southern half of Métzovo - a large town divided into two portions by the ravine, and presenting no very picturesque appearance. Here we arrived at half-past seven o'clock, after a harder day's work than I had contemplated.

Guards were stationed at the public khans to prevent anyone taking rooms in them, so we had gained nothing by our haste. Andréa, however, soon procured a lodging in one of the houses of the village, a great contrast to those of the ordinary Greek peasants, being, although very small, perfectly neat and clean.

Métzovo is inhabited by Vlákhi or Vlákhiotes - a people of Wallachian descent, already spoken of in these journals as occupying portions of Albania. In general, their employment is that of shepherds, and as such they move about with their flocks from district to district. But in certain parts of the mountains settled colonies of them exist, who possess large flocks of sheep and goats, and are distinguished for their industrious and quiet habits of life. Many of the men emigrate as labourers, artizans, &c., to Germany, Hungary, Russia, &c., and

return only in the summer to their families. They retain their language. Their costume is ordinarily that of the Greek peasantry, a dark blue capote, with the head frequently bound by a handkerchief turban-wise above the fez or cap.

MAY 15th

There is much that is interesting and pleasant in this elevated town. The houses stand mostly detached among gardens, rocks, beech and ilex trees, and a thousand pictures of pastoral mountain life might be chosen, though the general scenery is of too large a character for the pencil. The people also seem simple and sociable in manners. While I am drawing, many of them bring me bunches of narcissus and cowslips, and endeavour to converse. All have a robust and healthful appearance, very different to the people of the plains. At half-past six I begin to ascend towards the highest ridge of the Métzovo Pass, called the Zygós, a formidable journey when there is any high wind or snow.[2] At present the weather is calm, and the magnificent groups of pine at the summits of the ridge are undisguised by even a single cloud. Few mountain passes are finer in character than this part of the Pindus range. Towards the very highest point, the rock, bald and rugged, is so steep that the zigzag track cannot be overcome but upon foot, and the immense space of mountain scenery which the eye rests on in looking westward is most imposing. Parent of the most remarkable rivers of Greece, and commanding the communication between Epirus and Thessaly, the Zygós of Métzovo is equally renowned for classical associations, for its geographical and political position, and its picturesqueness.

But in this latter quality it is for the wondrous and extensive view over the plains of Thessaly that it is most celebrated - a scene I was not fated to be indulged with, for no sooner had I surmounted the last crag of the ridge, in enthusiastic expectation of the outstretched map of which I had so often heard, than lo! all was mist. Nor, till I had for some time descended through the beautiful beech forests which cover the eastern side of the Zygós, and which are carefully preserved as a shelter from the winds which would at some seasons otherwise prevent the passage of the mountain, did the clouds disperse; but even then only so partially as to show but little of the vast Thessalian distance.

Passing a khan - the Zygós khan - shortly below the summit, we descended through woods into the more open country to a second, and in two hours and a half from the Zygós reached the third khan, that of Malakássi, on the Salympria.

At the khan of Malakássi we rested till nearly one P.M., when we pursued the route by the banks of the Salympria or Peneus, often crossing and re-crossing it, according as the track was more eligible on one or the other side. The scenery, confined at first and unmarked by any peculiar character, became more beautiful as we advanced farther from the mountains, whose thickly-wooded slopes began to assume the blue tints of distance. Luxuriant planes grow in the greatest abundance by the riverside, and the route often wound for half an hour through fresh meadows and the richest groves, resounding with the warbling of nightingales, and overshadowing rivulets which flow into the stream. We met numerous files of laden horses, journeying from Thessaly to Albania, but picturesque as they often were, there was a civilized sort of commonplace appearance about them, which to an artist's eye is infinitely less pictorial than the bearing of the wild hordes of Albania. We passed also more than one khan by the road, and usually at these places the Albanian guards asked us questions, and insisted on seeing passports which they had not the slightest idea of reading. As a proof of this, on my taking out by mistake the card of a hotelkeeper at Athens, the Palikar snatched at it hastily and, after gravely scrutinizing it, gave it back to me, saying, "Good, you may pass on!" At the next guard-house, I confess to having amused myself by showing a bill of Mrs. Dunsford's Hotel at Malta, and at another the back of an English letter, each of which documents were received as a *teskere*. So much for the use of the Derveni guards placed by the Turkish Government to take accurate cognizance of all passers-by.

As the day wore on and the river opened out into a wider valley, the eastern horizon suddenly exhibited a strange form in the distance, which at once I felt to be one of the rocks of the Metéora. This object combines with a thousand beautiful pictures, united with the white-trunked plane trees and the rolling Peneus, ere, escaping from the woods, the route reaches the wider plain, and the inconceivably extraordinary rocks of Kalabáka, and the Metéora convents, are fully unfolded to the eye.

"Twelve sheets," says Mr. Cockerell in a letter, Feb. 9, 1814, "would not contain all the wonders of Metéora, nor convey to you an idea of the surprise and pleasure which I felt in beholding these curious monasteries, planted like the nests of eagles, on the summits of high and pointed rocks."[3] We arrived at Kastráki, a village nestled immediately below these gigantic crags, at sunset. I do not think I ever saw any scene so startling and incredible; such vast sheer perpendicular pyramids, standing out of the earth, with the tiny houses of the village clustering at the roots.

With difficulty - for it is the time when silkworms are being bred in the houses, and the inhabitants will not allow them to be disturbed - Andréa procured a lodging for me in the upper part of a dwelling, formed as are most in the village, like a tower, the entrance to which, for the sake of defence, was by a hole three feet high. Here, after having gazed in utter astonishment at the wild scenery as long as the light lasted, I took up my abode for the night. The inhabitants of this place, as well as of Kalabáka (or Stagus),[4] are Christians, and every nook of the village was swarming with pigs and little children. "Πολλα παιδια," said an old man to me, as the little creatures thronged about me, "δια τον νερόν χαλόν."

What a contrast is there between the precipices, from five to six hundred feet high, and these atoms of life playing at their base! Strange, unearthly-looking rocks are these, full of gigantic chasms and round holes, resembling Gruyère cheese, as it were, highly magnified, their surface being otherwise perfectly smooth. Behind the village of Kastráki, the groups of rock are more crowded and darkened with vegetation, and at this late hour, a sombre mystery makes them seem like the work of some genii, or enchanter of Arabian romance. Before the dwellings, a slope covered with mulberry trees descends to the river, and grand scenes of Thessalian plain and hill fill up the southern and eastern horizon.

MAY 16th

I went very early with a villager to visit and sketch the monasteries. Truly they are a most wonderful spectacle, and are infinitely more picturesque than I had expected them to be. The magnificent foreground of fine oak and detached

fragments of rock struck me as one of the peculiar features of the scene. The detached and massive pillars of stone, crowned with the retreats of the monks, rise perpendicularly from the sea of foliage, which at this early hour, six A.M., is wrapped in the deepest shade, while the bright eastern light strikes the upper part of the magic heights with brilliant force and breadth. To make any real use of the most exquisite landscape abounding throughout this marvellous spot, an artist should stay here for a month. There are both the simplest and most classic poetries of scenery at their foot looking towards the plain and mountain, and when I mounted the cliffs on a level with the summit of the great rocks of Metéora and Baarlám, the solitary and quiet tone of these most wonderful haunts appeared to me inexpressibly delightful. Silvery white goats were peeping from the edge of the rocks into the deep, black abyss below; the simple forms of the rocks rose high in the air, crowned with church and convent, while the eye reached the plains of Thessaly to the far-away hills of Agrafa. No pen or pencil can do justice to the scenery of Metéora.[5] I did not go up to any of the monasteries. Suffering from a severe fall in the autumn of last year, I had no desire to run the risk of increasing the weakness of my right arm, the use of which I was only now beginning to regain, so the interior of these monkish habitations I left unvisited, regretting that I did so the less, as every moment of the short time I lingered among these scenes, was too little to carry away even imperfect representations of their marvels.

I had been more than half inclined to turn back after having seen the Metéora convents, but the improvement in the weather, the inducement of beholding Olympus and Tempe, and the dread of so soon re-encountering the gloomy Pass of Métzovo, prevailed to lead me forward. Accordingly, at nine A.M. I set off eastward once more along the valley of the Peneus, which beyond Kastráki widens rapidly into a broad plain, enlivened by cattle and sheep, and an infinite number of storks. As we approached Trikkala, the pastoral quiet beauty of the wide expanse increased greatly, and the view close to the town is delightful. Standing on a rising ground, the Castle of Trikkala, with magnificent plane trees at its foot, makes a beautiful foreground to a distance, the chief ornaments of which are the chain of Othrys and distant Oeta.

The scenes of life and activity, the fountain with groups of Thessalian women at its side, the little mosque with its cypresses, offered a most welcome change to me after the sullen ravines of the Pindus, and the close-wooded valley of the Upper Salympria.

We halted at midday in a café of Trikkala, the keeper of which was a man of Trieste, who talked of "*quella Londra, e quel Parigi*" with the air of a man of travel. But the sort of mongrel appearance of every person and thing in the town, are not pleasing to the eye of an artist who has been wandering much among real costume and eastern characteristic. Blue-tailed coats worn over white Albanian fustianelles, white fleecy capotes above trousers and boots, are doubtless innocent absurdities, but they are ugly. At half-past three we again proceeded. The town of Trikkala is large,[6] but greatly neglected, and partly in ruins. Nevertheless, the bazaars seemed extensive and bustling.

The plains grew wider and wider. We passed a few villages, each more widely apart from its neighbour than the preceding, and by degrees I felt that I was really in Thessaly, for width and breadth now constituted the soul and essence of all the landscape. To the north only the distant form of Olympus reared itself above a low range of hills; and to the south, the hills of Agrafa and Oeta were gradually becoming less distinct. Before me all is vast, outstretched plain, which never seems to end. Agriculture and liveliness are its predominant characteristics. It is full of incident: innumerable sheep, goats, horses, buffaloes, and cattle, corn or pastureland, peasants' huts and hundreds of perambulating storks give a life and variety everywhere. And then so green, so intensely green, is this immense level; and the peasant women, in their gay, fringed and tasselled capotes, how far handsomer than any Greeks I have seen!

At sunset we halt at a village (Nomi). There are plenty of villages as halting-places on all sides, but I have had enough work for today.

The Primate's house, which we go to, is newly whitewashed and very damp, so Andréa persuades a Mohammedan agent for the Turkish proprietor of the village, Seid Efféndi, to let me have a room in his house. And a delightful house it is - the room on the upper floor is lined throughout with new wood, and adjoining a gallery, which looks over all the wide, wide plain.

With curried mutton, roast fowl, and fish from the Peneus, Andréa makes an excellent dinner. He tells me that Seid Efféndi possesses seven thousand sheep, which are kept by the shepherds of these villages, who receive the tenth lamb with the tenth of the wool of the flock as their pay. These Thessalian plains are alive with dogs, who bark all through the night.

MAY 17th

A lovely scene, as the sun rises over the immense extent of verdure, which soon becomes animated with rural bustle! It will be difficult at a future period to recall, even to memory, the indescribable clearness and precision of this Greek landscape, far more to place it on paper or canvas. We start early, and trot quickly over green roads, which cross the wide level from village to village. There are buffaloes ploughing, and there are strange waggons with spokeless wheels of solid wood, drawn by oxen, and great caravans of horses carrying merchandise from Saloniki to the mountains - the lading tied in sacks of striped cloth. With some there are whole families migrating, children, puppies, and fowls, mingled in large panniers. The men wear black capotes, the women white, and dress their long plaited hair outside a white handkerchief. There are great grey cranes too, the first I ever saw enjoying the liberty of nature. These birds seem made for the vast plains of Thessaly. How they walk about proudly by pairs, and disdain the storks who go in great companies! Now and then there is a vulture, but there is too much society for them generally. As for jackdaws and magpies, they congregate in clouds, and hover and settle by myriads.

We come to the Peneus once more, now a great river. Giant, white-stemmed abeles, in Claude-like groups, are reflected in its stream. Herons are peering and watching on its banks, and immense flocks of brown sheep are resting in the shade of the trees. Between nine and ten we stop for a little while at the khan below Zarcho, and after that we enter a wide valley through which the Peneus runs. The sides of the vale are low undulations, which shut out all the distant plain. At twelve, we come again to the riverside, and passing it by a ferry, halt for food and repose below large plane trees. Bee-eaters[7] with their whistling pipe flutter in numbers around the upper branches.

At two P.M. we are off again. The delightful character of the Thessalian plains is changed. The ground is no longer a perfect flat, but composed of undulations of such great size that no part of even the mountain boundaries of the plain - Olympus, Ossa, Oeta, or Pindus - can be well seen; and sometimes for half an hour the traveller dips into an overgrown cornfield, beyond the limits of which he sees and knows nothing. I confess I was most heartily weary, as I came in sight of the minarets of Lárissa; and although the view of all Olympus is unobstructed at its entrance to the town, from which there is a view of the river sweeping finely below it, yet it is clear that the extremely simple lines of this part of Thessaly are ill adapted for making a picture, and least of all can anything like expression of the chief character of the country, i.e., its vast level extent, be given.

The heat is great, and I have, moreover, a feeling of returning fever, so that I do not observe the environs of Lárissa so much or so carefully as I might, but entering the city, go at once to the house of Hassán Bey, the richest proprietor in Lárissa (to whom the Hon. Captain Colborne has given me a letter); and although the Bey himself is from home, his family gives orders for my being placed in a good room, where I pass the night.

Chapter XVII

*Visit to the Pashá of Lárissa - Hassán Bey's house and family - Excursion to Tempe -
Village of Babá and house of the Dervish - The Dervishess and the little Dervish - Life in
a Mosque or Teké - Ambeláki - Monsieur Hippolyte - Vale or gorge of Tempe - Its
exquisitely beautiful scenery - Route towards Platamóna - English park scenes - Distant
view of Mount Athos once more - Perverse little camel - Return to Babá and to Lárissa -
Storks and their mode of life - Visit to Férsala, Armyró and Volo - The woes of Thessaly -
Rain and discomfort - All idea of visiting Mount Athos finally given up - Return to
Nomi, to Métzovo, to Ioánnina, to Philates and Corfu - Farewell to Albania and Greece.*

MAY 18th

The morning is occupied in a visit to the Governor of the Pashalik, Sami Pashá,
an agreeable man, who has lived at Cairo, London and all kinds of civilized
places. He is a Greek by birth, but speaks French and Italian well. There is a
heaviness in the atmosphere here, which either producing or combined with a
constant fear of fever-fits, prevents my making the least exertion in sketching any
one of the beautiful things around me. Yet to be so near Tempe and not to go
there! Nay, whatever happen, I will see Tempe.

At noon I dine with two of Hassán Bey's sons, his eldest by one wife. Various
other sons come into the fine room in which dinner is served, but retire before
the meal begins. Hassán Bey has seven wives and eleven wivelets, or concubines,
and consequently is a sad polygamist. Nurses and children are continually to be
seen in every part of the residence, but they all appear to dwell in harmony. It is

provoking to know that from a high lattice on one side of the courtyard, all the eighteen pairs of eyes can perfectly look at us while at dinner, and yet that I can perceive none of them. The conversation of our party is not very current, as neither I nor my young hosts are very proficient in Romaic. After dinner, I amuse them by drawing camels, &c., till Andréa informs me that it is time to start for Tempe. Promising to return to Hassán Bey's family, a well-bred and good-natured circle, I set off with Andréa, two horses and a knapsack, and a steeple-hatted dervish, at whose convent in Babá, at the entrance to the Pass of Tempe, my night's abode is to be.

They call the dervish, Dédé Efféndi, and he is the head of a small hospitable establishment, founded by the family of Hassán Bey, who allows a considerable sum of money for the relief of poor persons passing along the ravine. The dervish is obliged to lodge and feed, during one night, as many as may apply to him for such assistance. There are many interesting views about Lárissa but, not feeling sufficiently fever-proof, I dared not halt to sketch.

During two hours we crossed the level plains and, as the sun was lowering, arrived at pleasant green lanes and park scenery, below the mighty Olympus. By six we arrived at Babá, which stands at the very gate, as it were, of Tempe, and is certainly one of the loveliest little places I ever beheld. The broad Peneus flows immediately below the village, and is half hidden by the branches of beautiful abeles and plane trees, which dip their branches in the stream. A small mosque with its minaret, amid spiry cypresses is the dervish's abode, and on the opposite side of the river are high rocks and the richest foliage, rejoicing in all the green freshness of spring. In the summertime, when this exquisite nook still preserves its delightful verdure, the hidden passage from the wide parched plains of Thessaly must doubtless be charming beyond expression.

The little square room in the Teké, or house of the dervish was perfectly clean and neat, and while I ate my supper on the sofas surrounding it, the well-behaved Dédé Efféndi sat smoking in an opposite corner; his son, the smallest possible dervish, five or six years old, dressed like his father in all points excepting his beard, squatted by his side. For the dervish is a married man, and his wife, he assures me, has made one or two dishes for my particular taste, and is regarding me at this moment through a lattice at the top of the wall.

Towards nine, many poor passengers call for lodging, and are stowed away in a covered yard by the mosque, each being supplied with a ration of bread and soup.

MAY 19th

The early morning at Babá is more delightful than can be told. All around is a deep shadow, and the murmuring of doves, the whistling of bee-eaters and the hum of bees fills this tranquil place. The village of Ambeláki is situated on the side of Mount Ossa, and thither, having heard much of its beauty and interest, I went early, before pursuing the road by the Peneus, through the gorge of Tempe. I cannot say I was so much delighted with the expedition as I expected to be, but this was mainly because heavy clouds shut out all the upper portions of Olympus, partly also from not having felt well enough to seek for the best or most picturesque points. But judging from what ought to be seen if the great mountain of the Gods had been clear, and relying on the descriptions and taste of perfectly good judges,[1] I believe Ambeláki would well repay a long visit. On returning to the route to Tempe I met a young man dressed in the usual Thessalian garb, and on my hailing him in Greek, I was surprised to find my salutation returned in good French. At the fall of the commercial community of Ambeláki, the father of Monsieur Hippolyte, one of the richest merchants of the place, fled to France, settled and married there. This was his son, who, returning to his native place, had for some years resided on the paternal property. "Sometimes I live here," said he, "sometimes in Paris; but I come here principally for hunting." Town and country - Paris and Tempe - certainly are two points of Europe in which one might easily find pleasure and occupation.

Leaving Monsieur Hippolyte I went onward into Tempe, and soon entered this most celebrated "vale" - of all places in Greece that which I had most desired to see. But it is not a "vale," it is a narrow pass and, although extremely beautiful on account of the precipitous rocks on each side, the Peneus flowing deep in the midst between the richest overhanging plane woods, still its character is distinctly that of a ravine or gorge. In some parts, the pass (which is five or six miles from end to end) is so narrow as merely to admit the road and the river. In others the

rocks recede from the stream and there is a little space of green meadow. The cliffs themselves are very lofty, and beautifully hung with creepers and other foliage, but from having formed a false imagination as to the character of "Tempe's native vale," I confess to having been a little disappointed. Nevertheless, there is infinite beauty and magnificence in its scenery, and fine compositions might be made, had an artist time to wander among the great plane trees on the border of the stream. A luxuriant wooded character is that which principally distinguishes it in a pictorial scene from other passes where there may be equally fine precipices bounding a glen as narrow. Well might the ancients extol this grand defile, where the landscape is so completely different from that of any part of Thessaly, and awakes the most vivid feelings of awe and delight from its associations with the legendary history and religious rites of Greece.

As it was my intention to pursue the route towards Platamóna as far as time would allow, and to return to Babá at evening, I left the gorge of Tempe and crossed the Peneus in a ferryboat opposite a khan at the eastern extremity of the pass. Hence, the scenery was precisely that of the finest English park - rich meadows and noble clumps of trees at intervals. In two hours we reached a guardhouse called Kara Ali Derveni, and from a rising ground above it I halted to make a drawing of the view, which is one of great beauty. The waters of the Peneus meandered sparkling in many a winding curve, through delightful meadows and woods, to the sea. Beyond was the low isthmus of Pallene and above it the lonely Athos, whose pyramid I gazed on a second time, without much hope of reaching it. Towards Ossa and Olympus also the scenery would, doubtless, have been fine, but thick clouds provokingly hid them throughout the day.

In some meadows near a little stream flowing into the Peneus were several camels, which are frequently used about Saloniki and Katerina, &c. They were very ragged and hideous creatures, and offered a great contrast to the trim and well-kept animals of our Arabs, which we had so familiarly known in our journey through the desert of Suez and Sinai. But as I returned towards Tempe, I perceived a young one among the herd, and I rode a little way towards it, spite of the clamorous entreaties of the Ioánnina muleteer. I had better have attended to his remonstrances, for the little animal (who resembled nothing so much as a large white muff upon stilts) chose to rush towards us with the most cheerful and

innocent intentions, and skipping and jumping after the fashion of delighted kids, thrust himself into the way of our three horses with the most facetious perverseness. One and all took fright, and the muleteer's reared, threw him and escaped. There was much difficulty in recapturing the terrified animal, and when we had done so, forth came the little muffy white beast once more, pursuing us with the most profuse antics over the plain, and rendering our steeds perfectly unmanageable. To add to our discomfiture, the whole herd of camels disapproving of the distance to which we were inveigling their young relation, began to follow us with an increasingly quick trot, and we were too glad to ford the stream as quickly as possible, and leave our gaunt pursuers and their foolish offspring on the opposite side.

It was evening when, having recrossed the Peneus, I arrived at the dervish's house in Babá, and the little owls were piping on every side in that sweet valley.[2] Mr. Urquhart says that when he was at Tempe,[3] the dervish roosted in one of the cypress trees; but I cannot say that the respectable Dédé Efféndi indulged in such a bird-like system of repose. He, the female, and the miniature dervish, all abide in a little house attached to the mosque, and the good order and cleanliness of his whole establishment very much disarranged all my previously-formed ideas of dervishes in his favour.

MAY 20th

On my return to Lárissa there as but just time to make one drawing of dark Olympus, ere a frightful thunderstorm, with deluges of rain, broke over the plain and pursued me to the city. It continued to pour all the afternoon, and I amused myself as best I could in Hassán Bey's house. It is a large mansion in the best Turkish style, and betokening the riches of its master. It occupies three sides of a walled courtyard, and one of its wings is allotted to the hareem, who live concealed by a veil of close latticework when at home, though I saw them pass to and fro dressed in the usual disguise worn out of doors. I watched two storks employed in building on the roof of that part of the building. These birds are immensely numerous in Thessaly, and there is a nest on nearly every house in Lárissa. No one disturbs them, and they are considered so peculiarly in favour

with the Prophet, that the vulgar believe the conversion of a Christian as being certain to follow their choice of his roof for their dwelling. Formerly, a Christian so honoured was forced to turn Mussulman or quit his dwelling, so at least they told me in Ioánnina, where two pair have selected the vice-consul's house for their abode. It is very amusing to watch them when at work, as they take infinite pains in the construction of what after all seems a very ill-built nest. I have seen them, after twisting and bending a long bit of grass or root for an hour in all directions, throw it away altogether. That will not do after all, they say; and then flying away they return with a second piece of material, in the choice of which they are very particular, and, according to my informants at Ioánnina, only make use of one sort of root. When they have arranged the twig or grass in a satisfactory manner, they put up their heads on their shoulders, and clatter in a mysterious manner with a sound like dice shaken in a box. This clattering at early morning or evening, in this season of the year, is one certain characteristic that these towns are under Turkish Government, inasmuch as the storks have all abandoned Greece (modern), for the Greeks shoot and molest them. Only they still frequent Lárissa, and the plain of the Spercheius, as being so near the frontier of Turkey, that they can easily escape thither if necessary. This is foolishness in the Greeks, for the stork is most useful in devouring insects, especially the larva of the locust, which I observed in myriads on the plains near the entrance of Tempe; and I counted as many as seventy storks in one society, eating them as fast as possible, and with great dignity of carriage.

That part of the roof of the hareem which is not occupied by storks, is covered with pigeons and jackdaws; a humane attention paid to the lower orders of creation being always one of the most striking traits of Turkish character.

The storm continued all night. The air of Lárissa was heavy and close, and so much threatened fever, that I resorted to quinine in no little quantities.

MAY 21st

It is fine, but with that instinctive feeling that certain air in this country infallibly brings on return of fever, I decide on leaving the capital of Thessaly without making even one sketch to recall it to memory; and I do this with great regret, for

there must be many of the most beautiful and characteristic Thessalian scenes to be found in its level environs, and on the banks of its broad river.

Starting about seven, we held a southward course. The plain was one unvaried green undulation. Lárissa, and even Olympus, except now and then its highest peaks, were soon lost to sight from the comparatively uneven nature of the ground; and it was only from some eminence where a village was planted (of which there were two or three in the day's ride), that anything like a satisfactory drawing could be made.

Yet the very simplicity, the extreme exaggeration of the character of a plain, is not without its fascination; and the vast lines of Thessaly have a wild and dream-like charm of poetry about them, of which it is impossible for pen or pencil to give a fully adequate idea. After passing some elevated ground, from which the view of the range of Mount Oeta is most magnificently fine, we halted at midday at one of these villages - the name I neglected to take (Hadjobáshi?) - and hence the charm of Mount Oeta and the hills of Pharsalus[3] or Férsala made one of the most beautiful of landscapes, combined with the mosque and its cemetery, and the profusion of animal life usual in these Thessalian hamlets.

Having crossed the stream Fersalitis (the Enipeus), it was past five P.M. ere we arrived at Férsala, which is full of picturesqueness. The scattered town on the side of the rocky height, and the splendid plane tree groups, delighted me extremely. I was glad to have visited a spot so famous in history as well as interesting from its beautiful situation - one, not the least of its claims to admiration, being the full view of the broad Olympus opposite. The view from the Acropolis, its ancient walls, the ruins, and the fountains below the town, with its kiosk below the white-branched planes, whose fluttering foliage shelters numerous storks and their nests, all combine to render Férsala a place worthy of a longer stay than I could make in it.

MAY 22nd

With a feeling of attraction towards new scenes, and with a faint hope that I might yet, if there were a fair wind, sail from Volo to Athos, I started early from Pharsalus. There was much interest, if not great beauty, in the morning's ride, and

the route passed near several ancient sites.[3] But it was not until the afternoon that, crossing the low range of hills near the Gulf of Volo, we came in sight of its blue waters and looked down on the plain of Armyró, with the chain of Othrys beyond, and the Magnesian promontory to the east. Visions of Athos still floated before me and I decided on going to Volo instead of Armyró, for although it had an appearance of great prettiness, imbedded as it was in green groves of wood, yet I must have devoted a whole day to it had I gone thither at all, the hour being already far advanced. So, having halted for a while, I turned northward.

Many were the incidents which filled up the rest of the day: first, we lost our way among cultivated rice grounds, and secondly, in a deep quagmire - a more serious matter, which took up much time to remedy. At length, by the sounding blue waves, we went onward towards the head of the gulf, keeping in view some white houses to the left where we trusted to find a night's lodging; but, alas! when we arrived at them they were nothing but ruined, uninhabited walls. At sunset, having retraced our steps, we were climbing the lentisk-covered cliffs at the furthest head of the gulf, and many parts of it brought back scenes and pleasant journeys in Attica and Euboea.

But as it grew dark, and we were descending towards Volo, Andréa's horse fell, and precipitated him from a rock some four or five feet in height. It was long before the muleteer and myself could lift the unlucky dragoman onto his horse once more, and the great pain he was suffering obliged us to go at a very slow pace over the causeway of rough pavement which leads to the town. There we arrived at ten at night; and it was midnight before we could procure lodging within the cellar of a house - in which nevertheless it was necessary to be contented till morning.

MAY 23rd

Alas! the woes of Thessaly! It is again pouring with rain, and the wind is set in southerly, so that once and for altogether I give up all idea of sailing to Athos. The horses are ordered, and as soon as Andréa can get about, I start at length to return to Ioánnina.

As I ride away, Volo, its gulf and the scattered villages on the hills of Magnesia, seem truly beautiful, but to what purpose should I linger? Tomorrow and the day after that may be equally wet. Mount Athos! Mount Athos! All my toil has been in vain, and I shall now most possibly never see you more!

All day long I rode on in hard rain, and at sunset we stopped at one of the many villages in this great green plain. No one would look at the Boyourldi, although poor old Andréa ran about with the open document in his hand, exclaiming! "*το βλεπετε* - look at it!" with the most dramatic emphasis. But no one would look at it. One said he was blind, another declared he had illness in his family, and all retreated into their houses from fear or obstinate resolve to have nothing to do with strangers; and if an old woman had not charitably given me a lodging, in a shed full of calves, I might have been drowned in the torrents which fell. Eventually, however, we procured a cottage floor.

MAY 24th

The woes of Thessaly continued - once more by deep mire and incessant cornfields, through pastures full of cranes, jackdaws and storks, and always in hard rain as before. We kept on the right bank of the Peneus, as far as the bridge near the khan of Vlokho, and in the evening found shelter once more in the house of Seid Efféndi, at Nomi.

Toward sunset it cleared a little; and as I arrived at the night's halting-place, all the village was alive with the gaieties of a wedding. Like the dance L. and I had seen at Arachova, the women joined hand-in-hand, measuredly footing it in a large semi-circle, to a minor cadence played on two pipes. Their dresses were most beautiful. Half the women wore black capotes bordered with red, their hair plaited, long crimson sashes, worked stockings and red shoes. These were the unmarried girls. The other half - matrons or betrothed - wore dazzling white capotes, worked at the collar and sleeves with scarlet, the skirts bordered with a regular pattern of beautiful effect and the red fez nearly covered with silver coins, which hung in festoons on their necks and halfway down the crimson sash tails.

Besides this the belt, six or eight inches broad, was covered with coins, and fastened by two embossed silver plates, four inches in diameter, and gave a

beautiful finish to the dress. The aprons too were magnificently worked. Of this lively company most were pleasing in countenance, but few could be called beautiful. The bride, one of the prettiest of the party, came round to every one present, and kissed their hand, placing it afterwards on her head, a favour she extended to me also as one among the spectators. Fatigued and wet through, I regretted not being able to avail myself of the opportunity of drawing this pretty village festive scene.

MAY 25th

The woes of Thessaly continued. In the middle of the night, the roof of Seid Efféndi's house being slight, a restless stork put one of his legs through the crevice and could not extricate it; whereon ensued much kicking and screams, and at the summons came half the storks in Thessaly, and all night long the uproar was portentous. Four very wet jackdaws also came down the chimney and hopped over me and about the room till dawn. It rained as hard as ever as we went over the plains to Trikkala and infinitely worse between that place and Kalabáka, so that the spectral Metéora rocks looked dim and ghastly in their gigantic mistiness. With difficulty we crossed the Peneus beyond Kastráki, and at sunset reached one of the small khans in the wood by the roadside which must be my abode till morning. This unceasing deluge was, however, a very serious affair, as should the Métzovo river be too much swollen to ford, I might be a prisoner in the pass for an indefinite time.

MAY 26th

The woes of Thessaly prolonged! Until a little after sunrise (when it began to pour again), how grand were the Metéora rocks rising above the thick dark foliage on the banks of the Salympria!

 For hours we threaded the narrowing valley of the river, which at each ford grew more violent and rapid. Above the next two khans, parts of the road were very dangerous, and near Malakássi the streams running into the Salympria - mere

rivulets on our journey hither - were now such foaming torrents that my little white pony could hardly accomplish the passage.

At noon we reached Malakássi, yet the peasants declared that it had been quite dry on the Métzovo side of the mountain. Starting at one, we made the ascent to the Zygós khan by half-past four, and thence to Métzovo, finding it to be true that less rain had fallen there (the summit of the mountain was in thick mist, as when I came, so that I never saw that Thessalian view). We passed the town, anxious to be as far advanced within, the gorge as possible in case of bad weather tomorrow, and halted for the night at sunset at the little khan about a mile above Triakhánia.

MAY 27th

No more Thessaly - we are in Epirus once more. We hasten down the river, now disagreeably wide, and reaching in places from bank to bank; at length we reach the Lady's khan, and ascending Mount Dhrysko, halt. Then bursts the rolling thunder and the buckets of heaven are emptied. Floods pour down from Métzovo and Zagóri, and the river will be very shortly impassable. It is therefore lucky I have crossed it. So I reach Kastritza and the causeway by the lake, and the Casa Damaschinó once more before five, most heartily delighted to have quitted Thessaly, however much I regret the little I had drawn there. But May is the wet season of Albania and an artist should avoid it.

MAY 29th

Resting throughout yesterday (when, as is universally the case, rain fell after ten throughout the day), I prepare to leave Ioánnina this morning, and take leave of the hospitable Damaschinó. Zitza, Kastritza, Zagóri, Dhramisiús and many other drawings I lose - so short is my time - so uncertain the weather. Addio, Ioánnina! which I gaze on for the last time from the height above the lake, its bright city backed by black clouds of thunder. Soon the storm burst, but we halted ere long at Vérchista, and in the afternoon proceeded to the night's resting-place - Raveni, a village in a beautifully wooded hill district.

MAY 30th

Wonderfully rich and beautiful landscapes are there between Raveni and Philátes! They are perhaps some of the most lovely I have seen in Albania, both as to the form and clothing and arrangement of the hills, and the disposition of the foregrounds. After descending a narrow ravine, we arrived at Philátes about twelve, a place abounding in exquisite beauty, and placed near that very remarkably-formed rock, which from Corfu is so effective a feature in the scene.

Much I regretted not to draw Philátes from the descent to the plain by the seashore, for, indeed, there are some of the very finest scenes in all Albania or its environs.

At the Scala of Sayádes I arrived at six and, hiring a boat for Corfu, was deposited safely in quarantine by noon on the 31st.

JUNE 9th

I was out of quarantine on the 5th, and have passed some pleasant days in the town since, though not so much so as formerly. "All things have suffered change." Lord Seaton's family and many others I knew, are gone. Good old Andréa Vrindrisi I have paid and sent off to Patrás, and today I am on board the Malta steamer 'Antelope,' and am sailing through the Ionian Channel for the ninth time. Off Párga there are the mosques, silvery-white. There, high up beyond the plain, is the dark hill of Suli. There is the fatal hill of Zálongo - the point of Prévyza.

At sunset, Sappho's leap - Leucadia's rock of woe. The mountains of Tchamouriá fade away, and I look my last on Albania.

At midnight, the moon rises over dark Ithaca and lights up the Bay of Samos, where we stay half an hour.

Sunrise. Patrás once more and the pearly-tinted Mount Voidhiá. Noon. Gay Zante, bright and bustling as ever. And so, with the last point of Zákynthus and the dim, distant mountain of Kefalonia, ends my journey in the lands of Greece.

Notes

INTRODUCTION

1. Leake, "Northern Greece," Vol. I, p. 61.
2. "Travels in Northern Greece," by Colonel W. Martin Leake; "A Journey through Albania, &c." (1809 - 10), by J. C. Hobhouse; "Travels in Albania, Thessaly, &c." (1812 - 13), by Henry Holland, M.D.; "Travels in Greece and Albania," (1813 - 14), by the Rev. T. S. Hughes, B.D.; "The Spirit of the East,"(1830), by D. Urquhart, Esq.
3. "Handbook for Travellers in the Ionian Islands, Greece, Turkey, &c." Murray (1845).

CHAPTER I

1. An odious banishment.
2. The Jews in Saloniki are descended from those expelled from Spain in the fifteenth century. They are said to amount in number to four thousand.
3. Such were the representations made to me at the time, and which naturally deterred me from attempting to reach Mount Athos; but I have since had reason to believe that the state of alarm and panic was greatly exaggerated.
4. For accounts of Saloniki, the ancient Thessalonica, see Leake, "Northern Greece," Vol. III, p. 239; Dr. Holland, p. 380.

5. Secretly.
6. *Menzil*, the Turkish post.
7. Tatar, a courier.
8. Vardhári, anciently the Axius: the bridge is eighteen hundred feet in length. - Leake, "Northern Greece' Vol. III, p. 258.
9. Or Jannitza: Apostolus, a village at a small distance, is the nearest place to the actual site of Pella. - Leake, "Northern Greece" Vol. III, p. 270.

CHAPTER II

1. Illness.
2. I beg pardon. On the contrary, you have done me a pleasure.
3. Karasmák or Mavronéri - anciently the river Lydias. - Leake.
4. Aegae or Edessa, the capital of ancient Macedonia. - Leake, "Northern Greece," Vol. III, p. 272.
5. Counted as four hours from Vodhená.
6. Leake, Vol. III; Urquhart, Vol. I, p. 176.

CHAPTER III

1. No, no!
2. See page 41.
3. Baksheesh, a present of money.
4. They are all miserable creatures.
5. I believe, the lake of Peupli - but neither my guide nor Soorudji knew; and I

foolishly omitted to ask at the place itself

6. The ancient Achris, on the Lake Lychnitis. Leake.

7. The Fez is the red cap almost universally worn by Mohammedans throughout Turkey.

CHAPTER IV

1. Bey, a person of superior rank, frequently governor of a town.

2. Cogia, a priest.

3. They count six hours' journey from Akhridha to the southern end of the lake.

4. Poor, timid, despairing, afflicted; wanting sense; wanting everything.

5. Anciently Genusus - the mountain range between Akhridha and Elbassán, in the Illyrian Candavia. Leake.

6. Kabóbs, slices of meat cooked on wooden skewers.

7. Loss.

8. Bad pass.

9. Without remedy.

10. Towns.

CHAPTER V

1. The devil draws! - the devil.

2. In Italy a vine trellis.

3. Palikari - Albanian or Greek military.

CHAPTER VI

1. Drink, drink.

2. Or Lesh.

3. Yes they are! but if it pleased Heaven tomorrow so to swell the river as that they might be all swept off into Paradise, I should be happy, &c. &c. May they all die of apoplexy!

4. Or Scutari, Albania.

5. The other is the Drino, or Drin.

6. *To σπιτι* - the house.

CHAPTER VII

1. Who went round the world.

2. "Revenge, intrigue, suspicions, incendiaries," represented to me as the daily ingredients of Skódra existence.

3. "We brethren of the true religion are dispersed here and there in these woods like frightened pigs."

CHAPTER VIII

1. Durázzo - Epidamnus, afterwards Dyrracheum.

2. A small Turkish coin.

3. This district is termed the Mizakia.

4. Papas, a Greek Christian priest.

5. Women.

6. Or Lusna.

7. "No, no!" "Yonder it is good!"

8. Anciently Apsus; above Berát it is called the Uzúmi. Leake.

9. Suffering for nothing.

10. Berát, anciently Antipatria. Leake.

CHAPTER IX

1. Magnificent dogs and stupendous guns.

2. Foot traveller.

3. Wine is better than water.

4. A dinner of Paradise.

5. Intent on my sketching, I carelessly omitted to ask and note down the name of this place, though I have an imperfect recollection of its being Kosma.

6. Suite.

7. Whip.

8. Viosa, the ancient Aous. Leake.

9. The storks arrive at Avlóna from the 15th to the 20th of May, and depart before the 15th of August.

CHAPTER X

1. Kánina, Bullis Maritima. Leake.

2. The cleverest of robbers.

3. A bad road, Sir.

4. Mirth.
5. Everybody knows me.
6. Rudeness, slight.
7. "O, Sir, why will you be such a fool? I tell you, you will be eaten, murdered, and if you won't do as I bid you, you are a dead man. I will not go farther with you in this manner; henceforth you shall not stir out of my sight"
8. River of Dukhadhes, Celydnus. Leake.

CHAPTER XI

1. Palása, anciently Palaeste. Leake.
2. See page 138, Skódra.
3. "O Madam, get up and walk, for the love of Heaven! (for I wanted to see if she did not limp)."
4. My aunt.
5. Two: one is sick and the other is gone, no one knows where.
6. Shyness - fear.
7. Terror.
8. Rage.
9. Ah, Sir, there are others who cry ever so much better!
10. And why? She has become deaf; that is the only reason.
11. Murder.
12. Nothing at all; but somebody must be killed under these circumstances, so we killed the father; it is all one.
13. Cousin.
14. Khimára, anciently Chimaera. Leake.
15. Everybody writes. Write your name also.

CHAPTER XII

1. Let us thank Heaven that we have already dined.
2. Listen, Sir! That is my aunt who is crying. She cries properly! How well she cries.
3. The priests alone wear beards among the Christians and Albanians.

4. They can hardly be heard.
5. I am uncertain as to the true name of this mountain; possibly Gika would be nearer the truth.
6. O that Turkish pig! Will she not let us sleep?
7. During the autumn of last year (1851), a terrible earthquake visited some parts of Albania described in these journals. The city of Berát is said to have been totally destroyed, and a volcano to have arisen near the castle rock. Avlóna, also, and its neighbourhood, are reported to have been quite demolished, but I have been as yet unable to obtain any correct details of the catastrophe
8. Tepeléni, anciently Antigoneia. Leake.
9. Childe Harold. Canto II, 56.
10. For accounts of the massacre of the Gardhikiotes by Ali Pashá; see Leake, Hughes, &c., &c.
11. Make the best of things.

CHAPTER XIII

1. I learned to think far differently of the scenery of Ioánnina afterwards.
2. See Journals, May 2, 1849.

CHAPTER XIV

1. Andréa Vrindisi of Patrás: an excellent guide and dragoman in every respect and worthy of high recommendation.
2. See Leake, Holland, Hughes.
3. Leake, Northern Greece, I, pp. 245, 519; in Hughes, II, p. 184, the number of women is stated at nearly 100. The rock of Zálongo is famous also for other combats between the Suliotes and the soldiers of the Vizier.
4. Leake.
5. Rogús - ancient Charadra. Leake. The stream of Lúro (Charadrus) runs below the walls.

6. Leake, I, p. 102.

7. Primate, the first or head proprietor of a Greek village.

8. As some notice of Suliote history may be desirable, I add as much matter as is necessary to illustrate the subject. The mountain of Suli may be conjectured to have been occupied by Albanians about the thirteenth or fourteenth century, and when the greater part of the surrounding country lapsed to the Mohammedan faith, this race of hardy mountaineers adhered firmly to Christianity. During the eighteenth century, the Suliotes carried on a predatory warfare with the surrounding territories of Margariti, Paramythia, &c., but when Ali Pashá, under pretext of reducing disaffected districts to the obedience due to the Sultan, had subdued all the surrounding tribes, the inhabitants of Suli found that he was an enemy, determined either by craft or force to dispossess them of their ancestral inheritance. From 1788 to 1792, innumerable were the artifices of Ali to obtain possession of this singular stronghold. In the latter year he made an attack on it, which nearly proved fatal to himself, while his army was defeated with great slaughter. In 1798, after six years of bribery and skirmishing, a portion of the territory of Suli was gained by the Mohammedans through treachery of some of the inhabitants, and thenceforward the accounts of the protracted siege of this devoted people is a series of remarkable exploits and resolute defence by Suliotes of both sexes, seldom parallelled in history. Every foot of the tremendous passes leading to Suli was contested in blood ere the besieger gained firm footing; and after he had done so, the rock held out an incredible period, until famine and treachery worked out the downfall of this unfortunate people Then, in 1803, many escaped by passing through the enemy's camp, many by paths unknown to their pursuers; numbers fled to the adjacent rocks of Zálongo and Seltzo; others destroyed themselves, together with the enemy, by gunpowder, or in a last struggle, or threw themselves into the Acheron or from precipices. Those of these brave people who ultimately escaped to Párga, crossed over to Corfu, and thence entered the service of Russia and France. Many, since the days of Greek independence, have returned to various parts of Epirus, or Greece; but they have no longer a country or a name, and the warlike tribe who, at the height of their power, formed a confederacy of sixty-six villages, may now be said to be extinct. See Leake, "Northern Greece," Vol. I, p. 501; Holland, p. 448; Hobhouse, p. 174; Hughes, II, Chapters 6, 7, 8, &c.

9. The river of Suli is the Acheron of antiquity.

CHAPTER XV

1. From the precipices impending over this ravine, it is related that the Suliote women threw their children when the contest for their liberty had come to an end. To such a spot the epithet given by Aristophanes, "The rock of Acheron dropping blood," may indeed be well applied. Holland, p. 452.

2. See the description of this spot by Col. Leake, whose remarks on scenery combine the taste of a landscape painter to the accuracy of a geographer. "Three tiers of steep, and almost precipitous

rocks present themselves in front, appearing through the gorge of the river, the hill of Trypa, crowned with the Castle of Kiáfa, between two smaller buildings at either end of the ridge. Above all rises the mountain of Suli, apparently double the height of Trypa, the elevation of which, above Glyky, seems to be about 1200 feet." Leake, "Northern Greece," IV, p. 57.

3. The appearance of this and similar Albanian villages is well described by Mr. Hughes at his visit in 1815, and will perfectly well serve for their illustration in 1849 - the best huts consisting of hurdles, were constructed "only of branches of trees, half cut through, which being turned down and fastened to the ground, form a kind of tent, to which the trunk of the tree serves as a pole. Notwithstanding its apparent misery, the village has a curious and picturesque appearance, being intersected with green alleys, covered with vines, shaded by trees, and adorned with a vast quantity of flowers for the nourishment of bees, which every family seemed to cultivate." Hughes, II, p. 437.

4. The ancient Cocytus. Leake.

5. Hughes, II, pp. 244, 474. Hansard, Vol. XL, pp. 806, 1177, &c.

6. Hughes, II, p. 430.

7. Leake, "Northern Greece," I, 263.

8. Leake, "Northern Greece," Vol. IV, Chap. 37, for a most interesting and admirable description of Ioánnina, its customs, history, &c.

CHAPTER XVI

1. Leake, IV, p. 157-196.

2. Leake, I, p. 296-301; Holland, p. 226. Dr. Holland states the height of the ridge of Zygós to be 4,500 feet.

3. Hughes, I, p. 509.

4. Anciently Aeginium. Leake, I, p. 422.

5. Yet more has been done for these monasteries, both by pen and pencil, than for any place so remote from the ordinary routine of English travel. The best accounts of them are published by Colonel Leake, who visited this and the adjoining villages in 1805 - 1810. Northern Greece, Vol. I, p. 418, and Vol. IV, p. 537; and in Dr. Holland's tour (1812, 1813), who gives accurate views of them, together with elaborate and excellent descriptions of the scenery, &c., see pages 231-245. The monastery of Baarlám represented in Mr. Cockerell's drawing (Hughes, Vol. I, 508), conveys, it is needless to say, a thoroughly correct idea of that place (1816). There are also striking descriptions of the Metéora rocks in Urquhart's "Spirit of the East," Vol. I, p. 271, &c. And last, not least, the drawings of Viscount Eastnor, and the Hon. R. Curzon's amusing account of these remarkable monasteries, have made them familiar to all who read.

6. Trikkala; ancient Tricca.

7. Merops Apiaster.

CHAPTER XVII

1. Leake, III, p. 385; Holland, p. 287.

2. The Strix Passerina (or Scops?) which abounds in these groves, as in the olive-woods of Girgenti in Sicily, and southern localities in general. Its plaintive piping, so different to the screech or hoot of the larger owls, is a pleasant characteristic of the evening hours.

3. Vol. II, p. 28.

4. Pharsalus. Leake, IV.

5. Thetidium, Eretria Phthiotis, Phylace?

Bibliography

CURZON, Robert

Visits to Monasteries of the Levant. London: John Murray, 1849.

Visits to Monasteries of the Levant. London: H. Milford, 1916.

Visits to Monasteries of the Levant. Introduction by John Julius Norwich. The Century Travellers. London: Century, 1983. xxiv + 424 pp.

Visits to Monasteries of the Levant. Presented by James Hogg. Lewiston NY: Edwin Mellen 1995. xxxi + 449 pp.

HOBHOUSE, John Cam

A Journey through Albania and Other Provinces of Turkey in Europe and Asia, to Constantinople, during the Years 1809 and 1810. London: James Cawthorn, 1813. xix + 1152 pp.

A Journey through Albania and Other Provinces of Turkey in Europe and Asia, to Constantinople, during the Years 1809 and 1810. London: James Cawthorn, 1813. 2 volumes.

Travels in Albania and the Other Provinces of Turkey in 1809 and 1810 by the Right Hon. Lord Broughton, G. C. B. 2 volumes. London: John Murray, 1858. 544 & 526 pp.

A Journey Through Albania. ISBN 0-405-02784-2. New York: Arno Press, 1971. xii + 181 pp.

HOLLAND, Henry

Travels in the Ionian Isles, Albania, Thessaly, Macedonia etc., during the years 1812 and 1813. London: Longman, Hurst, Rees, Orme & Brown, 1815. x + 551 pp.

Travels in the Ionian Isles, Albania, Thessaly, Macedonia etc., during the years 1812 and 1813. 2 volumes. London: Longman, Hurst, Rees, Orme & Brown, 1819.

Travels in the Ionian Isles, Albania, Thessaly, Macedonia etc. New York: Arno Press, 1971. x + 551 pp.

HUGHES, Thomas Smart

Travels in Sicily, Greece and Albania, by the Rev. Thos. Smart Hughes, late fellow of Saint John's and now fellow of Emmanuel college Cambridge. 2 volumes. London: J. Mawman, 1820. 532 & 394 pp.

Travels in Greece and Albania, by The Rev. T. S. Hughes, B.D. Second edition with considerable additions. 2 volumes. London: H. Colburn & R. Bentley, 1830. 512 & 512 pp.

LEAR, Edward

Journals of a Landscape Painter in Albania. London: Richard Bentley, 1851. 428 pp.

Journals of a Landscape Painter in Southern Calabria, &c.. London: Richard Bentley, 1852. xx + 284 pp.

Albania and Illyria. London: Richard Bentley, 1852. 416 pp.

Edward Lear in Southern Italy: Journeys of a Landscape Painter in Southern Calabria and the Kingdom of Naples. Introduction by Peter Quennell. London: William Kimber & Co, 1964. 212 p.

Edward Lear in Greece: Journals of a Landscape Painter in Greece and Albania. London: William Kimber & Co., 1965. 222 pp.

Lear's Corfu: an Anthology. Drawn from the Painter's Letters and Prefaced by Lawrence Durrell. Including eight views of Corfu reproduced from the original lithographs. Corfu: Corfu Travel, 1965. 38 pp.

Edward Lear in Greece: a Loan Exhibition from the Gennadius Library, Athens. Circulated by the International Exhibitions Foundation, 1971-1972. Meriden, Conn.: Meriden Gravure Co. 1971. 87 pp.

The Corfu Years: a Chronicle Presented through his Letters and Journals. Edited and introduced by Philip Sherrard. Athens: Denise Harvey & Co., 1988. 247 pp.

Journals of a Landscape Painter in Greece and Albania. Introduction by Steven Runciman. The Century Travellers. ISBN 0-7126-1885-6. London: Century, 1988. 222 pp.

Edward Lear in the Levant: Travels in Albania, Greece and Turkey in Europe, 1848-1849. Edited and compiled by Susan Hyman. ISBN 0719546141. London: John Murray, 1988. 168 pp.

LEAKE, William Martin

Researches in Greece. London: J. Booth, 1814. 472 pp.

Travels in Northern Greece. 4 volumes. London: J. Rodwell, 1835. Reprint Amsterdam: Adolf M. Hakkert, 1967. 527, 643, 578, 588 pp.

MURRAY, John (ed.)

Handbook for Travellers in Greece, Describing the Ionian Islands, the Kingdom of Greece, the Islands of the Aegean Sea, with Albania, Thessaly and Macedonia. New edition. London: John Murray, 1854. xi + 460 pp.

NOAKES, Vivien

Edward Lear: the Life of a Wanderer. London: Collins, 1968. Reprint London: Fontana 1979. 359 pp.

Edward Lear (1812-1888). With an introduction by Sir Steven Runciman and an essay by Jeremy Maas. ISBN 0-8109-1262-7. New York: Harry N. Abrams, 1986. 216 pp.

The Painter: Edward Lear. With a foreword by HRH the Prince of Wales. ISBN 0715397788. Newton Abbot: David & Charles, 1991. 96 pp.

NOAKES, Vivien (ed.)

Edward Lear: Selected Letters. Oxford: Clarendon Press / New York: Oxford University Press, 1988. xlii + 325 pp.

The Complete Verse and Other Nonsense: Edward Lear. Complied and edited with an introduction and notes by Vivien Noakes. New York: Penquin Books, 2002. li + 566 pp.

URQUHART, David

The Spirit of the East, Illustrated in a Journal of Travels through Roumelia during an Eventful Period. 2 volumes. London, 1838. 2nd edition 1839. xxviii + 435 & vii + 432 pp.

Index of Placenames

Following the placenames used by Edward Lear are an indication of the country in which they are presently to be found and the current form or forms of the names.

AL= Albania
GR= Greece
IT = Italy
MG = Montenegro
MK = Republic of Macedonia
TK = Turkey